Under Dalí Skies

MADDER THAN THE WIND

Patrick Farnon

Under Dalí Skies

This edition published in 2019 by

Van Loon • Amsterdam

vanloonprint@gmail.com

Copyright © 2019 Patrick Farnon

All rights reserved. No part of this publication may be reproduced, stored in a retrieval system, or transmitted, in any form or by any means, electronic, mechanical, photocopying, recording or otherwise, without the prior permission of the publishers

ISBN 13: 9781099501852

Cover Illustration & Maps by Norman MacDonald
www. macdonaldart.net

Cover design Juanjo Lopez
www.juanjez.com

ALSO BY PATRICK FARNON

The Scots Way to Santiago de Compostela:
[Marvels and Wonders, Encounters with Strange Humans, Beasts, Birds and Insects]
What McClafferty Did
[The Chiang Kai-shek Gold Bond Scam and Other Crazy Stuff]

Contents

1 The Landscape of Dalí's Imagination . 1
2 Under Dalí Skies. 9
3 Senyor Sideburns . 13
4 Paradise and Cadaqués . 24
5 Real-time Wind . 30
6 The Case of Lidia of Cadaqués . 36
7 The Badness of Cats . 47
8 Crazy Little Thing Called Love . 51
9 More Nipper than Ripper . 56
10 Epic of the Great Masturbator . 64
11 Shooting the Breeze with Milco Meppel 72
12 Idyllic Days in Port Lligat . 77
13 The Disease of Being Salvador Dalí . 81
14 Take Montsé . 90
15 Washed Up . 98
16 Demon Bride . 104
17 What about the Rhinoceros? . 116
18 The Thing with Moon Men . 122
19 Naked Lunch at the St Regis . 128
20 Looking for a well-filled Sandwich 133
21 Rainy Day Cadillac . 139
22 Cursing in Catalan for Beginners . 150
23 One Big Mac-Daly with Ketchup, Pliz 155

24	Going up the Country 162
25	How the Rat Pack Milked the Cash Cow 167
26	On Taking the Piss 175
27	Gala's Last Ride Home 179
28	Murder is so Easy 184
29	Salvador's Ignoble Demise 189
30	Prayer for the Donkeys 196
31	The Resurrection of the Mustache 201
32	Keep A-Knocking, Cécile 206
33	The Circle of Gala's Life 211
34	Aleshores ... 219

Sources ... 223

About the Author .. 225

1
The Landscape of Dalí's Imagination

ONCE YOU UNDERSTAND THE ELEMENTS THAT COMPOSE DALÍ'S work, his paintings become easier to understand: the landscape of the porous volcanic rocks of Cap de Creus; the penetrating light of the sky, the plains of the Empordan, the wind, his diseased psyche and the imagery it spewed out. All of these the master threw into the goody bag of his imagination, shook them all up for good measure, and splashed the results onto canvas.

Salvador can be immensely entertaining (indeed comic) if you take his ravings with a pinch of salt. We can say the same of his "relationship" (for want of a better word), with his muse Gala, a woman imbued "with the libido of an electric eel," in the words of art critic Sir John Richardson who knew the pair personally as vice-president of the New York art dealers that handled Dalí's sales in America. Terrified of death, she tried to keep it at bay all her life by paying boy toys (as they say in America or toy-boys as they say in Britain) to service her to the bitter end (and it was bitter) leaving Salvador to bankroll her excesses. To inspire her suitors, she invested whatever was left on face-lifts to encourage the believe that she was a fifteen-year old-virgin and not a hag coming on for ninety. It was all to no avail. The two buzzards came to an unseemly end, in keeping with the unseemly nature of their lives.

Reviewing Dalí's autobiography in 1944, George Orwell said, "It is not given to any one person to have all the vices…but otherwise

he (Dalí) seems to have as good an outfit of perversions as anyone could wish for…his pictures were diseased and disgusting."

Dalí was perhaps the greatest confidence trickster of all times. At the age of twelve he thought up a marvelous scheme (or so he says). He'd offer his classmates at school a ten-cent piece for every five they gave him. He borrowed some money from his parents and set up a little desk behind which he sat doling out money to his mystified classmates, giving them a ten-cent piece in return for every five they gave him. In doing so he intuited the schemes that later twentieth century fraud masters would apply to separate fools from their gold, people like Charles Ponzi who gave his name to the Ponzi pyramid scam or Michael Milken, the junk bond king, jailed in 1989 for racketeering and securities fraud. What all three had in common, was the insight that greed has greater currency than logic. Offer people an irresistible deal and no matter preposterous or improbable your offer, there are enough fools so greedy they will buy into it. Dalí conned his classmates into believing that he was a genius and had some secret that no one else possessed.

That little anecdote explains the parallel market in his graphic production that later developed. It was encouraged by his cavalier attitude to his own output that ultimately choked up the toilet bowl of the art market with counterfeits and duds. Dalí was not only a pervert, "as anti-social as a flea," to quote Orwell again, but also a scam artist.

Under Dalí Skies is my tribute to Dalí Land where I had the privilege to live for some years. Most of all, it is a tribute to the Tramuntana (Tramontana) that enters the Empordan through the Pyrenees and blows in off the Costa Brava all year round. At its epicenter — between Cadaqués and Port Bou on the frontier with France, with Llançà in the middle — it can reach speeds of up to 200 kilometers an hour.

Listening to the howling of the wind for days on end is invigorating for some but for some others it comes as a relief when it stops. After it blows itself out, ten or more days later at most, the sky is swept clinically clean, leaving an intensely bright light that creates a heightened sense of perception. The effect is akin to that of 3-D. It is as though a fine layer of skin has been removed from the cornea of the sky and that you are about to see the stars in the sky in the bright light of day. Any clouds in the otherwise crystalline blue of the sky, adopt strange shapes. Elongated and tattered like rags by the wind, at times they can be mistaken for those baguettes that Dalí liked to paint.

The Tramuntana is only one of the forces that have shaped the stubborn character of the people of the Empordan, of whom Salvador Dalí was one. We need only consult map of the region to see how it was formed.

The Romans were the first to invade. In 218 BC they landed in the bay of Roses near the former Greek colony of Empuries, to prevent Hannibal crossing the Pyrenees with his armies and elephants and call to heel the Celt-Iberian tribes who supported him. They created the infrastructure of Catalunya (Catalonia) that exists to this day. The Vulgar Latin spoken by the soldiers, merchants and common people, slowly replaced the Celtic languages spoken by the tribes and transformed into Catalan.

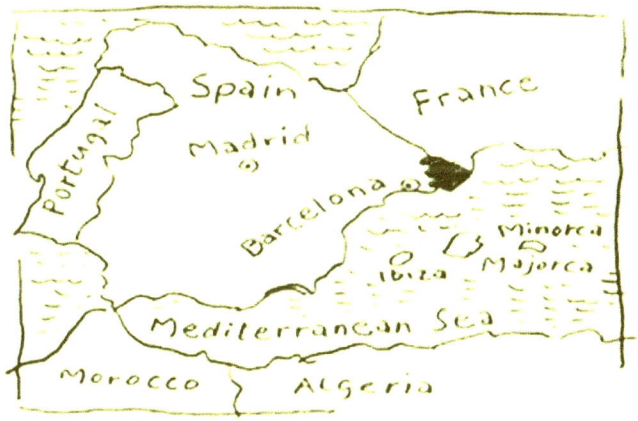

From the 12th to the 18th century, the coastal region was plagued by pirates and corsairs. It was big business. Taking people prisoner, to be held for ransom or sold into slavery, they plundered and raped, leaving the inhabitants of the small fishing villages up and down the coast traumatized. For up until the early twentieth century, the road over the mountain to Figueres from Cadaqués was practically non-existent. More of the villagers found it easier to climb into a boat and go to Cuba than wind their way on foot over the mountain to their provincial capital. That isolation, combined with the effect of the Tramuntana, possibly explains why witches were still present in the folklore of the village in Dalí's formative years. Dalí's chief muse who inspired his paranoiac critical method, was the daughter of the last sorceress of Cadaqués.

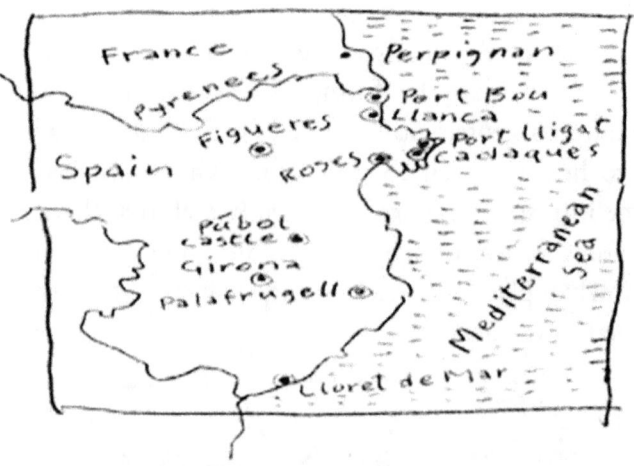

When I first went to live in Llançà at the turn of the millennium, one of the first things I did was to sign up to Pepe Lozano's art classes in a school-room near the village square. Pepe was a lovely man, in his sixties then probably, a committed artist all his life who, to make a name for himself when he was young, had wandered round Spain on donkey. He smoked big cigars and employed a technique known as wet-on-wet. He could make the most beautiful skies by simply

letting the watercolor course down the paper. He gave one of his finest watercolors to Paco, who ran the Casa del Mar, to hang on the wall. I know it was his finest because I pointed it out to Paco when a fire broke out in the restaurant and water from the firemen's hoses damaged it. It was then that I realized that Pepe had paid Paco a great honor. I'd also lunch at the *Casa del Mar* occasionally with Joseph Malats whose acrylic classes I'd attend on Thursday evenings at the Art School in Figueres. He knew Dalí personally, and if you'd seen a photo of Josep in his younger years you would have mistaken him for the young Dalí. He'd had a boat moored in Port Lligat, had a retreat in Villajuiga below Quermançó castle where he had a little artist's hut where he did his paintings. In the late year, we'd spread blankets under the olive trees and shake down the olives for cold pressing. He told me he'd seen Dalí come out of the Café de Paris in Figueres once with a folded tortilla sticking out of the breast pocket of his jacket. He was a "son of a bitch," he said. Dalí had been talking with Josep one day at his house in Port Lligat when a party of Japanese tourists arrived. Dalí lost all interest suddenly in Josep and rushed out to pose for the tourists. He seriously offended Josep's honor by doing that. Or so I understood.

But I've not been able to include all of these dear memories into this book. Of going down to the Casa del Mar early in the morning when it had just opened, with Pili and the smell of coffee when you went in and standing at the bar with the workmen. Or sitting on the sofa of her mother's house before the holiday season started, leafing through her collection of Josep Pla's works in Catalan, while the girls busied themselves getting the house ready for Doña Isabela's arrival by train from Barcelona.

Salvador was a piece of work. He hated the ordinariness and banality of everyday life. The seventeen stories in this book that relate specifically to Dalí and compose about two-thirds of the volume, are arranged more or less chronologically. In creating a portrait of the

artist, I have drawn as much as possible on what he says in his *Secret Life* and in his diaries. My chapter on *Crazy Little Thing Called Love*, for example, is practically a transcription of what he says of his relationship with Gala in his autobiography. The problem always with Dalí is can we believe anything he says? Is it fact or wishful-thinking? Or is he just trying to shock, manipulate, sell us a pig-in-a-poke to hide the real truth about himself?

To offset Dalí's surreal world, I have also interspersed stories about the Tramuntana and real people in Dalí Land. Tales of everyday folk like seaman Santi whose wife ran off with an orthopedic shoemaker; old Tina who reckoned witches had spirited away her cats; and Milco Meppel who moved from blowing dope in the city to growing dope with a bunch of moon men up in the Pyrenees.

I am particularly indebted to Ian Gibson for his scrupulously documented work *The Shameful Life of Salvador Dalí* which leaves few questions unanswered about the man who wrote a play in which he was God. Belgian writer Stan Lauryssens also deserves special mention. Having been himself involved in the Dalí art racket in the seventies and eighties himself, his account of how his American boss wanted to set up a chain of Mac-Dalí franchises to flog the master's work to well-healed consumers with pretensions to taste, is priceless. It inspired the chapter on *One Big Mac-Daly with Ketchup, Pliz*. As is his copy of an FBI report detailing the Catalan's apprehension in 1941 in the United States on suspicion of being a Nazi spy, the basis for *Rainy Day Cadillac*. Equally invaluable is his hilarious account — as related by Ultra Violet — of the afternoon teas (orgies) that Dalí held in the suite of his New York hotel which is described in *Naked Lunch at the St Regis*.

In the end, Salvador was a buffoon, a trickster who created his greatest works before he was thirty and spent the next fifty years and more playing the fool. With the gewgaws and inanities that he poured

out at the drop of a hat, he mesmerized that section of the public that loves to be conned and seduced by the glitter and flash of bling-bling. He ended up becoming a Seedy old Wizard of Was, in the words of art critic Sir John Richardson. Vested interests do their best to sanitize him, portray his inanities as an expression of genius, and present his hellish alliance with Gala as a love story.

But to give him his due, he was entertaining. He had a great sense of humor, one which is rarely remarked on by serious-minded art critics, seriously interested in taking him serious.

Even dead, he is a work in progress. He was mad about the Marx Brothers, universally considered among the greatest comedians of all time, and worked with Harpo Marx on a screenplay of Giraffes on Horseback Salad for MGM, which they finished in 1937.

Whether Harpo supplied any dialogue is not known — he played a curly-mopped buffoon in all the family movies, plucked the harp and never spoke. Salvador, as always, supplied the typical Dalí-isms for which he had become loved and revered. In this case, burning giraffes with gas masks on their noses. Chickens exploding and splattering their guts.

A giraffe on fire with a gas mask on its nose and lumps of splattered chicken on its saddle has no meaning in the normal sense of the word. When they heard about it, America's critics fell to their knees and cried out in unison "Tell us what it means, all-knowing one. Give us a sign. Show us the way." Salvador duly obliged. Shaking a nugget of fool's gold from the sleeve of his artist smock, he held it aloft and to the thunderous roar of applause in his skull and gasps of awe from the assembled multitude of admirers before him, visible and invisible, he read out the message written thereon.

"Its theme is the continuous struggle between the imaginative life as depicted in the old myths and the practical and rational life of contemporary society," he proclaimed

When he heard about it, MGM boss Louis B. Mayer — nobody's fool — wasn't impressed. Burning giraffes togged up in gas masks was a bum idea and the project had about as much chance of flying as pigs with whiskers, he reckoned. Having worked on the screenplay for long enough, Harpo was equally disappointed. "It won't play" he reportedly quipped in his characteristic verbal shorthand.

But who knows, we may get to see the movie yet. Worse could happen. There's still a morsel of two left on the carcass of the old buzzard, it seems. In May 2019, the Guardian newspaper reported that the Giraffes on Horseback Salad screenplay had been unearthed and was being made into a graphic novel. Which is halfway to being a moving picture, in a sense.

In the same month, Popular Mechanics reported that the Dalí Museum in Florida, had used 'deepfake' technology to bring the surrealist back from the dead. The artist's features were digitally copied and combined with a video of his body movements and gestures. Another actor recorded his speech patterns and idiosyncratic Spanish-Catalan accent. He now has a gleaming set of beautiful pearly white choppers straight out of an advert for teeth whitening — belying the fact that he had a mouthful of jagged stumps in real life. Babbling endearing inanities, he exudes the combined charm of George Clooney, Captain Birds Eye of fishfinger and Uncle Ben of parboiled rice fame. An irresistible combination for museum visitors wanting to take a selfie with dear uncle Salvador. At the rate technology is developing, it is only a matter of time before they are all giving Captain Salvador a big warm hug. Or a little peck on the cheek.

2
Under Dalí Skies

ACROSS THE WIDE BAY OF ROSES, THE WAVES SWEEP IN RAGGED white lines to shore. the wind whips the foam into spray and creates twisters that dance like Dervishes over the tumultuous waves. The air is crystal-clear, the sky as taut as canvas. Were it not for the wind you could well expect to hear the firmament crack. In the distance, the trees along the ridge of the distant hills spring out in sharp relief, backlit by the penetrating blue light. The landscape, the white villas, the houses along the shore leap forward into sharp focus in the purified air. The wind has the effect of sweeping the sky clean of impurities, making the light more penetrating, bringing the landscape and the objects in it, into sharper focus.

The Tramuntana can blow for up to ten days on end, but eventually when it runs out of breath, leaving the sky satiated, the first strange, tattered clouds drift into view. There is something endearing about these ragged wisps that pass for clouds with the stuffing blown out of them. There is something endearing about the whole show, and something quite absurd. Weird apparitions in the sky are legacy of the Tramuntana. For some it portends madness, for others it brings a heightened sense of well-being. Dalí loved the Tramuntana. He designed a giant wind organ to bend the wind into notes as it whistled high over Quermançó castle just outside Llançà. He filled his paintings with references to it, loved the crazy wind most of all because it gave him justification for acting as mad as a

hatter. After all, if the Empordan is full of crazies, touched by the wind: "tocats per el vent," as popular tradition has it, madness is normal. As far as Dalí was concerned, it was not only normal to be mad, it was his divine duty to be mad.

Sitting in front of the open fire at his home in Palafrugell on the Costa Brava one winter many years ago, Josep Pla (1897-1981), father of modern Catalan literature, wrote:

"I've spent the last few days sitting at the hearth listening to the howls and moans of this impressive wind called the Tramuntana…it is a wind that reaches us from the other side of the mountains. It rages across through the delightful Roussillon (in the south of France), with its gardens and fields and enters the Empordan after incising the frozen peaks of the Pyrenees. When it has settled down you can see the polar star, white in the night with a touch of blue… The everyday domestic variety, modestly routine, aerating the atmosphere, creating the most agreeable, most invigorating, most revitalizing climate you can imagine in this country of ours."

Pla pinpoints its entry into the Empordan plain through the Coll de Portus, and sometimes through the Coll de Banyuls before sweeping down on the high and low Empordan. The other form of the wind, he says, has much greater meteorological cover, embracing two outer limits. The cold climate of the Bay of Biscay on the Atlantic coast of Spain and the temperate climate of the gulf of Genoa, off the coast of Italy. The meeting of these two climatic zones, warm and cold, creates the turbulence that translates at times into violent hurricane force winds. This is the other form of the Tramuntana, the one "that carries off the roof-tiles and the chimneys, blows down walls, overturns train carriages and creates havoc of all kinds on land and sea."

The weather people regularly record hurricane wind speeds. In January 1995, it gusted through the streets of Figueres at up to 110

kilometers an hour and over 200 kilometers an hour up on the high Puig d´Esquers in the Albera. In 1929, it blew off the roof of the new railway station in Port Bou, blew down the railway bridge in neighboring Colera and sank three boats in the bay of Roses. A Dalínian touch was added when it sent a Guardia Civil flying four meters into the air in Port Bou and dropped him on his head. It got up his cloak, it seems. Its area of maximum effect is in a line from La Junquera — last stop for truckers before the border — to Palamós on the Costa Brava, passing through Figueres. However, its footprint is much greater. A reading on the anemometer of Figueres weather station in 1916 recorded it tracing a twisting ribbon across the land and the sea over a distance of more than 10,000 kilometers. On 6 February 2017, winds of 146 kilometers an hour were recorded in Port Bou that collapsed the electricity grid in Port de La Selva.

Books are regularly published on the subject to approve or disapprove the claims made of its effects. All mostly to no effect since it affects people differently. Conxita Rojo, a doctor in Port de La Selva, 12 kilometers along the coast road from Llançà, carried out a study of it in 2003. Not surprisingly, the dry intense wind, blowing up to ten hours non-stop, provokes contradictory feelings in different people. Two thirds of the locals modify their behavior when the wind is raging while the rest remain impassive. Some people hate the wind, while others are energized by it. It affects the neuro transmitters of the brain. It changes them more in women, children, and people who are over fond of chocolates and pastries. From time immemorial, the people of the Empordan have attributed to the Tramuntana the power of inciting madness, a bit like the Foehn of the Alps. However, as regards the popular belief that it causes an increase in the number of suicides and violent crimes, Rojo says there is no scientific foundation. She is of course talking about statistical certainties in study methods. Anecdotal evidence is something else. Salvador Dalí's grandfather Gal Dalí fled Cadaqués

to escape the Tramuntana. About ten years later, he went raving mad and killed himself in Barcelona. The Tramuntana is hardly felt as far south as Barcelona, so it can hardly be blamed. He was diagnosed as paranoid.

If you have a sweet tooth you might want to reflect on that reference to chocolate. Who was famous for his love of chocolate, particularly when poured over a lobster? Exactly! Salvador! And look how he turned out.

3

Senyor Sideburns

SALVADOR WAS A WACKO FROM DAY ONE. YOU ONLY NEED LOOK at those crazy eyes or the poses he adopted on cue throughout a lifetime to know in your gut there was something not quite right with him from the beginning. Great artists have eccentricities but Dalí was in a league of his own. Ignoring the fact that in keeping with family tradition in Spain, his parents had named him Salvador after his father, he liked to maintain the fiction that they had named him after his dead brother, also called Salvador. The fiction that the death of his brother (whom he saw only in a photo later) had a lasting-impression on him is mindlessly echoed by Dalí commentators. In his early diaries Dalí makes no mention of his dead brother who never became more than a footnote in the vast lexicon of the artist's imagination. His memory was highly selective and was fed more by wishful-thinking than fact. He had no concept of time, measure or chronology. Any dates or figures that he quotes are suspect.

Understandably eager to wipe out the memory of their first born, the artist's parents produced a second child within a year of the death of the first. It has been said that they spoiled the second little Salvador to compensate for their grief. No doubt there is some truth in this. But from what we know of Salvador's early years, a lion tamer might have had more success with a whip, than the lullabies the family hummed to send him to sleep. Salvador was a handful. Given to tantrums and outbursts of rage, he was unmanageable. Napoleon

was his hero. Dressed as a king as a child, he would parade around the roof terrace of the family home in Figueres, addressing his imaginary subjects.

All sorts of names would be given to his condition later. But no single term would deck the extent of its deviation from the norm. Far from being pursued by ghosts from his past, Salvador nourished his own self-created obsessions. With no authority to call him to heel, he unleashed the hounds of his fevered imagination on himself to slather and snarl in pursuit of his desiring. Insecure in his own being, pathologically shy, lacking a moral compass, he sought to establish his identity by all sorts of subterfuges. He adopted one mask after another, continually reinvented himself, making it up as he went along. One minute he was a Communist, the next a fervent Catholic, then a Fascist. He adored Hitler, Stalin, even the little dictator General Franco, together with an assortment of other insane people who had become famous by doing immense damage to the human race. One psychiatrist, stumped when asked on TV what was ailing the man — by then on his last legs — could only retort that the mere fact of being Salvador Dalí was a disease in itself.

He claimed he could remember his life in the womb. Or so he says wistfully in *The Secret Life of Salvador Dalí*. He made it up, of course. Still, it makes fascinating reading, which was his intention. "Divine, it was Paradise" in that warm cavity where his "most striking vision was that of a pair of eggs fried in the pan, without the pan." The biggest drawback — though he does not say so — was having no one in there with him to impress or cretinize. However, he made up for that soon enough. As soon as was pushed out of Paradise, he made his first squeak and noting that squeaking howling and wailing had a peculiar effect on adults, he made good use of them. Squawking and bawling non-stop when he was a little mite, it took his mother, his aunt and his nanny hours on end, to lull him to sleep.

In her memoir: *Salvador Dalí Vist per la Seva Germana* (*Salvador Dalí as Seen by his Sister*) Anna Maria recalls how each evening at nightfall they would sink slowly into slumber in the folds of the skirts or arms of their mother or la tieta (auntie) as they softly sang the lullaby of the Angel of Dreams.

> The Angel of Dreams with his white wings, his fine gold hair, his silver robe, and night falling, he is coming down from the sky, as the stars spread apart to make way for him. And as dawn clears the sky, he stirs, flaps his wings again and seeing him pass, the little birds sing, the sun comes up and the flowers spread their petals.

"We were convinced that that angel, whom we confused with our guardian angel, had the power to protect us from every evil," Anna Maria says.

Salvador was more than a match for the angel. As a child he was as stubborn as " a ram's horn" an expression, you could only understand if you saw a peasant grasping a ram by the horns and trying to turn it …"but he was affectionate and as sentimental as… the right words escape me because I have to say he was as stubborn and as violent as he was good-natured, and despite his bad temper, made himself loved. We were fond of him because such (bad behavior) was accidental and so his other qualities were what endured," his sister said.

What these other qualities were remains a mystery. They have never been found, and Anna Maria is silent in that regard too. They certainly didn't include kicking her in the head — which he claims he did, when she was three and he was seven — or dancing through the house holding his "treasure" in his overloaded intestines and with "voluptuous regret" relieving himself in a drawer, a shoe box or a sugar tin. Or wetting the bed deliberately to annoy his father when he failed to buy him the red tricycle he had been promised.

One Sunday, when their parents took them for a walk accompanied by their nanny Llúcia, the dear child became entranced by the glitter

of the hairpins on Llúcia's head. She wore a headscarf fixed with hairpins and *el nen* (the child, or the kid, as his father called him) tried to pull them off, an action made all the more difficult and painful by the fact that the hairpins were hooked and deeply tangled in the nanny's hair. "Leave Llúcia's headscarf alone or you'll hurt her," his father roared; but no sooner had he admonished him than *the kid* was at it again. And there they were, all five of them: on the railway crossing in Figueres, five minutes from the house, Llúcia screaming, the little brat pulling at her hair, father trying to pull him off, and all the while mother, terrified a train might come down the line at any moment, tugging at Dalí senior's coat and all of them in a frenzy, creating a dreadful din. Young Salvador continued unmanageable until they found the only solution was to distract his attention, change the subject and direct him to something that interested him.

Dressed in the long white ermine-fringed cloak and a crown on his head an uncle gave him, he would parade about the terrace of their second house (where they moved to when he was eight), giving imaginary speeches to his subjects. Later when he found out that Napoleon had a great hat, he ditched the crown and dropped the king. Napoleon's tricorne hat was the clincher. He had a thing about the French emperor from an early age.

"The kid was always saying he wanted to be Napoleon and one day when we went on an excursion to the hermitage of Saint Sebastian, he was so exhausted he couldn't take a step further. Auntie made him a paper hat and put it on him saying, "Now you're Napoleon." That was enough to give him a new lease of life and send him scampering up the hill with his broomstick horse between his legs, arriving there before the rest," Anna Maria says.

He had his moments, though. Learning that someone actually liked the man comes as a great shock, though the story may wrench a tear of commiseration from the congenitally sympathetic reader. When he was a teenager, he had a studio with two big rooms looking

Senyor Sideburns

onto the Carrer Monturiol near their house. It was always full of little gypsy kids chattering non-stop, playing the guitar and singing. Salvador used them as models for his paintings. He would be about sixteen at the time and already a bit of a dandy — it was before he went to the art school in Madrid. The kids were mad about him and would go out onto the balcony and shout down to their gypsy friends that they were waiting for Senyor Padilles (Mr. Sideburns) to start painting them. He would do two or three paintings a day of them, adding all sorts of fanciful touches to their great delight.

One day when Anna Maria and Salvador were in the lounge at home, a bunch of gypsy kids appeared at the door, all terribly upset and crying, carrying a bunch of wild flowers they'd brought for Sideburns.

> "Sideburns is dead, sideburns is dead," they cried, sobbing. I showed them into the dining room to see Sideburns in the flesh. Salvador hugged them. They looked him up and down, half-terrified, because apart from thinking he was dead; they didn't recognize him immediately. He'd changed so much since they last saw him. Then suddenly, from one moment to the next, they started jumping up and down, dancing and clapping their hands, shouting, "Yes, it's him. Yes, it's him. Then I got the whole story. When they hadn't seen Salvador for ages, they'd called round at the house several times wondering what was wrong. But there was nobody at home; we'd all gone off to Cadaqués for the holidays; that was it. It seems that one day they were passing through the cemetery in Figueres and saw a palette, some artist's brushes and tubes of paint behind the glass in one of those burial niches. And since they'd only seen things like that before in the studio of Senyor Padilles, they decided they must be Salvador's and that he must have died. Once we'd explained where we'd been and what had happened, they finally understood and ran screaming with delight down the same stairs they had come up only a few minutes before with their faces tripping them".

That was in the second house in Figueres where the family moved to in 1912. The first house was on the same street, on the Carrer Monturiol, named after Narcís Monturiol, the inventor of the submarine. It was at the center of town, a stone's throw from the Rambla. Don Salvador Dalí Cusí moved there from Barcelona in 1900 at the age of twenty-eight with his wife Felipa Domènech Ferrés, a pretty Barcelona girl, two years younger, after he won the much-coveted post of notary public in Figueres in the open competition of the Ministry of Justice. A big powerful man, passionate and opinionated, Salvador would later recall him rolling on the pavement outside the office, fists flying, wrestling with a — one presumes, uncooperative — client. A first son called Salvador was born on 12 October 1901 but died twenty-two months later (seven years, according to Salvador) of infectious gastro-enteritis flu. In keeping with family tradition in Catalunya, when a second son was born nine months later on 11 May 1904, he was also given the name of Salvador. His sister Anna Maria was born four years later. The apartment where Salvador spent the first eight years of his life was spacious and looked on to the gardens and the palatial villa across the street of the *Marquesa de la Torre*, who owned their building. On the ground floor, Salvador Dalí Cusí had his notary practice. From there an internal stairway led upstairs to a mezzanine floor which had a four-meters-wide balcony with sliding doors. At one end of the balcony was an aviary where Salvador's mother, a keen bird fancier, reared canaries and doves and kept pots of lilies and sweet-smelling spikenard. The floor above the mezzanine was rented by the Matas family from Barcelona who had emigrated to Argentina but had returned to live in Figueres with their three daughters. One of them, a beauty who attracted Salvador's attention as a boy, was Ursula Matas, writer Eugeni d'Ors' inspiration for his mythical Catalan heroine *La Ben Plantada*, (the well-planted or well-rooted) so called because he saw her as firmly rooted in the soil and thus representative of Catalunyan womanhood. In 1910 Salvador's grandmother Maria

Anna and her unmarried daughter — twenty-seven-year-old Catalina — came to live with the Dalí's and occupied the floor above the Matas family. Salvador was six at the time and Anna Maria two. Catalina or *la tieta* (auntie) as she was usually referred to, looked after the two children, sharing the tasks with her sister. When Felipa died in 1921, Catalina married Dalí Cusí. At the top of the house was a communal terrace where the washing was done and from where you could see a swathe of the Empordan plain and the outline of the mountains. It was a delightful house in a delightful setting; Dalí would later recall the huge eucalyptus tree bathed in the moonlight with a nightingale singing in its branches and frogs croaking in the pond in the garden of the Marquesa. When she sold the villa and the grounds to property developers, they had to move. The effect was traumatic, as Anna Maria writes in her book.

> All of us in the house still remember with sadness and distress the day they cut down the big chestnut trees with their pinkish flowers that endowed the gallery with such intimacy. It was enough to make you cry, having to dismantle the aviary on the balcony, with all the turtle doves and canaries, scented by the spikenards and the lilies under which grandmother so patiently picked through the washing, and mother, a pine nut in her mouth, would call out to a bird to come and fetch it while the kid and I would watch smiling, lips moist and mouth half open. The scent of the spikenards, (a favorite of Salvador's all his life), escaped into the warm air of that summer that had only just begun. We were going next day to Cadaqués. When we came back our lives would be changed irrevocably.

The new house to which they moved in 1912, when Salvador was eight, was on the same street but further along. The view was better. From the balcony they could see a strip of the Bay of Roses and the mountains. When the festive season arrived, they would make a crib with everyone helping, Salvador painting the moon a

silvery purple from sheets of marine blue paper he bought in the shop. Before Nativity, a big-knotted stump of olive tree was placed before the fireplace and covered with a blanket. Later, the two children would beat it with a stick to magically discover all sorts of presents underneath. Then with the Feast of the Three Kings (Epiphany) coming up on 6 January, mother, auntie and Llúcia would disappear into the sewing room and keep the door closed. When the magical day arrived, the balcony doors were thrown open for the children to discover that the pails they had filled with water for the horses and the camels of the Three Kings were now mysteriously empty and the Black King had left a lump of black sugar coal on a plate. With, of course, some twists of those sugared onions that little Salvador had once seen in the confectioners and cried blue murder because he could not get them.

Anna Maria paints a delightful picture of Figueres in the early years of the 20th century. "It was like a little town out of an operetta. On Sundays, dressed in their finery, the citizens would gather in the shade of the plane trees on the Rambla to listen to the music of the Sant Quinti regimental band playing waltzes by Strauss and Franz Lehar while the soldiers from the Estat Major with their white sashes and sky-blue cummerbunds, their chests gleaming with medals, flirted with the young ladies."

The cafes in the evening were meeting places for the local intelligentsia composed of aspiring artists and writers and the better-educated. Salvador Cusí was a member of the Sports Club across the street where the discussions were lively. There was plenty to talk about. Catalunya had been undergoing a cultural *renaixença* since the 1830s. As the remnants of the Spanish empire fell away, Catalans had even more reason to find a new pride in themselves and their language, after being under the imperial yoke of Madrid for centuries. The disaster of 1898, when Spain lost Cuba and Puerto Rico, the last of its colonies, gave a further impulse to Catalan

aspirations since Catalan entrepreneurs had been at the forefront in developing businesses in Cuba and Puerto Rico in the 19th century and suffered most from the loss of the Caribbean market. They were keen to establish themselves back in their native Catalunya. They were a force to be reckoned with. Already in the 19th century, about a third of the population of Cadaqués had been to Cuba. Some who had made their fortune, returned to retire in the impressive villas they built.

Anna Maria was inspired to write about her upbringing in Figueres in the early years of 20th century in response to the impression her brother gave in his *Secret Life* (published in 1942) of his troubled childhood and tormented relationship with their father. When Anna Maria's memoir appeared in 1949 (in Spanish) after his *Secret Life*, Salvador loathed the more idealized picture she painted of their childhood. He considered it an affront to him and his reaction was brutal. Inspired by an image from a pornographic magazine, he fired off a painting entitled *Young Virgin Autosodomized by Her Own Chastity*, depicting his sister bending naked over a windowsill looking out to the blue sky and the sea and being assaulted from behind by flying phalluses. It was the beginning of their life-long estrangement. She saw him once after that, when his health was gone and she went to see him in Púbol Castle. He bawled her out, calling her a lesbian. She died five months after her brother on 16 May 1989.

Briefly arrested, tortured and imprisoned by the Republicans during the Spanish civil war, Anna Maria believed Gala had denounced her falsely as having fascist sympathies. The same suspicion hung over Dalí, possibly with more justification, since in one of his notoriously unreliable autobiographies he wrote that: "Hitler turned me on in the highest."

But what seems to have bothered her brother most was that, although she said in her memoir that he was a born artist (and would have succeeded regardless of the circumstances) she did say — which

was pretty obvious — that both the family climate and life as they had lived it in Figueres and Cadaqués then contributed to his talents developing without struggle or difficulties — "que els seus dots es desenvoluppessin sense lluita ni dificultats. " This was the crux of the matter. It seems innocuous enough, but Dalí, born into a fairly wealthy family, would have the world believe he underwent a heroic struggle of Olympian proportions to make it on his own. "I was expelled by my family in 1930 without a cent. All my worldly triumph I conquered with the help alone of God, the light of the Empordan and the abnegation, heroic and daily, of my wife Gala," he liked to claim. It was the usual baloney. What was also denied the Prodigal Son, was access to Paradise in Cadaqués, when his father barred him from their holiday home.

Had Dalí been capable of self-criticism or experiencing such a thing as remorse, he might have recognized his fate more in the Myth of Lucifer, the fallen angel banned by God from Paradise for presumption. Born with a silver spoon in his mouth, loved and adored by his mother, mollycoddled all his young life, coming from a solid, well-off, highly cultured Catalan bourgeois family, he never wanted for a thing. All this he threw away by taking up with a Russian harpy his father reckoned was a cocaine addict, if not a drug dealer, and exhibiting a picture at his first show insulting his beloved mother (who died of breast cancer when he was sixteen). It went on show at his first exhibition at the Goemans Gallery in Paris in 1929. Known as *The Sacred Heart*, it is an Indian ink drawing. The figure of Christ is outlined with a fine pen, his right hand raised in peace. In the center of his chest is a tiny crucifix surmounting his sacred heart. Scrolled all around the image are the words (in French) *Sometimes I spit with Pleasure on the Portrait of my Mother*. It no doubt tickled the whims of the bourgeois surrealists, but when his father either read about it in the newspaper or heard of it via writer Eugeni d'Ors, he went berserk.

It was one of those things thrown up by an over-fertile mind. Summed up by the perennial woe-is-me, "It seemed a good idea at the time," he seems to have regretted it later. Pablo Picasso used to say that he had a mind like an outboard motor that was always running. His outboard motor, alas, whipped up more stinking lumps of fetid slurry than bubbles of spring water from the depths of his troubled subconscious.

"Congenitally unable to show affection, he gave no affection and received none in return," Ian Gibson concludes in his *Shameful Life of Salvador Dalí*. Anna Maria deserves our eternal gratitude for her anecdote about him and the little gypsies. Seen through their eyes, for a brief moment love's heavenly light shines on her brother and he becomes likeable. Most of the gouaches he painted of the gypsies have been lost but one called *Dos Gitanos* (two gypsies) still exists. It portrays two little gypsy boys of about seven or eight in close-up, dark-skinned, round-faced and round-eyed. The painting has great charm because of its naive style and its simplicity. Done about year before his life changed and he went to art school in Madrid, it hangs today in the Dalí Museum in St Petersburg, Florida. No doubt, the pair, one slightly bigger than the other, were among the group of little gypsies who came running up the stair that day looking for their dear friend Senyor Sideburns. It was his finest moment, if only he had known it. He was still a human then. Or could be mistaken for one.

4

Paradise and Cadaqués

CADAQUÉS WAS A PARADISE FOR THE DALÍ FAMILY. IT TOOK them away, it brought them back. For Salvador Dalí Cusí the notary, it healed the deep wound of his father's suicide; for his daughter Anna Maria it was the place where she spent the happiest days of her life and for his son Salvador it opened up the world of art in which he discovered the lunar landscape of *Cap de Creus* that inspired his paintings; got to know Lidia Noguer, source of his paranoic-critical method and met Picasso when he was six at the Pichots (Pitxots) a bohemian family of artists and musicians, friends of his father. In summer, they would give concerts on a boat just off the beach of Es Sortell, where they had a house. With a grand piano mounted on a platform on the boat, and dressed in evening wear, they would tune up their instruments as the villagers, lined up in reverent silence on shore, waited for the first tinkling notes to come sparkling across the becalmed waters like tiny silver fish as two tame swans sailed past on the leaden waters. For added effect they would wait for a night of the full moon with the waters in the bay as still as death for the whitewashed walls of the town to be projected on the flat surface of the sea like a mirror. La calma blanca, the locals called it, the white calm.

It may have been subliminal recognition that put Dalí Cusí in contact with the Pichot clan in Barcelona in his student days. Or simply, pure luck. But when his friend Josep 'Pepito' Pichot introduced him to his family, it was a life-changer. Fate was preparing

to return him to Cadaqués where he was born in 1872. Pepito's father, Ramon Pichot Mateu was a senior director at Vidal i Ribas (pharmaceuticals and chemicals) in Barcelona, and his mother Antonia Gironès Bofill, was the daughter of a Cadaqués man made good. They had a literary-artistic salon off the lower reaches of the Ramblas, near the Santa Maria del Mar church, that was celebrated for its dash and the exciting people it attracted. Barcelona, was the place to be then. It was a center of avant garde architecture and art following the international exposure it got from the 1888 International Exposition. The city was booming and when the railway line was extended to Gerona in 1878 and later to Figueres, wealthy Catalan families discovered a taste for the seaside. The Pichots started to holiday in Cadaqués in summer and later bought a property to develop on a little rocky peninsula on the little bay of Es Sortell, round the headland to the right as you descend the hill into town. Dalí Cusí initially rented a stable from the Pichots but in 1910 acquired a two-story house with a garden off the beach of Es Llaner, about two hundred meters or so from Es Sortell. Anna Maria Dalí describes the house fondly in her memoir. When he was fourteen Salvador made a drawing of it, which Anna Maria describes in her book.

> One afternoon when it was very cold and we could not leave the house, my brother passed the time making this drawing reproduced here (in her book) and that I have kept ever since that time since it reflects exactly the atmosphere at home during the long summer evenings in Cadaqués. While he was drawing and commenting, I watched in amazement how he brought to life what had happened the summer before...when I look at it even today, it makes me relive those summers. From one window, the head of my little toy bear, my favourite toy, is sticking out. In the other you can see a candle because in Cadaqués at that time the electricity was so feeble it cut out at times so you always needed to have candles ready...I see my grandmother coming out the

door opening the glass bead curtain. She is dressed in black. She was small, slim, very pretty. My brother would say she looked as neat as a spool of black silk thread. My father is reading the newspaper while my mother and la tieta (aunt Catalina and future step-mother) are sewing...They are all sitting on the canvas-backed chairs we had then. I am playing nearby with some friends. The eucalyptus tree is still small at the time and behind this tree, which later became big and leafy, my brother is painting, surrounded by children from the village. In the foreground is Enriquet, our gardener and boatman who is fast asleep stretched out on the beach. He hardly ever did a stroke, was laziness personified. Along the road the neighbors are coming with their children to spend the afternoon with us. And to make sure nothing is missing he (Salvador) has also put in the servants who washed their clothes in a pool in Melos' orchard, and also a cow that made us very much afraid and that we had to avoid when we wanted to go and get the oranges from the orange tree that you could just reach up and grab.

Lidia Noguer, the fisherwoman who would become Salvador Dalí's muse, lived nearby in the old part of town in the Calle Portdoguer. Dalí met her for the first time when he was seven in 1911 and listened often to her tales when she came around to the house with her basket of fish.

But it was the Pichot clan that fired Salvador's imagination most. They were of his father's generation mostly but through their artistry and their artistic contacts, tales of their travels and the famous artists, writers and musicians they knew, they opened the world to him.

There were seven children in the Pichot family, five boys and two girls and all of them were brilliant in one way or another. The eldest, Ramon (born in 1871) was a friend of Pablo Picasso and exhibited with him in Paris. Gertrude Stein, an American writer who had a salon where leading writers and artists (Ernest Hemingway, Matisse, F. Scott Fitzgerald) met him in Paris in 1907. She described him in

the autobiography of Alice B Toklas as a "rather a wonderful creature, he was long and thin, like one of those primitive Christs in Spanish churches and when he did a Spanish dance, which he did later at the famous banquet for Rousseau, he was inspiringly religious." Pablo Picasso's impotent friend Casagemes, who was besotted with Ramon's wife, Germaine committed suicide over her in 1901.

But they were all wonderful creatures. Pepito, the friend of Dalí Cusí, gave up the law, to become a horticulturalist, built a house on the little peninsula, made an oasis of it by adding an exotic garden. Maria, nicknamed *Niní* by her parents (the Catalan bourgeoisie liked to give their children nicknames) became an opera singer of international fame and was reputedly one of finest Carmens of all times. She caused a riot at a theatre in Moscow when she tossed a squeezed lemon to the audience before the opera started. In Mexico, on her way to sing for the President, she was captured by Pancho Villa, the Mexican revolutionary, general and bandit. On her promise to come back and sing for Pancho and his band of *bandoleros*, he released her. She came back and sang to them, melting their murderous hearts. Or so the Pichots liked to remind each other *en familia*. Then there was Mercedes, who sang with Maria, a dress designer who wanted to set up a shop with her sister in Paris. Born the same year was Lluis, a violoncellist who played with his younger brother Ricard for August Rodin the leading sculptor of the age who gave them a sculpted hand that they kicked about the garden and lost after the performance. Ricard, also a cellist, won first prize for the cello at the Paris Conservatoire at the age of seventeen and was one of Pau Casals' favourite pupils. He is fondly remembered in the family legends for a concert he gave dressed in a frockcoat to a bunch of bemused ducks. What the ducks made of it all has never been recorded. People who study this kind of thing, say that Ricard got it all wrong, that they were not ducks at all, but geese on the way south from Siberia and, as such, had a poor grasp of Spanish.

Although the Pichots were of Dalí Cusí's generation, Salvador played with their children and they were in and out of each other's houses all summer. The family also acquired an estate near Figueres, thanks to Maria's support. Called the Molí de la Torre (Tower Mill) it was a huge building made entirely of brick. The Dalí family were regular visitors (Dalí Cusí notarized the purchase act). Salvador was impressed by Ramon's pointillist paintings. Ricard's son Antoni Pitxot (as he liked to spell his surname later) who was thirty years younger than Salvador became a lifelong friend, was a trusted companion of the artist all his life. A director of the *Theatre Museum in Figueres*, he died in 2015 at the age of eighty-one.

Once Es Sortell was established and the word got around, the family's Bohemian friends started to arrives in droves. With the train now running from Barcelona to Figueres from 1878 and on to Port Bou at the border, visitors now only needed to get down to Figueres from Paris or up from Barcelona and take a *tartana* (a covered buggy) from the railway station to Cadaqués. The tartana, which was like the Irish jaunting car, had two big man-sized wheels (one on each side) and was covered with a leather hood to protect your head from the burning sun or a sudden downpour. The tartanas, which were the taxis of the age, came in various sizes and could hold up to six passengers. They were pulled by a horse or a mule. The smaller versions, drawn perhaps even by one of those humble little donkeys that French poet of the Pyrenees, Francis Jammes loved so much that he wanted them to accompany him to Paradise when he died. The buggy was as humble as the donkey. Rolling on its huge wheels, it proceeded at a snail's pace. It took about ten hours to get from Figueres to Cadaqués where, in the early years of the 20th century, women still fetched water from the well with jars on their heads. The houses were without running water.

Spanish novelist Vicente Blasco Ibáñez immortalized the Spanish buggy in his 1894 classic *Arroz y Tartana* (Rice and Buggy) a tale of

bourgeois tribulations in the rice-growing region of Valencia. How long the buggy continued to take visitors to Cadaqués is difficult to say. The first petrol driven car (a Panhard Levassor) was imported into Spain from France in 1881, but horses and carts remained a feature of the Spanish countryside until well into the 1960s. *Arroz y Tartana* was a popular read when Picasso and writer Eugeni d'Ors were bumping down the road on holiday. The title had a nice ring to it and they will have read it, or tried to, as they rocked about in the buggy.

Cadaqués sounds so paradisiacal in the years of Salvador's youth. Without a doubt it was. And for a long time afterwards too. But there are two sides to paradise. There is this side of Paradise and that side of Paradise. On this side the sun shines in a clear blue sky, the flowers are eternally in bloom and it is always summer. On the other side of Paradise, the wind is howling for days on end, the sky is clouded over, the fires are burning in the grate, the streets are deserted and the visitors have gone back to the city. But there is nobody around to write songs in praise of Cadaqués on that side of Paradise when the Tramuntana blows.

5

Real-time Wind

HIGH WINDS WERE FORECAST YESTERDAY ON TV, BUT WHEN the Tramuntana hits, it is with a vengeance: up to 200 kilometers an hour, as it turns out. I take a walk with Tuca, Pili's dog, up the hill to get a good view of the sea, but she wants to go back home. Branches of trees, plastics, bits of loose metal are whirling in the wind. A sudden strong gust catches Tuca from behind and sends her careering up the hill, her big floppy ears, vertical in the wind, her stumpy tail pressed down tight as a ship's hatch to protect her rear. Further along, Steve, an Englishman, is drilling a hole in one of the boulders that compose the wall below his house. His mail is scattered all over the road. The wind has ripped the top off the mailbox, which is lying on the ground. He has retrieved some of the mail but more of it has danced over the roofs and blown out to sea. He has also bought a new mailbox. A plastic one. "No, no metal. The only type they have in the *vila*," he says.

The postman refuses to bring the mail up the fairly steep drive to his house, something like fifty meters. Since there is only currently one postman who scoots about on a little yellow scooter, it doesn't seem much to ask.

The postman, a bearded guy, he says, has passed his exams and apart from stealing, there is now nothing that can shift him from *Correos,* which is a job for life. There's an open exam every year. Thousands apply. So, it's not just any old postman we're talking about here.

Real-time Wind

"Why don't you bung him something," I suggest.

But Steve is not a man for subornation or similar low-life doings. And anyway, there's no guarantee that the man will deliver, because "you know what the Spanish are like, right?"

"Right, Steve." He is considering a box in the post office and collecting his mail there.

"Already before eight I have to pull down every shutter in the house," he says when we are up in the top floor of the house. "Last time it hit us face on, the big panes of glass on the sliding balcony doors bent in dangerously. By about eight centimeters." We are standing in the big upstairs bedroom looking down onto the *puerto*, the sea and the hills.

"We had to sleep in the back room. If it falls on you, it could slice your leg off. And the light on the ceiling began to move on the cord."

"Look, the wind's coming in," Elena, his wife says. And true enough, it is suddenly colder and the pressure on the big glass window in front of us is so great the pane is curving in. How far will glass bend before it bursts?

Down in the port this Tuesday morning, the streets are littered with debris. On one street corner, the scaffolding is bent at a crazy angle. They are painting the block a beige colour. With stripes of deep green. The automatic drinks dispenser behind the Gola cafe on the sea front has been torn from its moorings and is lying on its side. The white dingy that was bobbing dangerously for days near the rocks has been blown on to the beach among the fishing boats. Along the wooden jetty boats have overturned. Ten or so other, proud little Catalan fishing boats, sit happily bobbing on the waves out of harm´s way. One of the overturned boats looks like it is made of polyester, the other of steel. They are designed to carve through the waves at speed and although they sit deeper in the water, this is their undoing.

During the night, we awake several times to the sound of objects crashing on the balcony but stay put and let the wind have its way. The shutters are down and we cannot see anyhow. In the morning, inspection shows, the wind has ripped the cupboard on the open balcony from its mooring, torn out the screws from the wall on one side and ripped the L-bracket loose from the chipboard on the other. Fortunately, it has not collapsed on its face as it has been blocked by the sofa which in turn has lodged against the cornice, forming an immovable block. Two of the cushions are gone.

Now that the wind has died down, I look for the cushions in the terraced piece of garden I have carved out at the side of the house, but nothing. Interestingly, climbing down the garden to the house below where Tina lives, I notice a tiny stream runs under her house. There is a fissure in the rock of the slope from which the water is easing. In the cleft in the rock is what looks like a statue of the *Virgin* placed in a little shrine. A sort of miniature Lourdes. The excess water dribbles down a gutter of terracotta tiles onto a small patio under the wall of the kitchen, through the kitchen inside and out on to the street at the front.

Even higher winds are forecast today. Fritz the cat has not shown his face. Pili is concerned. "Cats always have little holes to hide in," I tell her. Another unknown cat appeared this morning on the round plastic table that sits on the patio in front of the window and was looking through the window into the kitchen. An orange and white tabby. Someone's tablecloth is wrapped round the white painted steel pillar that supports the balcony of the upper story of our white apartment block.

The high winds of the last weeks have twisted the parabola on the sidewall, so I can't get satellite reception. I'll have to screw the window off its hinges to reach the parabola so I can adjust it. In the meantime, it's back to programs in Catalan and Castellano, which in terms of understanding are on a par with the twenty-plus satellite

Real-time Wind

programs available in German. I get the gist of them, just about. The Spanish national broadcasters are the worst: American soaps. About a third of the time you are watching ads. When the sun is out and the weather is hot, you could be in Florida watching Fox TV. The Catalan broadcasters are generally much better.

On the white-tiled wall of the baker's shop on the main street, there's a sort of star-shaped plaque encrusted with a mosaic of colored glass triangles, the sort of thing, first time you see it, you think: God, who thinks these things up? A closer glance reveals names are written round the circle in the middle. The names of the winds that blast the coast and howl over the hills: Levante, Tramuntana, Mistral, Garbi, Xaloc, Ponente. I promise myself to look for the wind in Dalí's paintings, the next time I am in Figueres. The red skies, and those elongated tubes of pink sausage, are no surrealist fantasy.

The red skies in the evening when the sun goes down behind the Pyrenees are regular, different every time, unspeakably beautiful. However, Dalí's long tenuous sausages, pink or white usually, need more patience. When they come, the sky has to be clear as a bell, scoured clean by the Tramuntana.

Late in the evening, strange shuffling noises come from the front door. The wind has picked up. The shutters rattle. The wind picks up a chair and throws it against the door. During the night, more noises. *Tuca* sits barking at the door and will not be calmed. About seven in the morning, a beautiful full moon is waning behind the hills under a clear sky. Before eight, when I walk with Tuca along the rocky path that runs high above the sea, a red sun is rising above Cap de Creus near the point where the shadowed promontory dips into the sea.

In the gym, after nine in the morning, the elderly Andalusian with the bad back, the one who always comes and sits together on the mat with his wife, can't touch his toes. There's something wrong with his back. He's locked at the waist. He makes a half grab at his

distant toes, flapping his hands over his knees while iron-hard Jordi, the gym teacher, who has metamorphosed since last year into a five-feet-something Michelin man to get his diploma in deep-sea diving, launches into another bout, announcing this time,

"Vint tocs."

Jordi is one of the old-school. Twenty times this, twenty times that. He must have learned it when he did his two-year stint in the *mili*.

So, the Andalusian has the advantage. Hands on his knees now while the rest of us of grunt in pain, he says,

"Over 190 kilometers an hour. They said it on the radio." He's talking about the Tramuntana.

"Two hundred and twenty up at Garbet," says Jordi, trumping him. That's the kilometer-long pebbly beach beyond the headland where, it is rumored, his father has a plot of land.

"Some people think it's the Garbi," the Andalusian declares unprompted downstairs in the dressing room. "But they're wrong, it's the Xaloc."

What's he on about? Xaloc? Now that is certainly advanced wind talk. Xaloc was the one I was thinking of keeping to the last. Xaloc, aha! I glance at him with renewed interest. Xaloc, I haven't heard anyone mention that one before. But who said? He said: "some people." But at this time in the morning who could he have been talking to? Because there's nobody on the street. I guess it must be his wife. Who else do you talk to so early in the morning? Anyway, they're both wrong. According to the greengrocer, anyhow. Because when I go into his shop at the side of the market, and remark on the wind, he pronounces unequivocally: "Ponente."

"Ostia!" Ponente indeed! Now there's another one, straight off the back of the moon. Well, hit me with a fish.

Real-time Wind

Wednesday is normally market day in this side street of the port, and I need to replace some things that have gone with the wind. How strange. Where are the stalls? Where is the market for that matter? "El mercado? No hay?"

"The wind," the greengrocer says, jerking his head upwards as he screws off the tails of the leeks and tosses them into the bin. None of the stallholders has turned up. The street where they hold the market every Wednesday is deserted. It's like arriving at the quay and finding the ship has cast off. Still, it's nice to know that nobody hereabouts has a clue. The Tramuntana can make you feel at home.

6

The Case of Lidia of Cadaqués

THERE WERE THREE WOMEN IN SALVADOR'S LIFE: HIS SISTER Anna Maria, his wife Gala and a fish wife. But of them all, the fish wife, Lidia Noguer Sabà influenced him most.

"She had the most magnificent paranoid brain, apart from mine, which I have ever known," *el Divino* said. To Dalí's delight, she could make the most surprising connections and associations between all sorts of things. She came from a community of fisher folk. Her husband was a fisherman. She sold fish and took in lodgers.

At the turn of the 20th century, Cadaqués was an isolated godforsaken place, burnt by the sun and isolated by the mountain that rises above it; where people still believed in witches. Lidia's mother, for example, was seen locally as a witch. Known as *La Sabana*, she was the last sorceress of Cadaqués.

Writing of her death in *La Vanguardia* of August 2017, journalist and former MP, Pilar Rahola, describes the scene (as told to her by her grandmother) the night La Sabana died.

> At midnight in the year 1900, with the last breath of day, a terrifying choir of caterwauling felines broke the silence, and heading down towards Es Opal, hundreds of black cats in spirit form, descended the mountain raising a cloud of dust so thick it obscured the light of the moon as La Sabana went running with the pack to meet up with other witches in Portvendres where they

arrived in boats, with each stroke of the oars covering a mile at a time. On nights when the moon was full, she would change into a wolf and had the Tramuntana at her mercy. She bewitched the fishing boats so the fishermen could not go fishing until another witch came with a book of exorcisms to break the spell. She charged sixteen silver duros a chant for doing so.

From this woman who turned into a wolf when conditions took her, was born Lidia Noguera in 1866. Four years later she would marry a fisherman called Ferran '*Nando*' Costa who gave her two sons. Nando's mother, *Dolors Puig*, was a witch too, referred to behind her back as 'la Rata' because of her greed. The Rat kept all her money in a mattress. The house burned down one day and the mattress disappeared. The police came and questioned Nando and his brother. There were suggestions that they had started the fire and stolen the money. Lidia was suspected of aiding and abetting them. Malicious tongues said she was the reincarnation of *'Sabana.'* Seven years later in 1916, broken by the accusations and insinuations, Nando hung himself, leaving Lidia's sons outcasts. They spent the days on their boat out at sea and the nights in the hut in Port Lligat talking about a vein of precious minerals they had discovered on Cap de Creus after a small plane crashed there, sucked out of the sky by the magnetic field of the minerals. Or so they reckoned. Salvador Dalí tells a tragic-comic tale of their doings in his *Secret Life*.

> But if Lidia was linked to reality, and of the most substantial kind, her sons on the other hand were really mad and ended up much later by being committed to an asylum. Nòrio and Venido thought they had discovered several square kilometers of precious mineral at Cap de Creus. They would spend the moonlight nights hauling dirt in wheelbarrows from a great distance to bury the vein of mineral so that no-one might discover it. I was the only one who inspired them with confidence because of my long conversations with their mother about The Master (Eugeni d'Ors) and La Ben

Plantada. They arrived one evening at my family's house, the summer before I met Gala, to inform me of their discovery. We shut ourselves up in my room. I asked what the mineral was that they had discovered. Then they insisted on my closing the shutters on the windows: there might be spies listening to us from outside. I shut the two windows and drew close to them, putting my hands on their shoulders to inspire them again with confidence.

"Well, what is it?"

They looked at each other again, as if to say, "Shall we tell him or shall we not?" Finally, one of them was unable to hold it back any longer.

"Radium! he whispered hoarsely."

"But is there much of it?" I asked.

And he answered, indicating with his hands a volume twice the size of his head, "Pieces like that and as many as you want."

When the Civil War broke out in 1936, without family or means of subsistence (her sons had been committed to an asylum) she was in a sorry state. Seeing her in distress, Anna Maria Dalí and some friends got together in July 1944 to pay for her stay in the asylum of Gomis in Agullana, a small town in the Pyrenees near La Junquera and the French border.

But it is the long drawn-out 'affair' she had with the writer Eugeni d'Ors for which she is most remembered. It lasted for fifty years until d'Ors died in 1954. In absentia, that is. It was all in the mind. Of Lidia in particular, a deception created by d'Ors who had a fatal talent for over-intellectualizing everyday life. Only much later, after both Lidia and d'Ors were dead, would a Barcelona psychiatrist put a label on Lidia's affliction.

It all started in the summer of 1904, when d'Ors booked into Lidia's guesthouse with his friend, Jacinto Grau. Eugeni was a handsome young man at the time. He was a man of learning and

dressed like a dandy. Having aspirations to be a philosopher, he carried the works of Nietzsche and Goethe in German with him in his suitcase when he arrived.

Their meeting ignited a fascinating relationship of posh meets peasant as the intellectual d'Ors came under the spell of Lidia's magical utterances and Lidia fell head over heels for the young poseur's looks, exquisite manners and convoluted speech. "He couldn't order two fried eggs without a big song and dance," Josep Pal said of him later. For a simple woman of no education who had taught herself to read and right, d'Ors opened up a new world. It was a meeting of fire and water, between a young man of twenty-four and an older woman of thirty-eight, d'Ors the water and Lidia the fire.

"She was robust and had a good figure," says Cristina Masanes in *Lidia de Cadaqués, Crónica d'un deliri*. "She moved with unaccustomed solemnity for a fishwife. She had a look that was both expressive and insistent, penetratingly inquisitive perhaps. She reminded d'Ors of a portrait Goya had painted of the actress *La Tirana* that hung in the museum of the Academy of Fine Arts in Madrid. She had a few teeth missing but d'Ors found her attractive, none the less."

When d'Ors started writing for *La Veu de Catalunya* under the pen name of '*Xenius*' two years later, he would use his experience at Lidia's house and the impression she made on him to create the firmly-rooted or well-planted *La Ben Plantada,* heroine that he would refer to in his columns or '*glossaries*' as they were known. Over a period of sixteen years, he came to write nearly four thousand of these with the purpose of reforming Catalunya morally, socially and culturally. Teresa, the well-planted, was his ideal of Catalan womanhood. By well-planted he simply meant a maternal figure, firmly grounded in the soil and representative of Catalunya.

Lidia took the glossaries to be his way of communicating with her. It did not help that d'Ors encouraged the deception. Once she

became convinced that she was *Teresa, La Ben Plantada*, nothing could stop her from sending missives in response to the encrypted expressions that, she believed, Xènius wrote in the press. All his life, he systematically ignored her letters, never answered one. The fictional Teresa, meanwhile, had become something of a rage throughout Catalunya. Young Catalan women took to dressing in Greek robes as described by Xenius in his columns.

When his glossaries started to appear in the paper, Lidia would go around to the barber's shop and read them. For her they were like the Holy Grail. She read and re-read them, looking for hidden messages from Eugeni, reinterpreting them to her own reality, believing that she was Teresa, La Ben Plantada, the idealized figure of Catalan womanhood that d'Ors regularly referred to or seemed to refer to. Reading between the lines, she discovered herself in just about everything he wrote.

The earliest photo of Eugeni shows him with his wife Maria Perez Peix (peix is fish in Catalan) a sculptor he married in 1906. Maria, serious and not particularly pretty, is looking over his shoulder. Eugeni's face is disproportionately big and square; his hair is greased and black and parted in the middle. Round his neck, he has a starched collar with tiny wings and a polka dot cravat. Later photos show him as a portly bourgeois, dressed in a long dark coat and bowler hat. In another, a portrait photo, he affects a rakish pose with an eyepiece covering one eye like a pirate. He was a poseur and a snob.

Over the years, d'Ors became a household name in Catalunya thanks to the vast number of glossaries he printed in papers and magazines. He also had his enemies. When an advertisement appeared in a local newspaper one day saying, "Who will stop buying the Glossaries of Eugeni d'Ors?" Salvador Dalí Cusí, saw it and without thinking twice sent in a reply saying, "I, Salvador Dalí, notary of Figueres, would stop buying them."

Senor Dalí had an issue with the young upstart. One day, passing through Figueres, Xènius went to see the notary and asked him why he would not buy his glossaries. "Because I'm sick and tired of seeing what is happening to that poor woman, who has gone insane and can think of nothing else but these glossaries of yours. When you are incapable of just going and telling her that there is not a word of truth in it. That these glossaries of yours don't refer to her nor are they addressed to her whatever she might think." Dalí Cusí knew it was the beautiful Ursula Matas upstairs that d'Ors had his eye on. That she was the one who had inspired La Ben Plantada.

Lidia saw Eugeni only twice after that summer of 1904. Once when she turned up, to everyone's embarrassment, at his father's house in Barcelona with a basket of fish. On another occasion, during the annual Flower Festival in nearby Castelló d'Empúries, from where she trailed Eugeni and his party to the monastery of San Pere de Rodes on the mountain high above Cadaqués, Lidia on foot and the others on horseback.

Salvador Dalí met her in Cadaqués for the first time when he was seven, in 1911. She would come around to the houses of the better-off with her basket of fish and regale them with her tales. Dalí's father had bought a summer house off the beach the year before. Lidia lived nearby and later ran a guest house. As he would say in her praise:

> She was capable of establishing completely coherent relationships between any subject whatsoever and her obsession of the moment, with sublime disregard for everything else and with a choice of detail and a play of wit so calculatingly resourceful that it was often difficult not to agree with her on questions which one knew to be utterly absurd. She would interpret d'Ors' articles as she saw fit, with such felicitous discoveries and a play on words that one could not fail to wonder at the bewildering imaginative violence

with which the paranoid spirit can project the image of our inner world upon the outside world, no matter where or in what form or on what pretext. The most unbelievable coincidences would arise in the course of this amorous correspondence which I have several times I used as a model for my own writings...such was Lidia of Cadaqués who, if she lived as she did in a world of her own, which was very superior, spiritually speaking, to that of the rest of the village, it did not on this account fail to keep her feet firmly planted on the ground with a sense of reality which the people of Cadaqués were as ready to recognize just as much as her folly whenever she got on the subject of Master d'Ors and La Ben Plantada. Lidia isn't crazy, people would say: just try to give her short weight when you sell her fish or put your finger in her mouth!

The affair with d'Ors — a comedy of errors in more sense than one — was played out mostly in absentia between the two for fifty years until d'Ors died in 1954. Absence that is in the physical sense, but not in the psychic sense. Only much later, after both Lidia and d'Ors were dead, would a Barcelona psychiatrist put a label on Lidia's affliction.

A spiritual marriage had taken place between them. Lidia knew that and acted in accordance. d'Ors, for all his intelligence did not. He had another agenda. This dandy, vain, cynical and intellectually arrogant who had started his life as a Catalan nationalist and trade unionist to later become a Falangist, what one writer described as "the first Spanish fascist," was one of the most brilliant Spanish writers of the 20th century. However, he had a practical problem. For the sake of Catalunya, he wanted to covert himself into a giant of the stature of Goethe and to be for Catalunya what Goethe had been for the *Weimar Republic* in Germany. It was a bridge too far.

When she died in 1946, Xenius composed the epitaph on her tombstone. It reads: "Here rests, if the Tramuntana lets her, Lidia

Noguer de Costa, Sibyl of Cadaqués, who by magical inspiration, dialectically was and was not, for a time Teresa, La Ben Plantada. In her name may the Goats and Anarchists be exorcised by the Angelic Ones." Goats and anarchists, was Lidia's term for her enemies and the *angelic ones,* the term she applied to her friends. The great distance between what d'Ors wrote down and what meaning Lidia took from it, is best summed up by Dalí.

> On one occasion Xenius wrote an ultra-critical article entitled Poussin and El Greco. That evening Lidia arrived, triumphantly waving from afar the newspaper in which the article had just appeared. She adjusted the folds of her skirt and sat down with that ceremonial air by which she indicated there was a great deal to talk about, and that it was going to take a long time. Then putting her hand up to her mouth confidentially she said, "He begins his article with the end of my letter!" It so happened that in her last letter she had alluded to two popular characters in Cadaqués. One of them was called Pusa and the other was a Greek deep-sea diver, who fished for coral and was nicknamed 'El Greco.' Hence the analogy was quite obvious, at least phonetically: Pusa and El Greco. But this was just the beginning for Lidia took the esthetic and philosophical parallel which Xenius established between the two painters as being the comparison she herself had made between Pusa and the Greek diver, elucidating it word by word in an interpretative delirium so systematic, coherent and dumbfounding that she often verged on genius!
>
> Later that evening she went home and put on her glasses. Her two sons, humble and taciturn fishermen of Cap de Creus, watched her while they prepared their lines for the next day's fishing. Lidia uncorked the ink bottle and on the best ruled paper that was sold at the village post-office; she began her new letter to 'The Master,' as she called him. She liked to begin with sentences like this. The seven years wars and the seven martyrologies have left the village of Cadaqués dry. La Ben Plantada is dead! She was killed by Pusa (Poussin, the French painter) and El Greco as well as by a recently

founded society of 'goats and anarchists.' The day you come here on an excursion, be sure to make it known to me in your daily article. For I have to know a day in advance so I can go and get meat from the butchers in Figueres. In the summer season with all the people here, it is impossible to find anything decent to eat at the last minute.'

One day she told Dalí that d'Ors had been to a banquet in Figueres two days before. Knowing that this was impossible he asked her how she found out. It was written in the menu that the paper published, she said and showed him the menu, pointing with her finger to the word Hors d'oeuvres.

"The Hors is all right," Dalí said, "but what does the d'oeuvres mean? She thought for a moment. D'oeuvres' is just like saying incognito. D'Ors incognito — he didn't want anyone to know he was coming!"

In 2004, the *Revista de Historia de La Psicologia* published an article entitled *El Caso de Lidia de Cadaqués* (the Case of Lidia of Cadaqués) quoting psychiatrist Ramon Sarrò (1900-1993) who read a speech in homage to d'Ors in Barcelona in October 1955 in which he said:

> We are faced with an unusual event in the History of Literature and Culture. Two great geniuses seek and find their inspiration not in the divine Muse but in a humble paranoid fisherwoman whose name is recorded in the Civil Register as Lidia Noguer Sabà. Her influence on Dalí is reflected in his book, *The Secret Life*, in the conception of the paranoiac critical method and in several paintings. In the work of d'Ors, the influence is nothing less than his posthumous book: La Verdadera Historia de Lidia de Cadaqués (The True Story of Lidia of Cadaqués). You could say that d'Ors spent the last stage of his life dominated by his obsession with Lidia of Cadaqués...the psychiatric diagnosis is quite simple: what she suffered from was paranoid erotomania.

The erotomania syndrome or the Syndrome of Clerambault is named after French psychiatrist Gateän Gatian de Clerambault who documented five cases of it in 1921. Victims of Erotomania, usually females, become absolutely convinced that someone loves them. In the case of women, when they are ignored or rejected by the object of their love, they perversely interpret this as evidence of love, and become all the more convinced that they are indeed loved. They will go to any lengths to find excuses for the rejection. The man is impeded from declaring his love, they tell themselves, because he is married or is in a sensitive position socially or professionally. In the same way, victims will deliberately distort the meaning of anything the loved one says, turning it to their own advantage. Of Lidia, Sarrò says:

> Lidia was never incoherent, given the letters she sent to d'Ors. The people who were unaware of what was going on were the two men that destiny had placed in Lidia's path: Salvador Dalí and Eugeni d'Ors. Each of them invented his own Lidia, a self-portrait of themselves. Dalí's version was surrealist and Freudian and d'Ors was mythical as can be seen from his descriptions of life in Cadaqués where the wind of the Tramuntana plays a mythical role, knows too much about human beings and only blows at moments of great human tragedy over Cadaqués which is ruled by women, as were the countries Ulysses visited in ancient times.

Of the two, d'Ors comes off worse. d'Ors colluded in the delusion because he wanted to create an ancient experience that had always remained hidden for him. Lidia came out of d'Ors' subconscious. "From the most profound nostalgia of his soul, out of a state and a sentiment of such profound loneliness it makes one shiver. In the final stage of his life, d'Ors was left alone with Lidia. The true story of Lidia was written at the gates of death. When he came to the last phase of his life and was faced with passing judgment on his own

existence, the only love that had not faded was that of Lidia. d'Ors created a symbol he needed to protect him in his life. But it is not the Lidia of flesh and blood...it is d'Ors' native land of Catalunya, where he was born and where he came back to die."

7

The Badness of Cats

THE LATE AFTERNOON SUN IS SHINING ON THE WALL OF LA TINA'S dilapidated cottage. Her house looks on to the wall of the parking lot where you can park for free. The terrain to the left was a vineyard once; forty years ago, maybe, running up the side of a hill. La Tina's cottage belongs to the age of the vineyard. It will be bulldozed out of sight by developers and vanish eventually, like Tina, to make way for the white walls of more modern apartment buildings that few will call their home, and that will be even whiter, when the sun comes out. But today, after the rain, Tina's cottage is grey, dark stained by the downpour and as dismal and defeated as the wet rags hanging limply on the line of the neighbor's house. A few meters up ahead, a big fat, grey-striped cat jumps up on the sidewall next to the gate. Like the house, Tina's gate is falling apart. Its four of five slats are askew, held together by a twisted, rusty hinge that has not seen paint since before the Civil War. When I look over the high gate, La Tina is standing on the garden path with a big walking stick in her hands. She looks like she's been frozen there since last I saw her. That was about a week ago when she told me her cats had been mysteriously snatched by the Tramuntana and had disappeared. Cats and the wind? Had she been implying some sort of witchcraft?

"Hola Tina, how is it with the cats?"

"All gone. Poisoned."

Poisoned? Mmm. Poisoning is it now? "How many did you have?"

"Twenty-two."

"Twenty-two?" Mmm. Why not twenty-three? Or fifteen for that matter? But no human being can answer that except Tina who is old, bent, and leaning on a stick and must be ninety if she's a day. But she's got a great smile and a twinkle in her eye and it's good just seeing her.

"Twenty-two. I have four big bowls round there," she says nodding with her head, meaning at the back of the house. At her feet, a fat grey cat is scratching at a strip of earth where flowers bloomed in bygone days. She is about to do her business, and she throws me that embarrassed looks that cats reserve for such occasions. Needs must.

"Twenty-two?"

"I used to get food for them every day. Not just any old thing. Good meat that people brought up from the vila for me. And they'd all eat from the bowls."

"Poisoned? Who'd do a thing like that?"

"Gente malo," she says, bad people.

"The town hall?"

"They said it was the Guardia Civil."

"The Guardia Civil doesn't go around killing cats. They've got more to do than that," I say.

"There were two of them came. I said if I find out you've been killing my cats, I'll kill you." She laughs and waves her walking stick.

The fat cat waddles down the path having done its business. It's even fatter than I thought, so fat its sides are practically touching the ground. It's pregnant.

The Badness of Cats

"You'll be having more cats soon for company?"

"Three maybe."

Looks more like six at least, I'm thinking, but she's the expert.

"By the way, part of your roof has fallen in. The heavy rains a few weeks ago. On that side. I live up there. Saw it from the patio," I say, pointing to the two-story block of flats looking onto the side of Tina's cottage. The block where Pili lives is fairly new, built in the eighties and contrasts with Tina's cottage which must got back to the time there was nothing in this dead-end part of the port but a couple of fishermen's' houses down by the beach and vineyards running up the rocky slopes.

"It's not my roof. It's the neighbor's but they live in Barcelona. Strange types."

Absent minded too by the look of it. They must be the ones who left those rags hanging on the line. Since last summer, I reckon. A week later, the mystery is solved. The town hall has been wiping the cats out secretly. Or so says Marjorie, a retired English lady who lives at the top of the hill in a tiny flat and has about eleven cats herself. The bodies of about a dozen cats were found in the bushes and the cactus at the bottom of El Castellar, the big rock that rises above the port and looks on to the sea.

It was a strange cat colony. The cats were either white or black. Either pure black, sleek-coated beasts or fluffy white beasts. It was as if the black cats were breeding with the black cats and the white cats were breeding with the white cats. Then they disappeared. All of them. Just like that: Snap! And they were gone! All that was left was a clan of grey-striped cats. And where did they come from?

"They're using nets," Marjorie says. They come in a van. From outside. They're hired to catch the cats and dispose of them. And they think it's great fun. Chasing cats. I've seen them. They come in a van from Figueres."

"There was a big scandal last year," I say. "I read it in the paper. Some place inland. A dog disposal unit was putting dogs into the gas ovens without sedating them properly. If at all. Somebody went in with a hidden camera and filmed them at work."

Marjorie winces.

"Oh, don't tell me that," she says, throwing her hands up to her face.

Oh, God, I've gone and done it again. I help her occasionally. I park the car in front of her apartment and get the trays of cat food out of the back and bring them up the stairs. She takes her cats regularly to the vet, and they have a band round their neck to show they have been inoculated. Cats get terrible diseases.

"Cats are *malo*," Marjorie says. "Bad. That's what the neighbor's boy says. There's no *malo*, I said. There are only cats. I said, look at that cat. It's not malo. How can it be malo? How can a cat be malo? How can a cat be bad?"

What do you say? If the badness of cats is a widely held belief in these parts, there's not much hope. For the cats. Or for anyone for that matter. Once these beings they call humans get ideas in their heads, there's no way an appeal to decency or good common sense will dislodge them. You'd be better off sticking an arm down a mule's throat and trying to pull out its back teeth.

But the cats weren't bothered one way or another, far as I could see. Maybe they knew something we didn't. Maybe they knew nature was intervening, had been intervening for some time in the form of the Swiss lady who regularly brings a truck load of after-sell-by-date cat food down from Switzerland. Maybe they got a whiff of cans being opened on the other side of the bay. Apart from having nine lives, cats also have a sixth sense. It's just as well.

8

Crazy Little Thing Called Love

IT IS 1929. SALVADOR DALÍ HAS RETURNED TO CADAQUÉS FROM Paris. He went there on several occasions after his student days with his bag of tricks to impress the art world and to make contacts. The elegant women he was looking for to indulge his erotic fantasies were not looking for him. Speaking partly in the third person he says "In the heart of Paris, where I sensed about me the gleaming foam of the thighs of feminine beds…Salvador Dalí lay down alone on his bed on the Rue Vivienne without the foam of thighs and without even the courage to think of women again. He would meditate a little on Catholicism before going to sleep."

Lonesome as a lonesome pine he drags himself off like an old hound dog to the Luxembourg Gardens, flops down on a bench and weeps his heart out, the poor sod. He is twenty-five and has never been laid.

Back in the whitewashed Cadaqués of his childhood he is going insane. He laughs so much it hurts. What is he laughing at? Anything he can imagine. Three little priestly curates running in single file across a little gangplank. He kicks the last one up the backside. On the heads of his friends around him he sees excrement and on top of the excrement on their heads he sees a little owl with excrement on its head. His friends are concerned. They have come down from Paris. First René Magritte, the Belgian surrealist and his wife, then

his associate, film-maker Luis Buñuel. Later the French poet Paul Eluard arrives with his wife Gala and they book into the Hotel Miramar. Salvador agrees to meet them in front of his father's house and go swimming. To make an impression he considers going naked with his hair tousled rather than plastered down on his skull, wearing his pearl necklace and carrying a palette with his artist's brushes. He cuts up his finest silk shirt, leaves one shoulder exposed and a nipple that is nearly black from the sun. He concocts a perfume from goat's dung and aspic (jelly) and smears it on his body. He cuts the bottoms off his trouser legs, scratches his shaved armpits with a razor until they bleed, pauses to admire his work in the mirror, thinks he looks more like a savage than a dandy all done up like that, reckons it might give the wrong impression to the woman of his dreams, has a quick wash, keeps the pearl necklace on round his neck, trims down the big red geranium to half size and sticks it behind his ear. He rushes out to meet her. He bursts into hysterical laughter. His painting of The Lugubrious Game has his friends concerned. The boy's drawers are splattered with excrement. Gala takes him aside. She says she wants to talk to him without having to put up with his fits of laughter. At the door of the hotel Miramar he runs into Camille Goemans and his wife. Goemens tells him to be careful, says he is working too hard. Next day he picks up Gala at the Miramar. They go for a walk. It's about your pictures, she says. If "those things" he refers to are part of his life, she can have nothing to do with him. If it's only because he's trying to make an impression, he runs the risk of weakening his work to a psychopathological document. If he admits to being what they think he is, it could make him more interesting, that is what he thinks. Her tone and expression induce him to confess that it is not true. She takes his hand. He laughs nervously. She recognizes the terror behind the laughter. He throws himself at her feet.

"My little boy, we shall never leave each other," she says.

It is the beginning of his cure. She has come to destroy his solitude, he thinks. He starts to reproach her. He is concerned that she is out to do him harm. He has lived all his life as a king, disguised in a king's costume. Each time he leaves her at the door of the Miramar he thinks how awful it is. How awful it is that what he has longed for all this life is now here. But he is terrified. His laughter becomes hysterical again.

"Something has to happen," she says.

They walk among the olive trees and the vines. They say nothing. They are in a state of painful, mutual restraint. Their tightly knotted feelings are subdued by the physical violence of their long walks. Sometimes he throws himself at her feet, kisses them passionately. She vomits twice. She has painful convulsions. She says they are symptoms of a long psychic illness. All during her adolescence. "Soon you will know what I want," she says.

Never in his life has he made love. They promise again never to hurt each other. It is September. The others have all gone back to Paris, the poet included. They are alone. "You need to get it over and done with," each encounter with her seems to say to him. She is dressed in white on the agreed day. Her light dress flutters in the breeze as they climb the heights. The wind picks up, gusts violently. He uses it as an excuse to descend to lower ground. They sit on a slate bench between the rocks. An incipient crescent moon is rising in the sky of the late afternoon.

"What do you want me to do?" he says. He puts his arm round her. She is speechless. She tries to speak but tears flow down her cheeks. In the plaintive voice of a child she says, "If you won't do it, you promise not to tell anyone?" He kisses her on the mouth, inside the mouth. He is aroused. He wants to eat her. He grabs her hair and pulls her head back. He is trembling with hysteria. "Tell me what do you want me to do to you! But tell me slowly, look me in the eye. But

tell me what in the crudest most obscene words that make us both feel the greatest shame," he says. Breathless, ready to drink in the details of the revelation, he opens his eyes wide to hear better. Then with the most beautiful expression that a human being is capable of, Gala prepares to tell him, giving him to understand that nothing will be spared. His erotic passion is now at the limits of dementia. Then he repeats to her in a more tyrannical, deliberate way: "What do you want me to do?"

And she says, "I want you to do me in. Croak me! Are you going to do it?" she repeats. Put me down?

He says nothing. He is so astonished and disappointed at having his "own secret" offered to him as a present. And not the ardent erotic proposal he expects. He is perplexed.

"Are you going to do it?" he hears her say again.

From the tone of her voice he senses disdain, doubt. Goaded by pride, afraid of destroying the faith she has put in him, he seizes her in his arms. Yes! he cries. He kisses her again hard on the mouth while deep inside he repeats "No! I shall not kill her." And with that second Judas kiss he consummates the act of saving her life and resuscitating his own soul. In minute detail, she explains her reasons. The hour of her death fills her with insurmountable horror. It has tortured her since childhood. She wants it to happen without her knowing. Without the fear of the last moment. He thinks of throwing her from the bell tower of Toledo Cathedral. But how will he explain being there? Poison does not appeal to him. She has just dissected her life for him. But he is not over it yet. He still might do it. That is what he thinks. But she can teach him to love. His hysterical symptoms disappear one by one as if by enchantment. Fresh as a rose a new health blossoms in his spirit. He takes her to the railway station in Figueres, puts her on the train to Paris. He is alone. At last, the murderous impulses of his childhood have disappeared. Finally. His

desire and need for solitude will be much more difficult to overcome, he reflects. He shuts himself up in the studio for a month, finishes the portrait of Paul Eluard and starts on The Great Masturbator. He sends the paintings to the Goemens Gallery in Paris for the November opening of his first exhibition.

But what kind of love is this? Is it the real-love kind of love? Is it the true-love kind of love? Is it your old happy-ever-after kind of love? Is it the lasting kind of love? Or the love that hurts instead? Is it your flickering candle, the glass of wine and the log fire in the hearth kind of love? Is it your old in-and-out kind of love? Your little peck-on-the-cheek kind of love? Or the tuck-under-the-chin kind of love? Or is it pure and simple that crazy-little-thing-called-love, kind of love?

9

More Nipper than Ripper

IT'S ABOUT EIGHT IN THE EVENING WHEN I COME UP THE HILL to the flat. There's blood on the low wall at the entrance to the flat and another blob in front of the door. I open the door but there's no one at home. The lights are on. Something is wrong. It's unusual for Pili not to leave a message. Then I hear a car come up the hill and Pili comes in and asks me to come with her to the vet. Tuca, her cocker spaniel, is lying on the vet's operating table. Its guts are hanging out in a greyish-blue ball. Its eyes are closed and it is breathing laboriously. Someone has given it a beating. I started to think of that morose East German, Wilhelm who works as a cook in Els Pescadors, on the main street. I'd heard stories about him. Six months or so ago, someone gave Tuca a beating. With a stick or a heavy blunt instrument, by the look of it. Later I saw Wilhelm pass in a car going downhill. He was glowering, staring straight in front of him, his knuckles white on the steering wheel. Inside the car in the instant he passed, the wife and kids were giving him hell, shouting and waving their hands, their mouths open, screaming behind the glass.

 The vet is not sure he should operate. He is nervous. It looks pretty hopeless, he says. He's pushed the intestines back inside. The next day when we go back, he has sewn the belly together, leaving a slash of about twenty-five centimeters. He can't quite believe the injuries the dog has sustained and thinks it might have been several dogs. At the top of the hill, there's an estate agent with two big

Alsatians. Years back, sometime in the Fifties, he opened a petrol pump on the road into the village and now he owns half the properties. He is not a man to mess with. Each time I pass the gates of his big house at the top of the hill; two vicious Alsatians throw themselves at the high iron gates. A couple of balls of cyanide rolled up in hamburger meat might be just the job, I reflect. Maybe even one for the owner. I met him once when I had to call in to his office: a thug.

"The cuts in the dog's side were that deep," the vet says, creating a space of about five centimeters between his thumb and forefinger. "Jabalí," he says. Boar. Wild pig. And with that in mind, I go check out the wild boar theory around town.

"They come down to feed from the containers where they dump the house garbage," a woman in the village says. She never goes out at night with the dogs. Then, when I am passing the tobacconist on the way home, I check the wild boar story with Jordi. Jordi is a sensible young man, married with a little daughter of about five who also runs a gym further along the road which is usually open in the mornings. He is to be found either in the gym or in the tobacco shop. The gym never has more than three or four people at the morning training sessions. That is no reflection on Jordi, because he is a pleasant enough lad and a keen enough trainer. It is simply a reflection of the fact that in the off-season the population drops to its natural level of under four thousand people, give or take the odd birth and the odd death, split between the *vila* and the port, about two thirds in the *vila* and a third in the port area, at a guess. People are thinly spread. Space is plentiful but people are few.

Renata is Jordi's wife. She is a nervous woman. Attractive but nervous. She jumps about like a bird behind the counter if you ask her for cigarettes or a stamp, because they sell stamps too. They also have a bookrack by the door with paperback titles. If you are desperate for something to read to pass the time with your feet on the couch in the afternoon, you might be tempted to consult some of the titles.

You are not likely to have much luck. They are a mixture of romances and detective stores and have lurid titles designed to appeal to what is called 'popular taste.' The sort of things the distributor in Barcelona is moved to select at the beginning of the season on the basis of no known literary criteria, and send up to Jordi in the hope that he can catch the odd tourist suffering from compulsive purchase syndrome and offload one or two when their guard is down whether he be a Dane, an Englishman or a German. Because the titles are in all of these languages which seriously limits your choice if you are not a polyglot. One or two will disappear from the rack between May and September but in the main when the season is over and Jordi is wrapping up for the winter; the distributor will get a small cheque for books sold and a wish-you-well until next year.

Standing outside the shop is another rack. Of postcards. Hence the sale of stamps inside. But all of this is irrelevant to the question of boars. I simply set the scene when I step inside, encounter Jordi behind the counter like a cigar store Indian, with the customary welcoming smile of the born salesman, explain about the dog and raise the question of boars.

"Boars? Sí senor, it certainly looks like boars. If they want, they'll tear a dog apart. Don't always kill it though, for some reason. But if they go for you, they go for you real good. And they twist their tusks round and round once they've gored you. Mash up your insides like a bullet from a Kalashnikov," he enthuses before he is cut brutally short when the bell tinkles and a man comes in for a lottery ticket.

A Kalashnikov! Nothing short of a miracle! Tuca has recovered from her ordeal. She's right as rain now. Has a great big scar down her pelt like a sewn- up haggis now the stitches have been removed. Long and thin and pink. The vet's as pleased as punch. He's a young guy, new in the port, just opened up for business. Runs the place with his wife. She loves the animals and he loves the money. They've got all the latest equipment; sell everything a cat or dog needs to lead a life

of luxury, including shampoo and pedicure. Have their little toe nails clipped. Painted even. Everything in the surgery is sparkling and brand new: metal, plastic and glass. The builders are in putting in some final high-tech touches. There is fat money in the beast business.

Wild boars again! This time they're reported in the Midi Libre I am reading over a morning *Americano* next day in La Gola, almost diagonally opposite Jordi's shop. A Frenchman driving home in his car the night before ran into a pack of them, just across the border. In France. In the dark. Somewhere south of Perpignan. A photo shows the ugly, terrifying brutes laid out side by side on the road, long-snouted and black-coated. The photo has been taken in the dark so it is murky and the wild boars could just as easily be demons from hell.

"If I'd been driving a motorbike, I'd be dead,*"* the headline says. I try to picture the Frenchman on a motorbike as he runs into the wild pigs, and see him fly over the handlebars as his front wheel ploughs into the porker, which squeals with fright and runs off. That's about as best I can do as far as the headline is concerned. Not much damage really, but closer reading reveals the headline has nothing to do with the text. It is what the driver of the four wheel-drive said after he hit the boars, leaving four of the beasts, dead on the road, one weighing eighty kilos. And when you think of it, in that instant before the motorist mowed an entire family of dangerous beasts crossing the road in the dark, they looked up startled into the blinding yellow light of his headlights wondering why the sun was shining in the middle of the night and their eyes had turned crimson red. Motorbike? Pity he wasn't driving a fast tank. It would have made a better headline. "I splattered demons from outer space all over the road without stopping, says proud driver."

The scrape with death has done Tuca the world of good. She has become almost lovable. I wonder how long it will last. Like a man saved from a heart attack, grateful as hell the Hooded One has turned

him down, "Both front paws through the door, she was. And entering death's kingdom. Being pulled in with both hands by the devil," I explain to Alina, Pili's sister, when she comes in. Tuca, God bless her, is wagging her little stump of a tail in a pathetically appealing way and is pouring out her dear little heart like a fountain through her snout into Alina's upheld hands.

"Ay que bueno, que bueno," Alina gushes lovingly.

Alina hates Tuca. She never allows her to cross the threshold of her apartment, which is a few doors down from Pili's. Never. Without exception. Tuca has form. She has bitten many people, both small and large. Not deep bites, granted. Nipped perhaps is a better word. She is not a ripper or a tearer, more of nipper, I would say. She once nipped my finger when I held it dangling over the table in Pili's place. It was when I was involved in bad domestic emanations with Pili. Bad vibes. Dogs are sensitive to bad domestic emanations. It seems they feed on them and Tuca was one bad jealous dog that got more out of bad energy than prime red meat. Even if you know nothing about dogs, you will learn that pretty quick. Bad vibes and bad emanations and they are snarling like wolves before you even come up the path to the door if you don't own them, but whine and wag their tails if you do. They know on what side their bread is buttered.

Tuca is under the table and I am eyeball-to-eyeball with Pili about who knows what. For some reason I have my finger dangling over the edge of the table. Maybe I am wiggling my finger and maybe I'm not. Maybe I'm doing the kind of thing you do with your hand on the table when you're upset. Playing about with your fingers, tapping them on the table. And maybe, if you're a dog down there on the floor and you're looking up, attracted by the noise, you see what looks like one of those white, uncooked, pork sausages you love, being waved about under your nose. And you get upset too and start growling, because the air is hissing and crackling from the dirty

electricity and the black energy that is shooting out of your mistress Pili's head and her usual demons are swirling in an evil cloud round the room, and all you can think of is that juicy pork sausage. It stands to reason. Tjak! "Ah, ma finger!" I don´t know how many people I've told that story to.

Tuca's relaxed now. After being mounted yesterday, Pili says. I say nothing, not even a nod. It sounds like one of those dark, dangerous alleys you'd be foolish to enter or ask directions on. She needs another pack of Marlboro so I go down the hill to Jordi's before he closes, with the dog on the leash. Take the quick way, down the stairs.

"Increible, no?" I say to Jordi looking at the dog. She's panting happily beside me, her sides going in and out like a soft bellows. The bell on the door rings behind us. I take her off the leash at the bottom of the street. She scurries off home up the hill, her ears flapping, the hair on her shaggy coat fluttering as she races on her stubby little legs. Her little claws are covered with long strands of orange and white hair that you only get to see if you have to examine her paws for a burr stuck between her toes that she caught from walking through the long dry grass coming back from the beach. Watching her ears flap up down as she runs, makes me think of Pipi Langkous (long stockings) who had freckles, long pigtails that stuck straight out of the side of her head with little ribbons attached, and wore long striped stockings. She was a Swedish invention. She was a kind of tom-boy, I suppose. I used to watch her with my daughter when she was young. On TV in Amsterdam.

When I get home Pipi Langkous has collapsed, stretched out on the carpet. She gets up and starts wandering about the room, shambling over to the gas heater, cutting in between the pouf and the armchair to end up back at the sofa, pushing her snout demandingly between both of us.

The canons have stopped roaring, the rifles have fallen silent. A truce has been announced. But it won't last. Pili is sweet as apple pie. Twenty per cent of the time. The rest of the time she is possessed by demons. I don't believe in those psychological explanations. As far as I'm concerned, demons live outside the body. I take the medieval view. They're not inside you but outside you. But you've got a host inside that lets them in. Don't talk to me about hormones. It's quite clear to me. I've heard myself say this so often I must believe it. It must be true. For me in any case.

Up over the top of the hill there's a telephone cell. It stands outside a block of flats that are empty just about all year. Nobody walks there unless they're going or coming back from the beach. I saw *Carans* make a call several times from that telephone cell which was about a hundred meters from the big iron grilled gates of his two-story villa that stood on the highest point of the hill like a fortress, surrounded by high walls. I told Pili. She said he'd be calling his girlfriend. He's probably dead by now. He was a bad bastard. I looked him straight in the eye a couple of times. Caught him once on the sharp corner of the road outside the flat where he had to slow to a crawl in his big, black, heavy car, to heave it round. Held his eye until he turned the wheel and slowly headed downhill. He knew. I read once in *La Vanguardia* that thirty per cent of Spanish men were psychopaths.

We are agreed on one thing though, Pili and I. On one thing, the verdict is unanimous. Say what you like about wild boar, it was the two big Alsatians of the estate agent "*wot did it*." That somehow got out. Those dogs were as ravenous for the flesh and blood of other humans as their owner was for the possession of their buildings and their property titles. Not for nothing are dog-owners said to resemble their dogs, not for nothing are dogs said to possess the character of their masters.

A year or so after that, Pili went down with the dog in her Mercedes to visit her mother in Barcelona and it got killed. Crossing the Diagonal, as far as I understand. She wouldn't talk about it. And I didn't ask. A few days later a little bird came and sat on one of the bars of the kitchen window. It was a beautiful little bird. Blue and yellow. I'd never seen its like before. It sent a shiver down my spine. It was a sign. It had been sent to tell us something. Either that or it was Tuca who'd come back as a bird. That's what I told her. I hope it helped.

10

Epic of the Great Masturbator

OVERALL, THE YEAR 1929 WAS AN ANNUS HORRIBILIS FOR Salvador Dalí, one he would never forget. In the summer he met Gala when she came down with her Surrealist friends to Cadaqués. The New York stock market crashed on Black Tuesday 24 October, heralding the Great Depression. That event probably went unnoticed by Dalí but it likely affected him indirectly later. His first show opened at the Goemans Gallery in Paris on 20 November and ran to 15 December. December started as a good month for him that turned into a very bad month. He sold most of his paintings for good prices at the Paris show but just over a week later, as he was celebrating his good luck, he had serious problems with his father. Fortunately, he had the Vicomte (viscount) de Noailles and his wife to fall back on. The Noailles were a fabulously rich couple of Maecenas who invested in the arts. They sprung from the marriage in France of Marie Laure Bischoffsheim (1907-1970), the richest heiress in France, descendant of a very rich family of German-Jewish bankers, collectors of Rembrandt and Goya, who could trace her ancestry on her mother's side back to the Marquis de Sade. Her husband Charles, who lived to be a hundred, came from a long line of aristocrats.

Two days before the Paris opening, he decided to leave with Gala on a "voyage of love" which took him to Barcelona and then to Sitges. But they soon returned to Figueres where Gala took the train from there to Paris. He had family matters to discuss with his father,

particularly about the "inconsiderate way I had of treating my family," and the question of how he was going to earn a living in future. The meeting went badly. Next day Luis Buñuel arrived with the news that the Vicomte had commissioned them to make a film and had bought *The Lugubrious Game.* He also learned that most of his paintings had been sold at the Paris show for good prices. He went to Cadaqués where he remained all alone in the house, eating "three dozen sea urchins with wine at a sitting or five or six chops fried on a fire of vine stalks in the winter sun." One afternoon, while he was opening a sea urchin, he saw a white cat. It had something sticking out of its eye that flashed in the sun. It was a large fishhook the point of which emerged from one side of its dilated and bloodshot pupil. He threw rocks at it but the sight of the cat filled him with unspeakable horror. A few days later, he understood why the cat had spooked him. He received a letter from his father saying that he was banished from the Cadaqués home. He returned to Paris, made contact with the Surrealists, dined with the *Vicomte,* and while waiting for a response from his contacts, went to the Cote d'Azur where he stayed two months with Gala at a solitary hotel, she knew called The Hotel du Chateau at Carry-Le-Rouet. He booked a large room and set up a studio. While there, he got a letter from the Vicomte saying that the *Goemens* gallery had gone bankrupt. Gala went back to Paris to see if she could retrieve some of the money the gallery owed them. The Vicomte sent a car to pick up Dalí and bring him to his Chateau de Saint Bernard at Hyères, where Dalí undertook to do a big painting for which Noailles agreed to pay him 29,000 francs. During the two months he spent at Carry-le-Rouet, Lidia was among the few people to correspond with him. When he received the cheque from the Vicomte, he thought of buying the miserable shack with a caved-in roof which they (Lidia's two sons) used to store their fishing gear, and fixing it up to make it habitable. 'This shack happened to be set exactly in the spot I liked best in all the world," he said. He wrote to Lidia saying he would buy it. When Gala came back from Paris, she

brought some money with her. The Vicomte's cheque also arrived. He spent the whole afternoon looking at the cheque, he says. "I had the suspicion that money was an important thing." The pair then left for Spain arriving in Cadaqués in the dead of winter. They tried to book into the Miramar but the hotel made an excuse that the place was being renovated. The word was out. They were obliged to stay in a small boarding house. From there they went to Barcelona cashed the cheque, had a sumptuous meal of two dozen *torts* with champagne. Next day a friend from Dalí's Madrid days invited them to Malaga, saying he was interested in buying a painting. It took them three days to get down by train.

Having been molly-coddled by the family all his life, Dalí had a rude awakening coming. At the age of twenty-five he was faced with the unpleasant prospect of having to earn a living. The prospect of poverty terrified him. Dealing with the realities of everyday life terrified him even more. When he was at art school one of his favorite games "was to dip bank notes into whisky until they began to disintegrate." Never having dealt with a cheque before, he was seriously tempted to eat it. It did not auger well for his future, financial or otherwise. The epic tale continues.

> We went to the bank to cash the Vicomte de Noailles' cheque for twenty-nine thousand francs. At the bank, I was surprised that the gentleman at the cashier's window deferentially called me by my name. I was not aware of my great popularity in Barcelona and this familiarity of the bank clerk, instead of flattering me, filled me with suspicion. I said to Gala, He knows me but I don't know him.
>
> Gala was furious at the survival of such childishness and told me I would always remain a Catalan peasant. I signed my name on the back of the cheque but when the clerk was about to take it, I refused to give it to him.

I should say not! I said to Gala. I'll let him have the cheque when he brings me the money.

But what do you expect him to do with your cheque, said Gala, trying to convince me.

He might eat it, I answered.

But why would he eat it?

If I were in his place, I would certainly eat it.

But even if he ate it, you would not lose your money.

I know, but then he would not be able to go and eat torts and rubellons a la llauna (little snacks and grilled mushrooms) this evening.

The bank clerk looked at us blankly, unable to follow our conversation, for I had finally dragged Gala out of earshot. She finally convinced me and I went back to the cashier's window full of resolution. I said to the clerk, disdainfully throwing down my cheque: All right, go ahead.

The cheque of the Vicomte de Noailles cashed, they went off for a few days to Barcelona where they deposited the 29,000 francs in the safe of the Hotel de Barcelona. Next, he got an invitation from a friend from his student days in Madrid who said he wanted to buy a painting and would put them up in Malaga. So, they hightailed it down to Malaga, couldn't find him, ended up in Torremolinos where they rented a cheap cottage by the sea and toasted themselves brown as two "Arabs", burning out the last traces of the pleurisy that had assailed Gala since they left Cadaqués.

From then on, the adventure takes on Homeric tones as Ulysses, aka Salvador, checks out the local scene and the highlights: the local fishermen dropping their pants on the beach to do a crap — not just one or two but a whole line of them, crapping happily away in some kind of communal ritual for the benefit of the visitors. Or so we are forced to conclude from his account.

Gala, with a build like a boy's, burned by the sun, would walk about the village with her breasts bare, and I had taken to wearing my necklace again. The fishermen of this region had no modesty of any kind and would drop their pants a few meters from us to perform their physical functions. One could see that it was one of the most pleasurably anticipated moments of the day, and sometimes there was a whole string of them doing it together along the beach beneath a relentless sun. They would take their time about it, all the while tossing epic obscenities back and forth. At other times, they would egg their children on with guttural cries as they fought with slingshots in pitched battles. These stone fights often ended with a few cracked skulls. The sight of their children's plight would awaken personal hostilities among the defecators, and quickly pulling up their trousers and carefully readjusting their genital parts, which were always of handsome and well-developed proportions, they would start arguing among themselves about their children's battles and would in turn end the polemic with one or two knife jabs, accompanied and embellished by the unimportant tears which their wives, in perpetual mourning, would shed as they came running with hair disheveled and arms raised to heaven, imploring Jesus and the Immaculate Virgin Mary. There was not a shadow of sadness or of sordidness about all this. Their outbursts of anger were gay, biological, like a fish-bone drying in the sun. And their excrements were extremely clean, inlaid with a few undigested Muscat grapes, as fresh as before they were swallowed.

So, there we have them, the two of them, Gala, naked to the waist, giving the tasty fisher lads the glad eye with Salvador, that old coprophagist, appraising their rumps as they strain and pant. And once the hullabaloo has died down, he sneaks back to the beach to check out the quality of the turds — it must have been tempting. Late afternoon sees the pair in their rented cottage, wringing their hands and pulling their hair out. Salvador especially, Gala is more

sanguine. The fates have struck with a vengeance. The buyer from Malaga has evaporated into thin air and the builder in Port Lligat wants his money *pronto*. They only have a miserable two pesetas, enough for four days and are at each other's throats on how best to get the money sent down from the Hotel de Barcelona.

Leaving the cottage in a rage, Salvador slams the door, picks up a stick and as he is walking through the fields towards the sea, furiously mows the heads off the carnations which shoot into the air "like the spurting blood of the decapitations so savagely painted by Carpaccio," as he heads for the sea.

> The seashore was hollowed out by grottos in which lived olive-complexioned gypsies who were cooking fish in boiling oil that hissed in the frying pans like the very vipers of my own anger. For a second, I thought of the absurd possibility of bringing down Gala's trunk and coming to live among them; the thought of this promiscuous contact with very beautiful gypsy women there half-naked, suckling babies, was a powerful aphrodisiac to which the tenacious dirtiness of these women contributed. I fled to a solitary cove, my imagination whirling with the memory of those nursing breasts mingled with the vision of the glistening rump — like a black horse's — of one of the women puttering over the fire. My legs gave way, and falling to my knees on the jagged rocks, I felt like one of those anchorites in the throes of ecstasy painted by Rivera. With my free hand I caressed and scratched the calcinated skin of my body. I wanted to touch it everywhere at the same time. And I riveted my half-shut eyes upon a shred of cloud from which the scatological golden rain of Danaë fell in oblique rays. My whole fury had now taken hold of the jerks and trembling of my flesh. All my pockets were empty. No more gold, eh? But I could still spend this! And I spilled upon the ground the large and the small coin of my precious life, which seemed to me this time to be extracted from the deepest and darkest recesses of my bones.

God, love a duck! Since the *Epic of Gilgamesh* or Homer's *Iliad* no writer had dared the challenge of creating an epic work equal in stature to that of these great masters. For Salvador it was like shelling peas (or urchins). And he has only just started. Leaving aside the (more likely) possibility of Salvador's rump being roasted over the fire and his eyeballs stewed in boiling oil by the gypsy women, he plunges on regardless with his epic tale.

> This new and unnecessary expense, the moment of pleasure is afforded me was over, only accented for me with an intensified feeling of discouragement about the intolerant reality of my financial situation. Then all my impulsive anger turned towards myself. To punish myself for having done "that" I looked at my closed fist, the recent instrument of my enjoyment, and with it, I pitilessly struck my face. I hit it several times in succession harder and harder, and suddenly I felt that I had broken a tooth. I spat blood on the ground on the very spot where a moment before I had squandered my treasure of pleasure. It was written a tooth for a tooth.
>
> "I returned to our cottage, in a fever of excitement but radiant.
>
> Victoriously I showed Gala my fist: Guess!"
>
> "A glow-worm? she said, knowing that I was fond of gathering them.
>
> "No! My tooth — I broke my little tooth; we must by all means go and put it in Cadaqués, hang it by a thread in the center of our house in Port Lligat.

In the name ae the wee man, what does one say? It sounds almost noble, a performance. Which it is. And that bit about punching himself in the face by way of retribution? No half measures for Salvador. None of your: "Now as penance, my son, say an Act of Contrition, one Our Father and two Hail Mary's, and don't do it again or you will go blind."

But he was at his purest then, God bless him. A few years further down the line, he's jerking off under a glass plate in a New York hotel, looking up Amanda Lear's skirts, his *limousine* in one hand and a camera in the other. Trying to find out what sex she was.

But fair's fair, Salvador had his moments. He helped raise jerking-off to new heights, gave countless misinformed youths the real gen, put them on the right track early in life. The imagery of *El Gran Masturbador* is so obtuse, so recondite that even with a product manual, no young man can be expected to understand the references and the allusions. Even then. Why has *The Great Masturbator* stuck his nose in the sand? Will he ever raise his head again? Why does he have no mouth? And why is that woman's face coming out of his ear? And what is it doing sniffing at those bulging underpants? And look, those grasshoppers, where are they headed? Maybe he was at it again, the old fart, taking the piss. Still, *The Great Masturbator* had its benefits as a painting. When the word got out and folks got to know and love the real Salvador better, got better tuned to his rhythms, aspiring perverts had a lot to thank him for. He helped upgrade their vision by demonstrating that jerking-off could be a useful tool when used in combination with other perversions. He also demonstrated that there was a whole world of opportunity out there for the ambitious young man. That you could graduate to in easy stages. From sniffing your sister's knickers or looking up girls' skirts in the gym to more serious, real he-man stuff, like voyeurism, domination and bondage. Without losing sight of the fact that all these pastimes were a lot cheaper than dope.

11

Shooting the Breeze with Milco Meppel

MILCO MEPPEL PREFERS TO SIT AND ROLL A JOINT AND SHOOT the breeze from one of the two wicker chairs leaning against the side of his caravan. Or what was once a caravan. So many bits and pieces have been added, it looks more like a beachcomber's hut on top of a mountain. In the morning sun, not yet warm, the grass dank with dew, I'm sitting at the table in front of his caravan-hut (nobody is up yet) and have written down the following description:

> Overhead there's a tarpaulin shading my back from the sun. To my left elbow is a copy of Catastronfonia in Dutch and the Mayan Code in English by Barbara Hand Cloud. To my left shoulder is a kitchen knife about eight inches long and a slightly smaller teaspoon; a yellow ceramic mortar with a pestle for crushing garlic with a price tag of 3.50 euros on it; an aubergine the size of a small rugby ball; two bananas; a copy (mine) of Irvine Welsh's If You Liked School You'll Love Work; next to that is a bowl filled with recently gathered almonds; a red Samsung mobile; a cup without a handle in a black and white flower pattern; a half-drunk bottle of Estrella beer from last night; a big aluminum kettle with a red wooden handle, bought in the Chinese shop in Camprodon, a metallic Thermos flask, a grungy saucepan with the remains of last night's potatoes; an ashtray bought by Milco's brother Mossie yesterday at the Chinese in Camprodon, containing the stubs of three hand-rolled fags; a big plastic bowl with a plate containing tomato puree or some such

hand-made concoction; an unopened can of Freeway Orange from Lidl supermarket and a circular wire brush for an electric drill.

It was cold last night in the teepee when I woke up under a thick heap of blankets needing to go to the toilet. I lit another candle and staggered out into the night. The grass was wet with dew. The stars were out, twinkling like little diamonds in the pure mountain air. To get to the toilet you need to duck under the beam put there to prevent the horses coming onto the field. Then it's up to the cubicle with your roll of paper in your hand to sit on the seat and look onto the trees. You're in deep dooly if you have to go there in the middle of the night. Fortunately, I only needed a pee. So, I did it against the fence of Milco's vegetable plot.

Milco Meppel's caravan-hut is about fifty meters further along the terrace from the tepee. It has small two-pit gas plate to cook on and in the back, Milco has his bed where he sleeps with his two big dogs. Next to the bed there's a circular hoop-net hanging from the ceiling where he dries his mountain weed. We spent a few days last week sitting outside the caravan clipping the leaves from his harvest. Just below the tent is a terraced piece of land on which he has a vegetable garden where he grows, in addition to his two-or-three meters high dope plants, beetroot, tomatoes, lettuce, onions, carrots and cabbage. This is also where the shower is.

Let me explain. If you want to take a shower you first have to find the showerhead. It's at the end of the green garden hose. The green garden hose is about fifty meters long. It runs all the way on the ground between the plants. If you want to take a shower, you have to walk all the way down the garden between the plants following the twisting line of the hose until you get to the end of it and discover the showerhead. It is not a showerhead in the normal meaning of the word. It is the end of the hose with a nozzle stuck on it. A nozzle for spraying plants with water. To turn on the shower you flip the nozzle.

Doing that naturally sends a rocket of water shooting high into the air above the plants. You then have to adjust the nozzle lower to get the water pressure under control and, when the flow is manageable, hold it above your head with one hand. Another point worthy of mention is that early morning showers are out. It is vital to remember that, because if you are standing bollock naked between the plants getting a kick out of the sun blessing your nakedness, and turn on the water, you are in for a rude awakening. The garden hose has been lying all night long on the earth and the water inside is freezing cold.

Cooking too is a bit haphazard since there is no system of who does what. Milco feeds himself as need be, that is he makes himself a coffee with the percolator in the morning and gobbles a bit of bread and sausage if some such comes to hand. There's a sink outside, next to the caravan door which has a tap which is supposed to supply cold water but you have to keep an eye on it as the supply is a bit iffy. Needless to say, the sink is usually choc-a-bloc with a colorful variety of greasy dishes. The caravan, or hut or caravan-hut, is now unrecognizable as the small double bed caravan on two wheels that it once was. Over the years stray bits and pieces of timber and tarpaulin have been added, transforming it. A canvas awning now hangs over the entrance to the caravan obscuring the doorway. A makeshift bar of scrap wood, has been added as an afterthought. It's the sort of bar that's quite popular in travel ads. Where you see sun bronzed gods and goddesses, crossed-legged on high stools, shaking their *mojitos* and gazing wistfully into the infinity of the ocean and the azure blue sky above virgin sands. This delightful illusion also holds true of Milco's bar. But only until you get off your stool and stand up. When you do that and reach for a bottle or a glass, you're suddenly staring into the haphazard trash that has been piled into the sink and forgotten about: plants, plates, cups, bits of tomatoes and a hard crust of bread that no bird in its right mind would consider pecking at.

I'm back at the hut again at about six thirty. It's Mossie's birthday and they've baked cakes for him. Mossie drove down mesmerized

from Amsterdam with a spider in a cobweb clinging for dear life to the wing mirror and delivered it safely to holiday in sunny Spain. Marta, a friend of Mossie's from Barcelona, has come up with her trumpet. Milco has gone storming down the hill again in his white undershirt. A bunch of freeloaders from Belgium arrived yesterday afternoon in a van to see Rocco. The van doors opened and a bunch of old Belgian hippies fell out, one with a pigtail and a cowboy hat. First thing the dogs do, after being cooped up for twenty hours in the burning heat of the van, is jump out of the rear door soon as it opens and chase the cats up the trees. Milco sees it and warns them. Now something else has happened and he's gone storming over to the parking space again. If it happens again, he'll boot the dogs' ribs in and then come back and boot in the ribs of their owners, he told them.

Later, Milco Meppel is slumped in the chair under the awning on his front porch shooting the breeze again. He has one big scuffed boot resting on a little hand-painted stool and is rolling another joint. The hulk raises his big hairy hands, big as shovels, to his lips to lick his *Rizla* rolling paper and as he does so I reflect that 'Meppel' is a nice little town in the North of Holland near Groningen. And that 'meppen' in Dutch means to strike or hit. As in "he stuck one on him." I take a drag, blow a smoke ring, and as it dissipates into the vast distance, somewhere between the dark-green crest of Mont Mas and a few wispy clouds in the otherwise clear blue sky of the late afternoon, I see Milco Meppel's big ham fist connect with the jaw of Mr. Pigtail, his big feathered cowboy hat sail high into the air, and a big dirty scuffed leather boot give the superannuated hippy one up the backside, as his white-haired skull-cum-pigtail sinks to the deck. All in slow motion.

Milco's voice, buzzing like a fly, wakes me from my reverie. When I get focused, I realize he's talking about whistling. About how the mountain men hereabouts used to whistle to communicate in the old days. From one mountain top to another. Or down into the valley.

"Wheee... ee.... How are things?"

"Wheee... eee....ee.... Okay."

"Wheeeeeee ...eee...eee...eee... How's your old man?"

"Wheee ...eee...ee...eee...ee…ee…The usual, the old bastard."

They used to whistle the news to each other across the valley in the old days, it seems. What was going on, what they were up to. And if one of them got their hands on a newspaper, how did that work? Whistling the news? That must have been pretty complicated. So, we kick that one about for a bit; the vocabulary of the whistling men of the mountains.

"Maybe even football scores?" I suggest, but Milco reckons they didn't know about football up here in those days.

That topic exhausted we turn to the ways of the birds of the air. I knew a guy once told me he knew a guy who could talk birds out of the trees — Dennis was his name. He was brought up in the country. Doves, I think. Pretty dumb creatures in my opinion. I 've never had any reason to disbelieve him. But there's no doves up here. Too high up. Milco reckons that crows or ravens — he's not sure which — can imitate the song of little birds. Chaffinches and sparrows sometimes have an impressive vocabulary, if you care to listen.

There's a lot happens up here on the mountain. I saw ghost once in the *cabanya* when the morning light was breaking — a hunter with his dog — and Milco's dogs won't cross the little stream that trickles downhill between the bushes to the river far below. And Rocco says there's a ghost in his kitchen. He brushed past him once or twice and he felt the chink of chain mail. The farm house was a look-out post. Way back. When the Moors were here. Or so they reckon. On that note we cast an eye to the deep green lines of the valley to see if the Moors are coming through the mountain passes, their helmets gleaming in the rays of the dying sun.

12

Idyllic Days in Port Lligat

AH, HOW IDYLLIC WERE THOSE DAYS IN PORT LLIGAT IN THE summer of 1930, when Salvador and Gala moved into the tiny shack that they bought for 250 pesetas from fisherwoman Lidia Noguera y Sabà. Salvador was a young, dark and handsome twenty-six years old then and Gala thirty-six, if you could believe her age. Be that as it may, and leaving aside Salvador's pathological fear of sex and the fact that the ridiculous mustache had not yet erupted on his upper lip, Gala exercised a fatal attraction on him. As we can see from the photos taken that summer: sitting half-naked on the rocks, swimming in the bay, Salvador, dark and suntanned relaxing in the sun, his arm resting tenderly round Gala's neck, looking like the cat that swallowed the canary. If he'd had any horse sense, he'd have left the canary chirping in its cage. That piece of wisdom would be spared the great genius for half a century before the little warning bells tinkled closing time in his head. By then it would be too late. But leaving him for a moment in his glory days, moving about that tiny space (four square meters, he says, which is absurd) that served as dining-room, bedroom and studio he says that:

> Port Lligat was a life of asceticism, of isolation. It was there that I learned to impoverish myself, to limit and file down my thinking in order that it might become as effective as an axe; where blood had the taste of blood, and honey the taste of honey. A life that was hard, without metaphor or wine, a life with the light of eternity. The lucubrations of Paris, the lights of the city, and of the

jewels of the Rue de la Paix, could not resist this other light — total, centuries old, poor, serene and fearless as the concise brow of Minerva. At the end of two months at Port Lligat, I saw rising day after day before my mind the perennial solidity of the architectural constructions of Catholicism. And as we remained alone — Gala and I, the landscape and our souls — the ancient brows of the Minerva's came more and more to resemble those of the Madonna's of Raphael, bathed in a light of oval silk. Every evening we took a walk and would sit down in our favorite parts of the landscape. We shall have to have the well dug five meters deep to try to find more water. At the new moon, we will go to the encessa and fish for sardines... We will plant two orange trees beside the well. These were the kinds of things I would say to Gala to relax us from a long day of spiritual work. But my eyes remained fixed on those smooth and immaculate skies of the serene winter days. Those skies were great and rounded like the intact cupola that awaited the painting of an allegory of glory

Oh, nostalgia of the Renaissance, the sole period that had been able to meet the challenge of the cupola of the sky by raising cupolas of architecture painted with the unique splendor of the Catholic faith...What has become, in our day, of the cupolas of religion, of aesthetics, and of ethics, which for centuries sheltered the soul, the brain and the conscience of man? The soul of man, in our day, dwells out in the cold, like beggars, like dogs. Our age has invented mechanical brains, that degrading and horrible apparatus of slowness, the radio. What does it matter to us if we can hear the wretched noises that reach us from Europe or China? What is this compared to the speed of the Egyptian astrologers, of Paracelsus or of Nostradamus, who could hear the breathing of the future three thousand years ahead! What does it matter that man can hear the congas sung from one hemisphere to the other — man whose ears were made to hear the sound of the battles of archangels — and the canticles of the angels of heaven?...What is a television apparatus to man, who only has to shut his eyes to see the most inaccessible regions of the seen and the never seen...what

is the socialist ideal of a higher living standard for man who is capable of believing in the resurrection of his own flesh?. If a donkey should suddenly begin to fly or a fig sprout wings and take to the sky this might astonish us and distract us for a moment. But why be astonished at a flying machine? It is more meritorious for a laundry iron to fly than for a plane, even though if you throw an iron into the air, it will fly too, while it is up in the air, like any plane. What is it for a machine to fly? And what is it for man to fly, he who has a soul…nothing in fact is more cretinizing to man than the speed of modern means of locomotion, nothing more discouraging than those speed records that are announced with weariless periodicity.

What beautiful sentiments and what a contrast from the previous year in Paris where poor little Gala did the rounds, knocking on doors, trying to flog his abject inventions (or so he says). Artificial finger nails in which you could see your image mirrored in miniature; transparent mannequins for shop window displays that you could fill up with water and put in goldfish to imitate the circulation of the blood; masks for the cameras of news reporters; kaleidoscopic spectacles that you could put on while out driving in your automobile to transform the scenery when it got boring; distasteful objects you could throw at the wall if you got into a rage were just some of the schemes he thought up in his desperation to make a buck. Not surprisingly, there were no buyers.

Gala, who was blessed with common sense, managed to make ends meet with what little they had, while the weaker specimens around them (the other artists) took the easy way out, cocaine here, heroin there, opium galore, alcohol and pederasty everywhere in their pathetic attempts to achieve ephemeral success. "Gala and his strength," he wrote, was that "they always lived a healthy life in the midst of all this physical and moral promiscuity, taking no part in it, without smoking, without taking dope, without sleeping around."

This was the phantasmagorical account he gave of that period a few years later in his *Secret Life*. Written in retrospect at the Hampton mansion in Virginia of his good friend: heiress Caresse Crosby, it was colored — the inventions in any case – by his American experience. As for the high moral tone; he was in his Catholic period at the time. Or so he says. In this ever-changing world in which we live, it is unfair to demand consistency of anyone, let alone an artist as pure as Salvador.

A decade or two after he wrote those reflections on his golden period, high moral sentiment went belly-up and was replaced by low when he started operating after-lunch orgies at his New York hotel. And although hardly on a scale or a level of depravity with those that Roman emperor Caligula held on his pleasure barges, he made an admirable show of things on a smaller budget using dope heads, dwarfs, Bowery bums and an alcoholic horse that drank champagne. And collected a fee at the door from participating guests, at the same time. Art like money, he had learned, has infinite forms of expression. His biggest problem when he started was what to do with the money once it started coming in. Cashing cheques had been a challenge at first until he learned to remember not to eat them and stash the cash under the bed like everyone else. That too became a challenge when there was no more room left under the bed. As in every other aspect of his life, Salvador rose to the occasion when that happened and threw the money out the window as fast as it came in.

But the dear lad had many arrows to his bow, which makes him such a comic delight. He simply did not give a toss about what anyone thought, nor did he give a toss about his own deficiencies and inadequacies. Everything he ever did or said was for effect, however inane or absurd it might be. He loved to take the piss more than anything. Like a naughty child presented with a box of fireworks at Halloween by foolish parents, he could never resist the delicious temptation of lighting the bangers when least expected. And frightening the living daylights out of everyone within earshot.

13

The Disease of Being Salvador Dalí

HAD SALVADOR EVER APPEARED IN COURT FOR CRIMINAL assault for the unprovoked attacks that he perpetrated on others during his life, he would have spent many long years behind bars. All his life, from early childhood onwards, an electrical storm raced through his head. Pathologically shy, he was prone to outbursts of rage, was seized by terror, hysteria, hallucinations, disassociations of reality, sadistic impulses, compulsions and fetishes, temporal confusion and dislocation, you name it. When psychiatrists opened his can of worms, the language got so clinical that you needed to consult a medical dictionary for megalomania, compulsive maniacal psychosis, cannibalism, exhibitionism and coprophagia.

To sum up his condition graphically, he didn't know his arse from his elbow. Half the time he did not know where he was, who he was or what time of day it was. It was a pattern that worked perfectly for him most of his life and that he profitably exploited. His biggest problem, as one psychologist said on Spanish TV, was that "he was suffering from the disease of being Salvador Dalí."

Being Salvador Dalí was no bed of roses. Not for Salvador, not for anyone. The uniquely contorted impressions that his brains cells received from the outside world were flushed through his tubes and lodged somewhere in his intestines where they lay festering long enough to send their turdish fumes upstairs into his over-sensitive

nostrils to be translated into visions. The effect of dreams and imaginings on the injured psyche of the great artist was akin to administering crack to an injured animal or some lower form of organic life. The results were cruel and unpredictable but enormously interesting.

He was, in his own words: "destined to truculent eccentricity whether I like it or not." To get an idea of what that meant, we need to see him in action. Speaking of his early years when he was six or seven, in the prologue to his Secret Life. He notes that:

> Aside from being forbidden the kitchen I was allowed to do anything I pleased. I wet my bed until I was eight for the sheer fun of it. I was the absolute monarch of the house. Nothing was good enough for me. My father and mother worshiped me. On the day of the Feast of Kings, among innumerable gifts I received a dazzling king's costume — a gold crown studded with great topazes and an ermine cape; from that time on I lived almost continually disguised in this costume. When I was chased out of the kitchen by the bustling maids, how often would I stand in the dark hallway glued to one spot — dressed in my kingly robes, my scepter in my hand and in the other a leather-thronged mattress (carpet) beater, trembling with rage and possessed by an overwhelming desire to give the maids a good beating. This was during the anguishing hour before the hallucinatory summer noon. Behind the partly-open kitchen door I would hear the scurrying of those bestial women with red hands; I would catch glimpses of their heavy rumps and their hair straggling like manes; and out of the heat and confusion that rose from the conglomeration of sweaty women, scattered grapes, boiling oil, fur plucked from rabbits' armpits, scissors spattered with mayonnaise, kidneys and the warble of canaries…(the) fragrance of the forthcoming meal was wafted to me, mingled with a kind of acrid horse smell.

In the opening chapter of his *Secret Life*, he recounts how, when he was five years old, he pushed another child riding a tricycle off a bridge onto some rocks fifteen feet below and ran home to tell his parents the news and later, on a rocking chair in the parlor of the boy's home, sat eating cherries while all afternoon blood-stained basins were brought down from the room where the boy lay in bed for a week with a badly injured head. On another occasion, when he was six and the drawing room at home was full of people talking about the famous comet (Halley's Comet) that would be visible that evening, and that would wipe out all life if its tail touched the earth, everyone ran upstairs to the terrace and he was left alone, paralyzed with fear. Summoning up all his courage he dashed into the hallway where he saw his little three-year old sister Anna Maria crawling through a doorway. As though kicking a ball, he gave her a terrible kick in the head and ran off, seized by "a delirious joy." The fact of not having been "allowed" to see the comet remained seared in his memory as one of the most intolerable frustrations of his life that "I screamed with such rage I completely lost my voice. Noticing how this frightened my parents, I learned to make use of the stratagem on the slightest provocation."

Did it all happen as he said? Or was it just a load of baloney? There's no way of telling. Whatever the case, this is how he wished to be seen. And these are the sadistic things he saw himself do. Or wished he had done. Recognizing the potential brazen absurdity has in the art world, Gala bought the entire Dalí's package and became indispensable to his success. She cured Dalí of his mad hysterical fantasies. For all his sensitivity as an artist, he was anxious and inept in everyday life. Without a strong woman like Gala who brushed aside every obstacle and organized the necessities of their everyday existence, he would never have enjoyed the success he had. But even in their supposedly idyllic first years together from 1929 onwards, Port Lligat was not exactly the cozy love nest Dalí would have us

believe. The two buzzards were regularly at each other's throats. According to Ultra Violet (who lived with them), when they were having lunch and Gala got on the Divine One's nerves, he would throw his eggs against the wall. Sometimes they got stuck on the ceiling where they would hang for weeks before falling off. He ate three every day at for lunch except on Sundays. In his late seventies, entering old age, when his relationship with Gala had become even more acrimonious, she gave him a black eye in the Meurice Hotel in Paris in February 1981. Dalí retorted by whacking her in the side with his metal-headed cane, breaking one of her ribs.

This is the man who at the age of eight, painted a portrait of his father with a loaf on his head to prevent him from eating him; who said Jesus Christ had smelly feet (probably in reference to Gala's last lover who starred on Broadway in *Jesus Christ Superstar*) made a piano-like instrument for stray cats and pressed a key to drop a weight on their tails and make them screech; sent Mia Farrow and Frank Sinatra a wedding present of a painted fish bowl with a live rat in it that devoured a lizard, to send the subliminal message that Mia was a rat and Elvis Presley a lizard; who discovered Freud was a snail; who said he had invented a mechanism to photograph thought and would offer it for consideration to scientists in the U.S.; who was obsessed with eating Napoleon's soft white belly.

At home when Salvador was young, his father kept a book about sexually transmitted diseases pointedly lying about the house so that Dalí associated sexuality with fear from an early age that was reflected later in life. That's his excuse, anyhow. It would stand him in good stead. When he was staying in the U.S., he was commissioned to do a work for the U.S. army in a campaign against sexually transmitted diseases. The illustration, which is untitled, shows the face of a U.S. marine, close up from the side and glancing behind him in the direction of two whores with bags over their eyes holding up their skirts to display their suspenders with, in the background, a huge bowl with

fluttering bats that looks like a skull. Against the dark background there's a flash of light on the horizon, suggesting a bomb exploding.

There was something special about Salvador Dalí even before his talent for drawing and painting emerged. It was clear he needed to be the center of attention, says Ralf Schlieber in *Dalí: Genius, Obsession and Lust*, "In a carefully posed photograph taken when he was about seven, the child is sitting in the midst of a close-knit family…all together on the rocky beach at Cadaqués …It is perfectly obvious who has his hands on the reins here, who is king of the castle: the child, sheltered and spoilt. A piece of string trailing artfully from the boy's hand seems to be hinting at some prank or scheme he is hatching behind that smooth forehead. And the string reinforces the sense that it is natural that he in particular should be chosen, showing that he of course dominates, protected by his father's authority in the background, yet already far beyond it."

Little wonder that Andre Breton and the Surrealists were wary of him. When they saw *The Lugubrious Game*, a collage he did in oil on cardboard in 1929, they suspected he was a 'coprophagist" or someone who eats or gets excited by human shit. The same conclusion, only worse, is drawn by Schlieber. "He was probably a cannibalistic copro-necrophile…who was cured of his perversions by the clever Gala Gradivna — who was Dalí himself…"

However, this is all by the bye. These psychiatric explanations are enlightening but they are labels, none of which covers the full extent of his deviance. His life is best seen as a runaway train hurtling down a mountain side with no brakes, pulling carriages of fornicating groupies, fame addicts, thieves and freeloaders with dozens of Salvador lookalikes sitting at little tables, counterfeiting his signature on blank sheets of printing paper, the wagons loaded to the gunnels with glittering bric-a-brac — more trashy bling-bling than Ali Baba, or his modern Chinese namesake, ever managed to squirrel into forty times forty dark caves in a lifetime.

What was the point of all these flashy objects, these exuberant performances that became his hallmark later in life? He liked to say that his lineage was Arabic and that "From these origins, comes my love of everything that is gilded and excessive, my passion for luxury and my love of oriental clothes," and ascribed the vast sandy spaces he depicted in his paintings to an "atavism" inspired by his Arab blood. His skin would go almost black in the summer sun of Port Lligat, another Arab trait, he liked to say.

There was also a skeleton in the cupboard, however. It was taboo in the family to speak of it. He himself, never mentioned it. But there was another paranoiac in the family. In 1886, his grandfather *Gal* threw himself from the third-floor balcony of a flat he rented on the Rambla de Catalunya in Barcelona. A bit of a character, he gathered his family (including Salvador's father) and belongings together in Cadaqués in 1881 and set off for the railway station at Figueres to get the train to Barcelona. Swearing never to return because of the Tramuntana, he took with him a sack of gold coins and two hired guards carrying blunderbusses to protect it. When he arrived in Barcelona, the city was in the throes of gold fever and people were pouring their savings into the stock market. Within a year of his arrival sixteen new banks had opened. Gal joined the feeding frenzy and added to the bubble his hoard of gold that he had probably earned from smuggling. Inevitably, the seven-year boom fizzled out, the market collapsed and Gal lost all his money, plus that of some others. Having already been in and out of court regularly, litigating often against powerful people, he was already suffering from persecution mania. The reversal of his fortunes came as a terrible blow. In the early hours of 10 April 1886, he appeared on the balcony of his house screaming that thieves were trying to steal his money and kill him. The thieves were all in his head. That afternoon he almost succeeded in hurling himself into the street, but was prevented by the police. Six days

later, however, he did the job properly, landing on his head in an inner patio and dying instantly. According to one Barcelona newspaper, the "unhappy madman" was to have been interned that day in a lunatic asylum. He was only thirty-six years old.

As Ian Gibson says in *The Shameful Life of Salvador Dalí*, "In view of this unacknowledged family trauma, surely, we are justified in assuming a connection between Dalí's stubborn silence about Gal, his famous insistence that he himself was sane — "the only difference between a madman and me is that I am not mad" — and the elaboration in the 1950s, of his paranoiac-critical method. The concern in the Dalí family about inherited paranoia (and depression) was justified: years later when his cousin Montserrat's father, Rafael, tried to kill himself in exactly the same way as his father Gal, and was only prevented by the sudden appearance of a servant."

Spaniards like to say that when the wise man points at the moon, the fool looks at his finger. Salvador was fascinated by his own finger and incapable by nature of looking beyond it. If what Gibson says is true, the inner turmoil in his tortured, paranoiac mind gave birth to the famous paranoiac-critical method — a term that he invented to imply some sort of tantalizing meaning, when in fact it was nothing more than the random selection of the peculiar obsessions that he put into his art.

As a child I was wicked, I grew up under the shadow of evil and still continue to cause suffering," he admitted. Fondness or tenderness was impossible for him. Speaking of his relationship with Gala, he would get all excited with loving care when they were embracing at the start. But then the tenderness would turn to sadism and he would squeeze her tighter until "I was grinding that little fairy face with a force that I felt to be dangerous, as though I were pulling, kneading, folding over and over, patting a piece of dough to make a loaf of bread.

Prospective visitors to these parts of the Empordan need not be alarmed, few locals display such eccentric behavior or are driven to such excesses by the wind or flaws of character. True, the occasional gratuitous murder is reported in the press and men regularly beat up their wives. Up in the hills, hunters hang their dogs from the trees when the hunting season is over because they have no further use of them. And there's a place somewhere in Spain where the villagers throw a donkey off the tower once a year for some reason. According to Steve. When Pili's mother, Doña Isabela— "la Marquesa" the Heep calls his virtually mother-in-law — comes up from Barcelona to spend the summer at her sea-front residence, every Sunday without fail she'll position herself straight-backed in front of the TV when the bullfight comes on around four, to be mesmerized by the antics of young men in colorful costumes sticking darts and swords into bulls.

At the bottom of our street, Rosa has a new cat. It sits either on the stoop by the door or on the window sill next to the flower pot. It's a black cat. It's a happy little cat and when it looks at you, it looks out of happy little eyes. Round its neck is little red bow. When she steps out of her little cottage, Rosa is trim and neat and shines like a new pin and her lips gleam bright and juicy like a ripe cherry from the thick coat of lipstick she applies. And when she steps out on the street, she steps out bright and alert too, with her eyes sparkling as though she's on her way to a wedding. And although she keeps to herself, Pili says she's got the Swiss lady to include her in the network of free cat food when the sell-by-date truck arrives from Switzerland, so that's nice.

That's why I say, taking all these things into account, don't be put off by Salvador's antics — I've never heard his name mentioned once in all the years I've been here — people are pretty decent and no worse than elsewhere. Take Montsé, for example. Her ambition is to go to Australia, so I kid her on about those boxing kangaroos. Or Santi. His girlfriend used to spin the octopuses he caught in the

washing machine to soften them up. They've all got their stories to tell. But none of them, far as I know, comes anywhere near Salvador when it comes to phobias. True, Pili lines up little colored pills on the bar-top in the morning and the Heep is seized regularly and spontaneously by fits of the most amazing twitches, of which sniffing combined with nose rubbing, is only one. It has intrigued me for years. But you never get around to asking about these things, do you? Naturally, you wonder about yourself, keep an eye out. You never know, these things might be contagious.

But Salvador was in a league of his own. There has never been anyone like him, never will be. Even the psychiatrists gave up trying to catalogue all his phobias. I thought I had listed them all at the beginning but there were many more, I discovered later. He was terrified of death: *thanatophobia*. He had a phobia about blushing. And he had a thing about insects. Grasshoppers made him hysterical from a young age. The other kids at school used to get their own back on the smart aleck by sticking them down his shirt. Then there was that phobia he had that went under the delightful name of *delusional parasitosis*, that convinced him non-existent bugs were infesting his skin. He found one on his back in his hotel room one day and tried to hack it off in the mirror with a razor. It turned out to be a mole. It was too late to stop the thick, black blood from streaming down his back.

14

Take Montsé

TAKE MONTSÉ, THE PLUMP LITTLE WAITRESS WHO SERVES IN THE Gola cafe on the main street. Main street, first of all, is too generous a term. It is the only street in the port area. It's so narrow you could jump across it. Two cars have difficulty passing. It comes to a dead-end less than a hundred meters beyond the cafe. There's no place else to go.

Montsé told me once she'd love to go and live in Australia. It struck me as strange at the time, since I've never heard her say a single word in English. Following a little chat that we had about boxing kangaroos later, I suspect she has a hidden agenda. She'd seen them too on the telly. So now I'll occasionally say "cangúrus" to her when I come into the cafe and make boxing motions in the air with my fists. It never fails to bring a smile to her lips. She said once, by way of confession, that there were twice as many kangaroos in Australia as people, which got me thinking. Did she want to go to get away from the few people here and be with the kangaroos? She's quite shy is Montsé It's a matter of waiting patiently for the occasional gem to sneak past her lips to get an insight into what's going on in her head.

Take the other day. After I got up, had a shower and got dressed, I went down to the Gola for breakfast. Dave was at the counter ordering something from Margarita when I went in. Margarita is the owner and has a little bakery in the *vila* which supplies bread around town as well as to the other cafe-baker café she has in the village.

When Dave was gone with his baguette, I said to Montsé, "he speaks very good Catalan for an American."

"Sí," she said.

Little Montsé eased out from behind the counter, came up close so no else could hear and in a conspiratorial tone, whispered, "there's a lot of people who don't even bother. They've been here for years and they don't speak a word."

I assumed she was referring to the vast sweep of unnamable foreigners: British, German, Belgians, Dutch, Swedes who come this way and pass on, who knows. To pre-empt what was coming next, I attempted to summon a sort of apology for the invisible legions of the dumb. Just in case, I was included.

"If they're pensioners, all they need to do is watch television and go to the supermarket. They know enough Spanish to buy what they need. Some people have no facility for languages. They don't know you can learn a language other than your own. A lot of the *ingleses*, are like that." And here I had in mind those Brits I'd read about in the paper, down south in Bellydorm way, who'd a problem with the natives speaking Spanish — God forbid, they might be saying nasty things about the pillocks.

"No pero, con respeto," Montsé said, pouting her lips in a twist as though a fly had landed on them and she was trying to shake it off. She was practically right under my nose and looking wide-eyed into my face when she said. "That live here."

"Ah, you mean...?"

'That work here."

"Ah!" And the penny dropped. I had a sudden flash of vast legions of the southern poor, the Andalusians, who for decades have been driven north to seek work in Catalunya.

'The Andalusians," I prompted, "People from the south?"

"Sí. They come here to live but they never learn the language. And they don't want to."

'They refuse," I said, filling in another gap.

"Sí!"

And strike me down dead if I tell a lie, but who should come through the door that very minute but the prototypical Andalusian himself in person: José Mentira. And strike me down dead twice, if he didn't take a seat at the very spot where I christened him. That day, quite a few sunrises hence, when he sat there with elbows resting on the formica-topped table, and scrutinizing the news for meaning, intoned the historic words "Mentira! Mentira! Mentira!" Not once but three times. "Lies! Lies! Lies!" in a voice so loud everyone in the cafe, including those sitting at the tables outside looking onto the sea must have heard him. Big, plump, white-haired — potentially jovial if newspapers are ever banned — with his hanging jowls and watery eyes, he bore a distinct resemblance to Sherlock Holmes's sad old bloodhound. José was the kind of Spaniard you could expect to retort "Habla Cristiano," when aroused by some other native of the Iberian Peninsula daring to address to him in a language other than Castellano (Castilian), which by fortunate alliteration — for him in any case — rhymes with "Christian."

"Speak of the devil!"

Montsé muttered n'er a word, as she was entitled to do given the thrust of the conversation, but turned the moment round, showed her back, busied herself with the coffee machine and pretended we had never spoken. Just in case. I took a seat facing the street, with my back to José Mentira, looking onto Estel's bookshop, which sits between Jordi's *tabacalera* and the fish shop on the corner, and pondered further the Catalan language question. Because it was in Estel's bookshop that I discovered Martin Tree, an Englishman who thought Catalan the most beautiful language in the world and

used it when he went in search of Catalunya. When I read a review of his book: *Un Anglés Viatja per Catalunya per Veure si Existeix* (Travels of an Englishman in Catalunya to see if it exists), I immediately went down to the bookshop and bought a copy. Estel positively beamed when she handed me the last copy she had and we talked about Tree. Here was a man who had abandoned English to write in Catalan! It was the greatest compliment anyone could make. The Catalans adored him. And I agreed. Wholeheartedly. I was so happy for everyone. For Estel. For all Catalunya. The mutually incited euphoria reached such a pitch in the bookshop as the compliments flowed and I clutched my copy of the book. It was touch and go. One second longer and I'd have thrown my arms round Estel, smacked her on the lips, thrown my arms in the air, bawled a resounding "Visc Catalunya" — long-live Catalunya — and asked her to marry me.

Dave was like Tree in that respect. He was an American and spoke good Catalan. He was a young guy. From California. Maybe in his late thirties, if you think that's important, and worked for Silicon Valley. Did stuff on his computer all day long. Lived up the hill in a block that looked onto the main street. He found Llançà the most wonderful place in the world years back and decided to come and live — it takes all kinds. That was after looking up and down the Costa Brava for months on end to find the right place. Why he plumped for Llançà is pretty easy to understand. When you get to know Dave a little better, that is. Llançà is like one of those little chipmunks you see on nature programs on the telly that awakes from its winter hibernation around June. When it has recovered from the shock, it shakes its fuzzy head, blinks into the blinding sun, gets frenzied up for a second or two, manages to keep its eyes open till around the end of September, by which time the tourist season has wrung it out like a wet dishcloth. And then it creeps back into its little hole and falls into a deep sleep again, the poor little thing.

Dave is a bit like that, the only difference being that when you see Dave, it's the bit where the chipmunk has just woken up and is full of beans and raring to go. He has no time for chit-chat, scurries back to his lair to examine whatever nut he's managed to get his claws on, scratching the internet all day long.

Dalí was a lousy linguist. I feel the same at times. Although I have attended Catalan classes in the village and in Figueres for two years and have a dubious diploma to show for it, read the Catalan newspapers just about every day in the cafes and restaurants as I find them: *L'Avui, El Punt, El Diari de Girona,* in real life I don't seem to get much further than good day or goodbye before being spiked.

"Bon día," I'll say in Catalan on leaving the grocers, pretending I'm one of them.

"Buenos días," the grocer inevitably calls after me in Castellano. Or I'll say "Bona nit," and get "Buenos noches," in return. "Déu," invokes "Adiós." And so it goes.

But behind that simple remark of Montsé's, inspired partly by José Mentira's presence, lies a plaintiff cry against the power and domination of the Spanish state. And it goes back over two thousand years to the Carthaginians. When the Romans defeated the Carthaginians, who were descended from the Phoenicians, the original traders of the Mediterranean, they conquered first the north of Spain and then the south. The south was immensely more attractive. The Carthaginians had been there for over five hundred years and had silver, copper, lead, iron, tin and mercury mines. When Carthage fell in 146 BC to the Roman army, the financiers and the merchants of the Roman Empire moved in. They spoke the high Latin that later evolved into Castilian Spanish. Catalunya on the other hand was poor. Its initial invasion had been prompted

not by the greed for gold, but the need to protect Rome by hindering Hannibal's movement across the Pyrenees with his elephants. And so, in the course of the centuries the high-class Latin spoken by the administrators in the south developed along a different trajectory from the demotic language in the north spoken by the legionnaires and the settlers. This was the root of Catalan. And since there was a constant flow of traffic from Rome through the north, this movement of tongues renewed the language and kept it more modern. When the Frankish kings in the north retook the Catalan towns from the moors in 801, Provençal became the language of administration, literature and poetry from the ninth to the 16th century. Catalan became closer to Provencal than Castilian Spanish. After the reconquest and the discovery of the Americas, the effects of this division in language between north and south became more accentuated. Long after Spain lost its colonial empire many people were unable to relinquish their dreams of glory and association with the great days of empire. In justification they could point to the fact that half the world on the other side of the great ocean sea, as Columbus had called it, now spoke Spanish. The same post-colonial mindset in Spain is partly responsible for the continuing Spanish agony and the question of Catalunya's place in the world.

A few basic examples are enough to illustrate the distance between the two languages. Fear in Castilian Spanish is *miedo*. In Catalan, it is por, in French, it is *peur* and in Italian it is *paura*. To speak in Castilian is *hablar*. In Catalan it is *parlar*, in French it is *parler*, in Italian *parlare*. You could say that that Catalan is closer to Italian than it is to Spanish, as we know it today.

Catalan identity is best rendered by what is considered their national anthem. Sung to the music of the sardana of *La Santa Espina* (The Sacred Thorn). It was loathed by Franco, who banned it.

Santa Espina

Som i serem gent catalana
tant si es vol com si no es vol,
que no hi ha terra més ufana
sota la capa del sol.
Déu va passar-hi en primavera,
i tot cantava al seu pas.
Canta la terra encara entera,
i canta que cantaràs.
Canta l'ocell, lo riu, les plantes
canten la lluna i el sol
i tot treballant la dona canta
i canta al peu del bressol
I canta a dintre de la terraJ
el passat ja mai passat,
i jorns i nits, de serra en serra,
com tot canta al Montserrat.
Som i serem gent catalana
tant si es vol com si no es vol,
que no hi ha terra més ufana
sota la capa del sol.

Sacred Thorn

We are and always will be Catalan
whether some like it or not,
because there's no more prouder land
under the sun.
God passed here in spring,
and everything sang in His wake.
The whole earth is still singing,
and sings as you will sing too.
The bird, the river, the plants sing,

Take Montsé

the moon and the sun sing,
and working, the woman sings,
sings at the foot of the cradle too
And deep inside the earth sings
the past never yet past,
days and nights, from mountain to mountain
they all sing to the Montserrat.
We are and always will be Catalan
whether some like it or not,
because there's no prouder land
under the sun.

15

Washed Up

IT'S SUNDAY, EARLY AFTERNOON. THE BEACH IS DESERTED AND the boats in the port are tied up. The tarmac of the car park at the side of the Casa del Mar is sweating in the late September heat but it is empty save for the cars of a few diners who have come into town for Sunday lunch at one of the restaurants: La Casa del Mar, La Marina, Els Pescadors, the Miramar or even at the new restaurant the town hall opened at the end of the pier, high up where you get a magnificent view over the sea and the coast all the way up to Port Bou. The streets are deserted. Occasionally a seagull calls high up, spotting some movement on the water. At the end of the pier, beyond the three of four fishing boats lined up along the quay, a man is thrashing a bulging plastic bag against the flagstones. He opens the bag and pulls out a huge octopus, close to three-quarters of a meter. It must weight two or three kilos. I ask him to hold it up and I take a photo and he says "I've got more in the bag," pointing to a bulging white plastic bag. He takes out an octopus, wrestles with the skin of its head and pulls the skin like a cap over its skull to smother it. The tentacles of the octopus writhe.

The good weather has brought out two or three fishers. They take a small block of wood wrapped with white plastic or painted white, about ten centimeters by five, and attach two ugly big hooks to it. They strap a piece of chicken to the block with black elastic band. Then then they tie a piece of thick length of cord, ten or fifteen meters long, and throw it out into the water.

Washed Up

"How long does it have to be? The cord?"

"As long as you like."

When they throw the weighted block, it sinks side down and rests on the seabed. The hooks and the chicken are left upright. The white color of the chicken flesh attracts the octopus or the squid. The squid has a tiny beak like a parrot. When it opens its beak to get the chicken it gets entangled on the hooks. That's what the fishermen hope. The system appears to work. Today in any case. judging by their catch.

On dead days like this, I occasionally run into Santi. Santi lives in a house upstairs next to the Casa del Mar. It's one of those white houses with half-moon shaped balconies that were a popular style in the fifties and sixties, but that they don't build like that anymore. The curve has been replaced by the square and the rectangle. Santi too has been replaced. "washed up" is the first phrase that springs to mind in his case. It's not an expression people use much these days. When I look it up in the Oxford English dictionary, it says Americans mostly use it, as in "he is all washed up."

In Santi's case it has a further dimension. Santi is an old seadog whose has sailed the seven seas and, after his many adventures, has been washed up here in his own home village like the rubble that gets washed up on the beach in winter when the storms rage and the Tramuntana howls; the only difference being Santi has been washed up high and dry in the upper floor of an unprepossessing vacant villa that looks on to the sea in Llançà.

When I look at his bleary nose and those watery eyes and that heavy black woolen, three-quarters-length jacket-coat he always wears that is out of season for most of the year and is justified only by a few cold days of winter, I'm reminded of *Mon Oncle Jules*, a short story that we read once in French class at school. It was written by one of the great masters of the short story, Guy de Maupassant.

It's a sad kind of a story. Uncle Jules is a waster. Years back he borrowed money from his brother, young Joseph's poor father, to go to America to make his fortune. But they never hear from him again, not even a letter, until they run into him unexpectedly.

"And every Sunday, seeing the great liners returning from distant, unknown lands, my father would invariably pronounce the same words: Goodness me! If only Jules was on board, what a surprise that would be," Joseph Devranche says.

Then one day, on a trip on the ferry from le Havre — where the family comes from — to Jersey in the Channel Islands, Joseph spots his uncle on board and recognizes him despite the fact that his hair has gone white and he's scruffy and beat-up. Uncle Jules' job on the boat is to open the fresh oysters and sell them to the passengers. When Joseph goes to pay for the oysters the family has just eaten, Jules tells him it's 90 sous. Joseph pays him the money and gives him a generous ten sous tip. Jules takes the money but does not recognize his nephew. They never meet again. Ever after that, whenever Joseph sees a beggar, he gives him the substantial sum of 100 sous.

On another of those dead days, with nothing better to do, I go down to the port, walk along the breakwater, and on the way back drop into the *Llotja de Peix* — the fish auction market — climb the metal stairs to the visitor's gallery, watch the fish being wheeled in under a coat of ice in blue plastic boxes, follow the numbers going up on the board like at the bookie's, and run into Santi again. He is a few paces ahead of me when I come out of the Llotja out half an hour later, in that unmistakable woolen coat of his, his hands behind his back, his head down. I still have the octopus on my mind that the fisherman caught that Sunday from the end of the pier, so when I catch up with him, we get to talking about fish and, of course, octopus. Eventually I say, "They tough to eat, that big, the pulpos?"

"I had a girlfriend lived over there," he says pointing across the narrow bay in the direction of the little Hotel Berne, "who didn't know how to cook them. Used to put them in the washing machine and spin them round for an hour or two."

"And does it work?"

"Oh yes, it makes them nice and soft."

He signed up on ship when he was eighteen and went to sea. He'd been all over: to South America and the Baltic ports. Even Murmansk once.

"When I was twelve you were rich if you had a bike. The rest of us walked about the town but you always had someone to talk to. Now everybody goes about in a car and there's nobody to talk to. In Franco's time, it was all Germans. The Germans were very popular. Now that's changed…I was in Hamburg once, with a ship, and we were hosing down the quay after taking oil on board. The first mate said to me I'd get fined for that and I laughed. When I came back, he said there's two policemen waiting for you up on the bridge. They had a little flask of water. One of them held it up and said: look! There was a little film of oil on the top. I had to pay a fine. I don't know, five or seven marks. The first mate told me later the inspectors went under the wooden quay on their boat and held up the little bottle and caught the oil a drop at a time. Germans! Ahhh!"

Each summer a volunteer force comes in a little boat to clean up the bay and the port area. As the volunteers come into the harbor, we wait by the edge of the quay to see what they've fished up. It isn't much: a rubber tire from a car or a cart, assorted poles, bottles and other junk. They'd fished up a fridge last year, Santi said. Either it had been brought into the bay by the current or it had been dumped off the end of the quay, I thought, but it could have come from anywhere. After certain storms the beach could be littered with branches of splintered hard, red wood foreign to these parts and that could only have drifted across from north Africa.

I didn't see Santi much after that. One day I passed his house, coming out of the Casa del Mar after lunch, and the shutters were down. And they were down every time I passed after that. There was no one else living in the four-apartment villa. When Santi was gone the villa began to take on that sad, down-at-heel look that such houses acquire when wind-blown papers and sand accumulate on the stairway; cobwebs spread under the eaves; and cats and birds take life away with them as if fleeing a graveyard.

I ran into him one day in the street in Figueres. He said he'd sold out because it was too lonely up there in winter and that he was happier in a town where there were good medical services. He had a sister who'd been a teacher in Figueres and had never married, I learned. When he was younger, he married a nice girl and they lived together in the villa with his parents. But he was often away at sea. For up to six months at a time. The girl got fed-up waiting and went off one day with a man with a club foot who made orthopedic shoes for his fellow limpers and sold them in his Gerona shop. When Santi came back from sea, there was no-one left in the house. His mother had died and his ailing father had gone to live with his sister. And that was where he was living now. With his sister. Pili knew him well. She said he was an alcoholic. When I asked her about the club foot — I kept getting regular flashes of his ghost limping along the pavement across from the Casa del Mar or scuttling around the old villa, dragging a huge club foot behind him — she said she'd never seen the man his wife ran off with, so she couldn't say one way or another, whether it was a big club foot or one of those small ones you hardly notice.

There's not much more I can say about Santi. For some reason I took to him. And like Uncle Jules in that Guy de Maupassant story, when I was out walking the dog and saw a great liner far out at sea from up high on the Cami de Ronda, heading up to Genoa or down to Barcelona, that sweet, peaceful feeling in which everything in the

world becomes one, would come over me and I'd imagine him returning from a distant, unknown land, see him clambering eagerly down the gangplank in his fisherman's jacket on to the golden shore with the rest of the bums and the toffs. To reclaim his birthright to happiness and a hero's welcome in that perfect time when everyone's ship comes in.

16

Demon Bride

SALVADOR WAS A CELEBRITY ALL HIS LIFE IN AMERICA FROM the day he arrived in new york for the first time in 1934. Already on the ship coming over from France he had orchestrated his reception by an eagerly waiting press. For the next forty years he would spend his winters with Gala at the St Regis Hotel in New York, keep the press fired up with his antics, and return to Europe (Port Lligat or Paris) in summer. He loved America and America loved him in return. By way of appreciation — back in Port Lligat in the warm weather — he would become a Catalan cowboy, donning a fancy cowboy shirt. Instead of crude cowboy boots, he would slip his feet into rope-soled Catalan sandals (espadrilles) and tie them round his skinny ankles with black laces. The half-cowboy and half-Catalan effect that he created is what made Salvador a typical Dandy.

Back in America, he tended to dress more formally. He had no wish to distract the media's attention from the delivery of whatever new absurdity, outrage or trinket his over-fertile imagination invented or saw fit to spew forth for the entertainment of an adoring public. A one-man advertising agency, he promoted his own product: himself. Consummate showman and jack-of-all trades, he turned his hand to Hollywood films, portraits of the rich and famous, Fifth Avenue store displays, stage designs for operas and musicals, TV quiz shows, and personal appearances in little halls. No offer was too petty or too menial if it helped push the Dalí brand and rake in the money.

But, like humans, all products have a life cycle and the Dalí brand eventually exceeded its sell-by date.

During those glorious days of his stardom, Gala accompanied him. They were often pictured together in the press. A gullible American public, nourished in their formative years by happy-ever-after Hollywood movies, cooed sweetly and reverently in his praise from the trees like doves. Doubting Thomas's, who thought there was something weird or creepy about the guy were sharply reminded of the *Wonderful Wizard of Oz*, that icon of American popular culture that they'd all loved in the movie when they were kids. And if those characters weren't creepy, who was? The Wicked Witch, Cowardly Lion, Dorothy Scarecrow and the Tin Man? Now if they'd loved that crazy looking Tin Man, all they had to do was think Tin Man when they saw Salvador and Bob's your uncle. He was a dead ringer.

It was just as well the truth about the Tin Man (or the Cowardly Lion) and the Wicked Witch was kept hidden. Getting the real lowdown would have been the death of tens of thousands of adoring fans. Dalí had confessed all (if you could believe it) in his so-called autobiography, the *Secret Life of Salvador Dalí*. Published in 1942, it was well reviewed and seems to have sold well. Art buffs and the odd pervert were entranced by his well-scripted attempts to shock and took the, often unsavory, revelations at face value. Leading critic James Thurber, not a man to fall for the Dalí palaver, saw through it all. Reviewing the book in the New Yorker, he said, "What Salvie had that we kids didn't was the perfect scenery, characters and costumes for his desperate little rebellion against the clean, the conventional and the comfortable."

With the publication of Ian Gibson's, *the Shameful Life of Salvador Dalí* in 1997, the fat hit the fire. Little was left to the imagination. Particularly as regards his relationship with his partner in crime, Gala. One person able to add some spice to the saga was John Richardson, a British art historian who studied at the Slade

School of Fine art in London. Richardson (later Sir John), was a personal friend of Pablo Picasso, and is best known for his authoritative three volume Life of Picasso. An upper crust Englishman, he moved to New York in 1960, where he headed Christie's New York art dealership before moving to Knoedler & Co. Knoedler was then America's foremost art dealership and had been in operation for a hundred and sixty-five years till it closed its doors in 2011.

As vice president in the 1970s, Richardson was responsible for keeping Dalí to the terms of his contract. With close personal and professional experience of the dastardly duo, he was uniquely qualified to review Gibson's book. Writing in Vanity Fair's December 1998 issue under the heading of Dalí's Demon Lover, Richardson paints a lurid picture:

> At a time when his eye was so bleary and his hand so shaky that assistants had taken over his more arduous work", he writes, "I could not help feeling sorry for the seedy old conjurer with his rhinoceros-horn wand, leopard-skin overcoat, and designer whiskers, not to mention his surreal breath. The Wizard of Was, as someone called him, was all patter and very little sleight of hand. His virago of a wife and the creepy, conniving courtiers in charge of his business had reduced Dalí to a mere logo, a signature as flamboyant as his mustache. Gala's business methods were very Russian: she did not haggle as much as berate and bully. In a jet-black wig held in place by a Minnie Mouse bow, this ancient harridan would drive home her wheedling demands for money with jabs of ancient elbows and blows of mottled knuckles. After one gruesome dinner at Maxim's in Paris, which left me black and blue, I refused to deal with her ever again.
> "Dalí need more money."
> Jab!
> "Then Dalí had better start painting again."

"Dalí paint every day. You give more money, he give more paintings."

"All our money got us last year were bits of paper smeared with ink from an incontinent octopus. Ouch! Gala, that was my kidney!"

To put one of Dalí's biennial shows together, I was obliged to beg, borrow, and improvise: cover nude girls in paint and roll them on sheets of paper; jazz up dud old masters with Dalían trademarks — a swarm of ants or a rotting sardine — thereby transforming them into artifacts that were no less dud but far more valuable. Amazingly, the stuff sold.

When she was angry, she roared like the MGM lion, Dalí used to say of Gala. He called her, among other things, his little lion. It came from her Tatar (Tartar) blood. Her mother was a Tatar and Tatar women were renowned for being fiercely independent and standing by their man. And it was that innate strength of character, together with her intelligence and love of poetry and the arts that were the making of Paul Eluard and Salvador Dalí. They would have been nothing without her. She encouraged Eluard with her knowledge of French poetry. She was responsible for half of Dalí's production eventually, providing him often with about half the concepts and ideas that fired his imagination and got him down to work. In later years he would sign his pictures Gala-Salvador Dalí, in recognition of the fact.

If Gala was the Siberian Tiger, Dalí was the Cowardly Lion. Hypocritical and cowardly, he spent his life playing both sides of the field against the middle, lauding something one moment and praising its opposite the next. Gala kept him on the rails, made him and managed him. Without her driving ambition he would have been a footnote in art history. Love her or loathe her — Luis Bunuel nearly strangled her once on the beach in Cadaqués — Gala was ten times the man Salvador would never be.

Born Elena Ivanovna Djakonova in Kazan in 1894 (she says), of a civil servant father and a mother who wrote children's stories she was sent to Switzerland to recuperate from tuberculosis (it is said) where she met and fell in love with Paul Eluard one of the founders of surrealism, whom she later married. When her father died, her mother married a Moscow lawyer.

That briefly, is Gala's standard C.V. And even those few facts are disputable. Her daughter Cécile said she did not know where or when she was born.

Generally brushed aside as an enigma or a mystery woman because of her Russian background and her roots in pre-revolutionary Russia, she rarely gets a proper hearing. And yet hordes of Russians flock every year to her shrine in Púbol Castle to pay homage and reverently peer at the correspondence displayed in the glass cases. Clearly the Russian visitors have a different take on things, understand something about Gala that we don't.

Catalan director Silvia Munt threw some light on the subject some years ago with her documentary film, *Elena Dmitrievna Diakonova: GALA*, (adding to the confusion by using her stepfather's patronymic as her middle name) which was released in Spain in May 2003. Tracing her journey from Russia via Switzerland to Paris, Spain and Salvador Dalí, Munt comes up with some interesting findings.

Kazan, which lies on the Volga, is one of the few places in the world where the local hero is a woman. Local legend holds that the most beautiful women on earth came from Kazan. The khans of the Ottoman Empire picked them for their wives because of their penetrating gaze as well as for their reputation for being well versed in the secrets of love.

Silvia Munt's team found no trace of Gala (or her family) in the Kazan registry, even though Kazan appears on her passport as her

place of birth office. The family seems to have come from Tomsk in Siberia over 1500 kilometers from Kazan. Her mother's father had a gold mine in the region.

Kazan city legislation at the end of the 19th century prohibited Tatar merchants from having accounts: their wives had to do the work. Gala's mother was a Tatar. And Gala had the talent of the Tatar woman for managing both the household and the business of their men. It was just as well for Dalí. He couldn't count.

Gala's name does appear apparently on the Moscow registry in 1985, so either she arrived there as a baby or she created a myth about herself as an exotic oriental woman. She was the second in a family of four. She had one older brother and a younger brother and sister. When she was eleven (it is said) her father died and her mother married a Moscow lawyer named Dmitri Illitch Gomberg soon afterwards. In her early years, before her father became more successful, the family, all six of them, lived in a small flat. The cramped conditions turned out to be a blessing in disguise. She ended up spending more time staying at the spacious house of a fellow student at the Moscow institute, Marina Tsvetajena, later to become one of Russia's greatest poets. Marina's parents lived comfortably in big eleven room house (with no electricity) in spacious grounds. Her father, a philologist and art critic, was director and founder of the Museum of Fine Arts and her mother, a brilliant pianist, was a student of Anton Rubinstein.

Regular visitors to the house included some of the greatest writers and artists living in this the most creative age in Russian history. Marina who started to write poetry when she was six, would correspond later with Rainer Maria Rilke (in German) and Boris Pasternak. When her poems were later recited in public, crowds of up to a hundred thousand turned up to listen.

In Marina's shadow, Gala realized that if she wanted to create something it would have to be through the men she knew. She became the last great muse of the age.

"She was made to live alongside great artists and stimulate them, push them to extremes. She adored art and things of the mind, poetry and philosophy," Antoni Pitxot, close companion to Salvador, said.

She was sent to a sanatorium in Switzerland in 1912, not because she had tuberculosis as is generally claimed, but for another reason. "She told me her father was in big trouble because he was working (as a lawyer) for both the tsar and the communists and that he said that he was going to say she had tuberculosis so he could send her to Switzerland to escape the collapse of Russia," says her last lover, Jeff Fenholt, in Munt's documentary.

At the sanatorium she met and fell in love with budding poet Paul Eluard. They were both seventeen. None of her family visited her. Gala's father had foreseen the collapse of Russia and she would probably have waited it out in Switzerland, had Paul Eluard not returned to Paris early in 1914. She returned to Moscow. "My father said l was sick with love and wanted to take me to the doctor," she said of those interim days. Late in 1916, she could stand it no longer, broke with her family, packed a small suitcase and crossed a war-torn continent to be with him in Paris. Gala was more prescient than her father.

Her licentious behavior would later invoke comparison with a contemporary — Grigori Rasputin, the mad-monk. Seen by some as a mystic, seer and holy man, Rasputin seduced hundreds of women who came under his spell and was even rumored to be bedding the empress Alexandra herself, under the pretext of curing her son Alexis of hemophilia. It was in all the papers. Gala fled Moscow late in 1916 before Rasputin was brutally done to death on 30 December that year. He had prophesied the apocalypse, if he was murdered. It came soon enough. The next year revolution broke out.

Uncompromising and down to earth, tough, passionate and ambitious the opinions of others left her cold. Elegant and sophisticated, she recited the French poets to Eluard and inspired him to become a poet. She had a spiritual side to her too, read the Tarot cards, and exercised a magnetic influence on those she lured into her web, leading some to attribute to her hypnotic, mesmerizing powers.

> Eluard prided himself on his sexual prowess, but he failed to satisfy Gala so she took lovers on the side. They had to be exceedingly young, handsome, and horny. Since Gala was blessed with striking, Slavic looks, an appetizing little body, and the libido of an electric eel, she had no difficulty finding them. One of her first lovers was the charismatic German Dadaist Max Ernst, who had recently moved from Cologne to Paris. At Gala's insistence, Eluard let this hot young genius share their bed. Two men proved much better than one. Her only regret was that an "anatomical problem" ruled out simultaneous fore and aft penetration. She was the demonic dominatrix of his dreams. In the market for another celebrity husband. And in the 25-year-old Dalí, she found the man of her dreams, someone who shared her passion for money, power, and notoriety, but also someone whose latest paintings, with their references to Freud and de Sade and their meticulous, Vermeer-like finish, were destined to have an instant *succès de scandale*.

That was Richardson's take on the 'Russian harpy'. Munt's documentary paints a different picture of the *ménage-a-trois*. "She loved him all her life, Eluard was the problem," Jeff Fenholt says. They maintained a friendly relationship after they separated.

With Dalí, the situation was different. From the day she came with Eluard to visit him in Cadaqués in August 1929, some sort of attraction was struggling to express itself. If not to her heart, then to her mind. He was clearly a 'good catch' for a bounty hunter like

Gala. She had her reservations — his presumed homosexuality and coprophagism. And as regards the boy-toys she would recruit later in life, Salvador was a boy-toy of sorts too, leaving aside the money aspect. He was a virgin when she met him and stayed a virgin all his life. An emotional retard, he inhabited a no-man's land somewhere between a spoiled six-year-old brat and a juvenile delinquent. He got his kicks from watching. He was also a child for Gala. Ten years his senior when they met, he was the boy-child to replace Cecile, the daughter she had with Paul Eluard. She'd always wanted a son, it seems. And that pattern, that need to act as mother to her lovers would be repeated all her life. With two of her last lovers, William Rothlein and Jeff Fenholt, for example, for whom she was more a grandmother if not a great-grandmother.

She married Dalí in a civil service in Paris in 1934, and later cemented the union in 1958 with a Catholic service in the church of Mare de Dèu dels Angels (Mother of God of the Angels) in the little village of Sant Marti Vell, a few kilometers from Púbol.

The location is interesting. Over a decade later Dalí would buy a castle in Púbol for Gala. That was in 1969, when she was seventy-five and needed a place of her own to entertain her boy-toys. Salvador could visit only be appointment. Not that her love life held any mysteries for him. Or objections. He liked to watch 'it' and she like to do 'it.' What actually was done — if anything — is thankfully, something of a mystery.

Married to a man with the sexual drive of a snail, her raging libido scoured the landscape like the specter of a beast of prey while the breadwinner worked his butt off in the studio. Over the years she stalked all who came within her territory, from the local fishermen (who came to loathe her) to the servants and business associates of Dalí. And when she exhausted that source, a charming French pimp (who claimed the Madame du Barry, mistress of Louis XV of France,

as his ancestor) would send up fresh flesh for her table from Barcelona. But with the advance of her years, even Spain's readiest and most willing studs were groaning under the strain, protesting they'd rather mount a goat or a hedgehog. But all strength to little Gala's arm, never say die. If you wait long enough, God will reward you. And there he was that day in 1964 on a New York street — and her still only a young girl of seventy-two, the love of her life (again) — a dead ringer for Salvador when she'd first met him, conveniently disguised (for people who believe in fairy tales) as a derelict drug addict — William Rothlein, twenty-two years old. Whom she took to Italy and asked to swear eternal love on the tomb of Romeo and Juliette and then Dalí went and spoiled it all. He'd been using Rothlein as a model and since he was his spitting image, he sent the couple off to Rome for Rothlein to do a screen test for the leading role in the *Secret Life* of Salvador Dalí. To be filmed by Federico Fellini.

Whether Fellini had any intention of making such a film is unclear. From what transpired, it seems more likely that Salvador was chancing his arm again. In the event, Fellini duly gave Rothlein a screen test and offered the aspiring actor in a film of his own: *Juliet of the Spirits*. Gala then persuaded Rothlein to turn it down, fearing Dalí's disapproval. That riled Rothlein and then and there, he grabbed Gala and kissed her in protest before the cameras. The photo duly appeared in the press. Dalí was incensed at their secret affair becoming public and sent Rothlein back to New York on a one-way ticket. But Gala was still very fond of him, and sent him letters, giving him motherly advice, advising him on his career. She planned to meet up with him again in Manhattan but Rothlein died of an overdose not long afterwards. Or was reported to have done so by both Richardson and Ian Gibson. He seems to have been and may well still be, very much alive. In June 2,000, his lawyers sued Richardson and Ian Gibson for Libel. Rothlein sued

for libel, denying being a junkie, dying of an overdose, and failing a screen test for Fellini. The case was dismissed on technical grounds.

Never one to give up, after the affair with Rothlein, Gala quickly dusted herself down and threw herself back into the fray with renewed vigor. Nearly eighty, she fell for a young student from Aix-en-Provence, who gave her the illusion of eternal youth. Hopelessly addicted to eating breakfast at supper time, when he disappeared from the scene, the flag came down again and the little Tatar filly shot out of the gate heading for the centenary marker and was just in time to squeeze in the last love of her life — seriously the very last, as it turned out — Jeff Fenholt, the long-haired star of *Jesus Christ Superstar*. He was a frequent visitor in summer to Púbol Castle for seven years. Gala installed a grand piano and electronic equipment for him to practice (he started life as a rock musician). The affair cost her a fortune. She bought a house for him on Long Island valued at 1.2 million dollars and gave him some of Dalí's paintings. When Dalí discovered how much she was spending on Fenholt, he went berserk. It was one of the causes of his gradual decline in the late Seventies and early Eighties. Fenholt, who later became a TV preacher in California, denied that there had been anything sexual in his relationship with Gala. "How could he possibly have gone to bed with an old woman with skin cancer?" Fenholt's lawyer said in a letter to the Dalí Museum in St Petersburg Florida, protesting an allusion to the actor's relationship with Gala in its Exhibition Notes.

In a sense Púbol Castle was Gala's reward for well-earned services, a place to retire to in privacy. It took Dalí a few years to find it. First, he looked at Requesens castle, a huge fortress sitting high between the trees near La Junquera and the border with France. Then Foixà castle near Gerona city, once the residence of the counts of Empuries, where he started negotiating with the owners. In the sixties he also looked at Quermançó castle, halfway between Figueres and Llançà.

The castle sits high on a rock just off the main road and dominates the entire Empordan plain all the way to the mountains on the horizon. A dilapidated ruin of a place, it is right in the path of the Tramuntana. It inspired the hare-brained idea of catching the wind and having it play tunes as it moaned through the pipes of a huge wind organ. There was also talk of a rhinoceros.

17

What about the Rhinoceros?

WE'VE ROARING DOWN THAT LONG STRETCH OF TWO-LANE highway between Figueres and Llançà — in Josep's ramshackle and low-down-at-heel battered, blue Mercedes station wagon, the red sun flaming behind the Pyrenees away on the left and everything looking fine and dandy — "What a lovely sky, Josep? No?" — and the world at peace and everybody happy and feeling good when Quermançó castle comes into sight high up on the rock to the right. And yes, it's Dalí's castle. Or that hijo de puta — son of a bitch (whore literally) — as Josep calls him. Josep's smoking a joint, one hand on the wheel, the other hand gesturing, all speedy-freaky in his head but slow in his hands. So, I'm thinking the best thing I've done tonight was to take a few drags at the joint he offered when we stepped into his car in front of the art school after class. Because since then he's been launched into psycho- babble — or that's what it sounds like in the state I'm in — and I'm shitting myself all colors of blue as he overtakes three kamikaze trucks down the long stretch and gives the beast more gas heading down the demented highway with demented cars roaring at us at over hundred forty and "whoosh" making the Mercedes shudder as they slash the air like jet planes on a mean mission. Then the roaring, rusty, hoarse, splutter of the broken exhaust and we're in the clear. Then a gap and "bump" the Mercedes throws its rear wheels up in the air like a bucking bronco when we hit the bridge. And then we're swinging round past the castle of Quermançó and Josep is hitting me with all

sorts of stuff about *The Golden Goat* that was supposed to be buried in the castle. And how it was buried there by the White Lady who wove a tunic for her man deep into the night with the moon shining and how Heinrich Himmler, Hitler's deputy, visited the castle in 1940 looking for the Holy Grail after seeing Wagner's Opera Parsifal back home in dear old Deutschland.

We've just come from Josep's painting class in the Art School of Figueres and are heading home in the falling dark to Llançà. Josep knew Dalí. Josep used to have a yacht he won in a poker game that he moored it in the bay in front of Dalí's house in Port Lligat. That was before the boat burned under his pants in Majorca. Now Josep does fishing boats and sailing yachts under deep blue skies. In acrylic. With a surreal touch. Not much. Just a touch. Surreal, what else would you expect in this neck-of-the-woods? Here, they're all a bit touched in the head by the Tramuntana.

So, as we fly round the curve past the castle and the hidden treasure, I try to get Josep to stop waving his left hand and the joint and get it back on the steering wheel. Because that's bothering me. I won't say I'm scared, just slightly apprehensive. So, to unhook him from the monologue, I mention how some Spanish flim-flam artists, or entrepreneurs as they are termed, have thought up a scheme to squeeze mega bucks out the volcanic rock of Quermançó. They've raised a million euros and are going to renovate the castle. I've just read the press release. They want to make it into a tourist attraction. And install Dalí's dream of a wind organ plus a rhinoceros to guard it.

Years back, Dalí wanted to buy the castle for his muse, Gala. Half a million pesetas, was the asking price. That's what Josep says and he should know — he'd thought of buying the castle ruin himself but instead bought a piece of land below the castle to build his little artist's retreat among the olive trees.

I can't get a word in edgewise, he's still in full psycho-babble mode, raving about Moors and Romans, or is the Celt-Iberians? Or who was here first, because I've lost the place. And what I'm thinking about now is that half a million of old pesetas is not much, maybe twice the value of Josep's clapped out Mercedes at going rate to the euro, and about half of what it's going to cost to bury us if this crate goes off the road. I spare Josep the details of the promotional scheme. And the rhinoceros. I can't speak, I'm staring straight ahead, fixated on the curve and beyond the curve the cement truck that's coming slowly down the hill up ahead. It's still pretty small but when it gets to the bottom of the hill, it's going to cut across the road to go up to the stone quarry, like it always does. And it's going to be huge when it slowly cuts across our path and heavy as meteorite when we run bang into its side.

So instead I'll give you the details of the press release and leave Josep behind the wheel, staring eternally into the twilight like a bewitched toad all big puffy eyed and the road hissing under his belly, unaware he entered the fourth dimension some time back. It goes like this:

Dalí's Surreal Wind-Powered Organ Lacks Only a Rhinocros

A giant wind-powered organ dreamt up by Salvador Dalí is finally due to resonate down a hilltop 100 years after the Spanish surreal artist's birth. After extensive feasibility studies, engineers at Ramon Llull University in Barcelona have produced two prototypes of the organ. "We're going to build the first ever surrealist organ," said Josep Puig, spokesman for three local entrepreneurs who raised € 1 million to breathe life into the 20-year-old project. Dalí who died in 1989 first had the idea of a giant organ played by the wind at the end of the 1970s. He wanted the organ's music to be heard by the people of the Ampurdan region where the fierce Tramuntana wind blows from the north. But his original idea came up against technical problems

such as the winds irregularity. Engineers have perfected a revolutionary, wind accumulator. The wind blows into the organ via a huge funnel, is channeled past a pressure regulator and blasted out of the instrument's 500 pipes…

Bla, bla, bla…but the whole point is never mind Josep, never mind Dalí, never mind the organ, the rhinoceros or even where they're going to site it on the steep slope, because that's got me puzzled too. They'd need to chain it to prevent is sliding down the hill. But never mind all that, that's all secondary, I'm coming up the steep rocky path weeks later for another reason that's got nothing to do with Dalí. I'm coming for a poem. A love poem, that's on a tile cemented to the rear wall of the castle. Some years back, I discovered the tile and the poem as I was climbing into the crumbling castle ruin. I wrote it down but I lost it and now need to get it back. For you Maria! For you! Who wrote it. Who lived down there, two kilometers from the castle in the village of Vilajuiga. Because that's what it said on the tile. Vilajuiga and Maria. At the bottom. And you climbed up there one day, after he died. God knows how. Maybe alone. Maybe with a friend. And cemented the tile to the castle wall above the sheer drop where few people ever see it. So that you could look up at Quermançó castle from your house down there in the village and know your man was nearer the sky, nearer the birds. And all for love. Like you were the last person on the planet who had ever loved anyone. Or maybe the first. That's what it felt like, reading your poem, Maria.

But when I get up to the castle, clutching a notebook, a pen between my teeth, the carpetbaggers have bolted, closing off the entrance. And what about the renovation? What have the bums done with the million euros they said they'd raised for the wind organ? Pig-all renovation! Now I'll never get to see the rhinoceros. Now you'll never get to see the rhinoceros. They've rigged a wire fence over the

entrance! The miserable bastards, a cheap wire fence! Criss-cross mesh. That's all the money they raised. Enough for a wire fence! There's nothing left for it but to climb in through the opening at the side overlooking down on sheer, instant, drop-down death. Along a ledge wide enough for two toes. Entering through what was a window a thousand years ago. The kind of thing only a fool would do. But I'm doing it for you Maria, lovely sweet Maria, last of the Troubadours. Who never forgot her man. Who lived in love until the end. I'm doing it for you. Offering up your *Below this Castle* poem and your love to the sky above Quermançó castle, sending it out into the deep blue, way far out, to drift like a sweet perfume through the universe for the angels to read to each other in God's silence in the long dark night. I'm doing it for you, Maria.

A dall d'aquest castell
Envoltat de muntanyes
El vent se t'emporta
Carinyo, fa un any
Pero per a mi
Com si acabes de passar
Si les ocell i ales tingues
Volaria fins al cel
Fins que et trobes
Per aixo et plor
I recordare tota la vida
Lo felicos que em sigut
Quan et tenia en vida
T'estimo. Maria

Castell de Q (Vilajuiga) 2 de febrer de 1999

Below this castle
Surrounded by mountains
The wind took you away
Dearest, a year ago
But for me
It is as though you had just passed
If I had wings like the birds
I would fly up to the sky
Till I found you
That's why I lament you
And I'll remember all my life
How happy we were
When you were here alive
I love you. Maria

Castle of Q (Vilajuiga 2 February 1999)

Together with his close friend Antoni Pitxot, Dalí used to climb the meandering pathway between the rocks up to the castle to take in the Pyrenees and the setting sun. He did a drawing entitled *Castel de Quermançó* in 1977 and an oil painting called *La Cabra d'Or* (The Golden Goat) in 1979 both of which are on view in the Dalí museum in Figueres.

18

The Thing with Moon Men

ONE SUMMER A FEW YEARS BACK, I MET NED FOR THE FIRST time up on the mountain round a campfire, a burnt sausage on a stick and a mug of red wine. He was straight out of that poem of John Cooper Clarke's *Evidently Chicken Town*. Some tormented hole of a place in the English Midlands or the North where:

> *The bloody scene is bloody sad*
> *And the fucking cops are fucking keen*
> *To fucking keep it fucking clean.*

He'd pop up occasionally after that like a bad egg whenever I drove up to the Pyrenees to see the mountain men. But Ned wasn't what you'd call a regular mountain man. He fell into a different category I later deduced, that had to do with *Moon Men*. It was thanks to Ned that I was introduced to the term "moon men."

And thereby hangs a tale. Ned called people "moon men" indiscriminately. Anybody he didn't reckon, that he thought was a weirdo, he'd say "moon men." He had one of these weird Spanish dogs with big ears sticking straight out of its dumb skull like flags, skin like a bat's and a stubby, stuck-up snout. It breathed through its ears. Just to look at it, gave you the creeps. Bit like Ned, skinny, little, grey-skinned runt of a geezer.

Thing is, Ned never spoke of moon women, only moon men. He always used the plural, never once said: "moon man." That got

me thinking that there was a bunch of them out there, maybe all around, only you couldn't see them. And that they were a collective. And they were all men. It made sense, in keeping with Ned's reasoning, that Ned himself couldn't be one of the moon men. Nor could any of the mountain men. Moon men were people who did stupid things that you and I don't do, is what it came down to. But I started to have second thoughts on that point later.

I hadn't been back up the mountain since the *Guardia Civil* paid a surprise visit. It must have been the year before. They came down the track on their motorbikes. Three of them. I only saw one because I was outside the hut at the time, on the terrace below Bennie's place, admiring his vegetable garden. He made lovely gardens with runner beans and tomatoes winding up canes, and watercress, sunflowers three meters high with heads big as parasols. He made delicate fences with reeds, wove the reeds into a rolling, rippling pattern. He also grew mountain weed. In select spots. By law you can have about five plants. Plants? Some were more like trees.

It was just as well there were none in Bennie's garden that day when everything went strangely quiet. The sky held its breath as if before a peal of thunder. Someone or something scuttled through the bushes downhill behind the hut and next thing you know, a strange figure is striding through the hut, which is open at both ends. I already knew from the signs — "Oh, Oh, here comes trouble" — from the determined way he strode through the hut that bad news had arrived. No one in these parts strides about purposefully. Then he was beside me and said "Nice garden" as if he were my neighbor and we'd known each other for *yonks*. I didn't have to ask who he was because the green uniform and the cap spoke for both of us. He asked me where I came from and where I was staying. "Not here." I assured him. I was only a visitor.

He was a young guy, very friendly, a corporal it seems. I know that because I heard later from the mountain men how the captain

told the two Guardia Civil guys to pull up all the plants they could find and burn them. They piled the plants in a heap in the garden in front of Bennie's house. And then the captain went up the hill and disappeared but when he came back down the hill again less than an hour later, only a few of the plants were burning so he captain told the other two to throw more on the fire and then climbed back on his big machine and headed up the track again to the main road.

But they didn't burn well the second time either, just smoldered. They were too green. It must have been after midday. By then the two Guardia were like old friends with the mountain men. They hadn't been too impressed with their cultivation methods. Some guys an hour's walk further up the mountain in were doing it better, apparently. Then they climbed back into the saddle, leaving the mountain men a few tips on how to improve their crop. That's the story I got anyway. Obviously, they'd didn't go as far as to smoke a joint themselves, but I wouldn't be surprised if they each took something back with them. For further investigation, so to speak. They knew more about dope than all of those hillbillies taken together.

Remi was filling me in on the details of what had happened that day at the in the *cabanya*, when a head appeared out of nowhere. It was a girl. She had a horse blanket pulled over her shoulders and looked like she hadn't slept for days. She was looking for a fag or some shag.

"I don't have any," I lied.

She crept back noiselessly into the bunk in the corner where she pulled the hairy blanket over her head again. She'd been to some rave party or other in Madrid which was where Rocco had picked her up and brought her back, he said in a low voice. She was German.

So many people came from all over the place, freeloaders and "crusties." Now there was another expression. Where did that one come from? I think it was Zippy I heard say it for the first time. "Crusties?" It sounded pretty derogatory. One day some old hip

camped out in the undergrowth somewhere tossed a crust of bread to some poor scrounger hanging around and all the rest in the encampment bayed "crusty" at the poor sod, and a new word was born. That's the way I saw it.

Like "moon men." As far as I was concerned the moon men were everywhere. They weren't just holding out on the dark side of the planet, they were all over the place, up trees, in tents and on their way down highways in rusting trailers and campers as I sat there with Remi. I was beginning to get another perspective on things now another crusty was dozing in the bunk in the corner. The only good thing about them, crusties or moon men — and it was part of the dynamic — was they didn't usually stay too long, but moved on like those grazing herds of reindeer you see on the tele in Lapland, hoovering up every blade of grass, shrub, and twig in sight into their bellies, leaving the steppes more barren and devastated than Genghis Khan when he passed with the Golden Horde.

Another illuminating discussion ended, and none the wiser, I climbed the wooden stairway under the trees into Bennie the Bean's garden, crossed the lawn past Rocco's place and threw a leg over the fence to the space where the horses hang out.

Ned had just come down the hill with his Spanish mate, Django. They were unloading boxes of wine from the back of a van. It was one of those little Citroen jobs with the corrugated panels at the side that have great suspension and can get you up and down the worst tracks. Django said they went around the farms with it. They were pretty special wines he'd got from a friend of his who had a vineyard. But looking at the boxes I reckoned it was just plonk they'd bought cheap at Lidl's big supermarket. Now we were really talking moon men, Ned a bigger moon man than all the rest of the do-do's put together. Moon men you could have some sympathy for if you were in a receptive mood, they were just loopy. Mountain men drank booze and smoked dope but they didn't flog plonk as vintage wine. Ned

was a bloody Pharisee, a hypocritical penny-pinching little English hustler, descended from the fly. Django didn't qualify. Spaniards don't have moon men, and anyway Django was pretty normal.

I headed up the steep rocky track to the road. And what I was thinking was this. What if the mountain men weren't really mountain men but were the moon men that Ned was always dismissively alluding to and that no one had ever seen? And what if they didn't even know themselves that they were moon men because it's hard cheese enough trying to be a mountain man. The thing is — and I'd be the first to admit it — my confidence in the mountain men had been shaken to the core. Especially that bit about the Guardia advising them on how to grow weed. What was the world coming to? Where would it all end if the Guardia Civil was advising you on how to grow dope instead of beating you up? The more I thought about it, the more I became convinced that moon-menism must be a temporary condition, like venial sin, a condition into which you lapsed when your guard was down. Like those discarded plastic bottles that give a loud crack out of nowhere when they pop back into shape just when you're gazing into nothingness, and startle you, I reckoned the mountain men who'd turned into moon men would pop back into shape when I was gone. I saw no hope for Ned who'd started the whole business. I just couldn't shake the conviction that moon-menism was a permanent condition in his case. On the bright side, I was delighted to have located the first real moon man known to exist in Europe. I'm keeping his location secret. I don't want people going around looking for an ugly little git like Ned or getting a thing about flies. The Moon Man of the Pyrenees could end up like Bigfoot. And look what happened to him — learned men who should know better, trying to track him down all over the Canadian Rockies to God-knows what purpose. Even a miserable specimen like Ned deserves a fate better than that. Evidently, having escaped from Chicken Town, he has no plans to go back to where:

The Thing with Moon Men

The fucking pies are fucking old
The fucking chips are fucking cold
The fucking beer is fucking flat
The fucking flats have fucking rats
The fucking clocks are fucking wrong
The fucking days are fucking long
It fucking gets you fucking down
Evidently Chicken Town.

19

Naked Lunch at the St Regis

ULTRA VIOLET MET SALVADOR DALÍ FOR THE FIRST TIME around 1952. He was the first person she met in New York when she stepped off the boat from France, she liked to say. Dalí took to the strikingly beautiful Isabelle Collin Dufresne who had studied art in Grenoble, France, and made her his studio assistant. She been dispatched by her wealthy family to go and live with her sister in New York, after her father failed to set her on the path of righteousness, calling in a priest at one point to exorcise her demons. She became Dalí's *'lover'* — which in Dalí-speak means she let him lick her toes. Lunching with Dalí in the St Regis one afternoon in 1964, she was introduced to Andy Warhol. Warhol who was making films at the time in the Factory told her she would have to change her name if she wanted to be a film actress. To find a suitable name she says she "took the gold scissors I use to cut the split ends of my hair, and cut out the word ultraviolet from Time magazine." As Ultra Violet she acted in *Midnight Cowboy* (1969) with Dustin Hoffman and John Voight. She subsequently acted in some seventeen films, counted among her lovers Rudolf Nureyev the ballet dancer and Milos Foreman the film director. She became part of the Dalí household in Port Lligat as studio assistant when the Dalí's spent the summers there. After a nervous breakdown, having had her fill of walking on the wild side with Warhol's Factory girls and boys, she went religious, joined the Mormons and went back to working as an artist. Her memoir *Famous for Fifteen Minutes* (1988) was translated

into seventeen languages. She appears to have met writer and former art-dealer, Stan Lauryssens for the first time around 1976 in Nice. And again, in the Bar Boia in Cadaqués a few years before Dalí died in 1987, where she gave him an account of the lunch parties that Dalí held in his suite at the St Regis hotel in New York (every Sunday evening according to Andy Warhol). It is difficult to date the Dalí tea parties which Ultra Violet describes. But if we take the reference to Vietnam veterans, and Minnie-Mouse Gala romping away with gusto in her seventies unhindered by multiple facelifts, and ignore the reference to Crick and Watson (awarded the Nobel prize for the molecular structure of DNA in 1962), it could be anywhere from around the early Sixties to the mid-Seventies. The account is plausible enough — Captain Moore said he used to buy hundreds of lobsters for the parties and that Dalí spent a fortune on them. By the Seventies the two old swingers were past their prime for indulging in acrobatics. Dalí had a large bald spot on the back of his skull by that time and his exhausted locks looked like bits of old string died black. And Minnie Mouse was no chicken by then. Ravaged by facelifts, the skin of her face gleamed like a lamp in the dark. There is something slightly sad about the two old vampires trying to rock and roll like a couple of teenagers. At the same time, seen so gung-ho in action, the two old ravers are hilarious, thanks also to Stan Lauryssens' account of their shenanigans in *Dalí & I, the Surreal Story*

> Ultra Violet started recounting the most amazing story I've ever heard. It gulped out of that frail, angelic body and I didn't interrupt her even once, fearful as I was of stemming the flow of her narrative. The story began shortly after Dalí's daily siesta in the St Regis Hotel in New York. He was staying in his splendid suite, the kind reserved for heads of state, oversized, plush, with high windows and draped mirrors. He was in great shape, flitting around, attending to several things at once. His skin was tanned and his vivid hazel eyes glowing with pleasure. The tips of his

mustache, luxuriously waxed and always erect, were glistening in the light of a hundred candles in the crystal chandelier Dalí had inserted stones from Port Lligat and freshly laid eggs sent to him daily from Cadaqués. He felt adventurous and gave his entourage his usual laundry list of bizarre requests: a tramp who spoke perfect Russian, the most beautiful androgynous and angelic starlets and catwalk fashion models in New York, girls with ballerina legs, a lady with a preference for standing on her head, a couple of tall professional homosexuals, bald hermaphrodites, an albino with a hunchback, and someone so fat you couldn't see his eyes. Dalí was wearing a black cowboy shirt. His bare feet were clad in Catalan espadrilles with black ribbons tied around his ankles. He walked to the windows, opened the curtains and let the sun flood in. "We are going to have a parrrty," Dalí said, "Invite two Nobel Prrrize winnerrrs, prrreferrrably Crickkke and Watson. They know the secrrret of DNA...The two Nobel Prize winners came in, curious to meet the most famous living artist in the world and Dalí ordered a puree of string beans.Eat thizzz! he commanded strrring beanzzz nourrrish yourrr deeeoxyrrrybonucleic acid! Eat! Eat fast! You arrre too thin! I need giants! I need fat mennn! Dwarrrfs and monsterrrs. Crick and Watson were understandably puzzled. Suddenly they remembered they had a plane to catch and made a hasty escape...From New York backstreets, Dalí's entourage had picked up the ugliest men around: midgets, deformed dwarfs, crippled Vietnam veterans, hopeless drunks, freaks and carnival performers, bums, bag ladies, subway beggars, twins, transvestites, bald basketball players, and hippies with long hair. Circumcised men were out: Dalí didn't approve of circumcision. Greek sculpture isn't circumcised either, he used to say. Gallantly he led them into his suite and issued instructions, like a warlord. The starlets and catwalk superstars had to crawl on all fours, balancing a spirit level on their backs, with lighted sparklers sticking out of their asses. While a catwalk model was undressing — she later married a famous movie actor — Dalí bit her toenails and licked her toes. The most beautiful

New York boy-toy s lowered their trousers and sat with their bare bottoms on blocks of wet clay, while Dalí signed and framed the imprints of those gorgeous asses. In the middle of the room, a white stallion drank champagne from a silver bucket. For snacks, trays of animal eyeballs — cow, sheep, goat — were carried around on a platter.

Dalí had invented a name for his afternoon tea parties. He called them his sex circus or his ballet of passion. Apart from the cowboy shirt and Catalan espadrilles, he dressed as Santa Claus with a clown's red nose, waving about a tiny flag — the Stars and Stripes. Snorting cocaine, the dwarfs, drunks and Vietnam veterans were copulating with the catwalk superstars. Whenever someone had an orgasm, Dalí was delighted and shouted: Brrravooo...c'est magnifique... in French, stretching out each vowel while the girls screamed: I'm doing this for the Divine One! Only for the Divine Dalí! though he himself wasn't fucking anybody. His eyes closed, he was farting and masturbating frantically. The sex circus was a colorful chaos. Gala listened in devotion while the Russian tramp recited Tolstoy in Russian. Then she jabbed him with her shoe, and they had sex. Imagine, she was in her seventies! On any normal day, Gala screwed multiple men, and her lovers were reportedly the most expensive lays in the history of sex, since she paid her studs with small but genuine-genuine Dalí paintings. Ultra recounted that Gala had inserted a black Minnie Mouse velvet bow tie in her wig. She looked horrible. After years of plastic surgery, she had become a surrealist painting herself, Gala needs morrre money! she shouted and jab-jab-jab with her shoe, and sex again. A harlequin with a powdered face pedaled a unicycle around the room. He overturned a tray of cows' eyes, and the eyeballs spilled onto the floor and rolled away in every direction. Lobster telephones seemed to be ringing throughout the suite. A snake woman lit a cigarette. She bent her body in incredible ways and moved the cigarette to her vagina. Steadying her muscles she smoked the cigarette with her vagina, cigarette smoke swirling from her anus. Brrravooo! Dalí shouted. Brrravisimo! Some of the

people who performed humiliating sex for Dalí in those days have become really famous since. He even asked Marilyn Monroe to join his sex circus, but she declined.

That day Ultra Violet told me what a strange and unpredictable man Dalí could be. He called his penis, his limousine. In reality, it wasn't a limousine at all. Apparently, it was as small as a Fiat 500! His fly he called his garage. The tall and balding Dado Ruspoli came out of the bathroom. He was an Italian nobleman with a big Roman nose and the largest cock in erection in the whole of Europe. Twenty-seven centimetres, imagine! Dalí's sex circus was planned down to the last detail. He told Ultra: You arre my notarry! Wrrrite everrrything down. Everrry orrrgasm, everrry fuck must be rrrecorded for posterrrity!In a ledger she wrote down Dado's name and cashed a registration fee. Then the Italian nobleman fucked the catwalk model in her ass. Dalí insisted personally if penetration was total, of course, and as he stuck his nose in between Dado's enormous cock and the girl's ass, Salvador Dalí unzipped his garage and took out his Fiat 500 and began jacking off, garbling and gasping for breath. His eyes rolled and rolled. After two minutes Dalí screamed, his body shuddered, and a frothy speck of sperm slipped from what he called his limousine, like milk boiling over. That was the end of the show. The air was thick with cigarette smoke. Before leaving the hotel, every participant received a framed certificate hand-signed by Dalí himself.

20

Looking for a well-filled Sandwich

HILARITY ALL ROUND IN BAR MIRANDA. I AM WITH MIKE HEEP, an English wag I have known for years. He lives in Barcelona and has come — one presumes —'to visit' his paramour, Pili's sister Alina who has emporarily escaped from his clutches. He is a heavy deal at times, but with the Heep it's never a dull moment. We take a seat and he bawls his instructions for a sandwich to the grandfather — *l'avi*—who is positioned at the cash-register at the end of the bar. The grandfather shouts to the grandmother — *l'àvia* — also behind the bar. *L'àvia* shouts to the two anorexic cases slumped over the bar top after a hard night out by the looks of it. Rumor has it they are Czech, Russian or Ukrainian. No one knows for sure. Where the family dug them up is another mystery because nobody but family was ever known to work in Bar Miranda before. And that's going back a few generations.

Reacting to grandma's instruction, one of the girls, (we'll call her the Ukrainian girl, because there's a Ukrainian girl serving in the Gola up in the port and she is blonde, like this one, though with much more fat on the bone). The Ukrainian waitress, attuned, unlike her partner, to the delicate tones of the Catalan language, shakes herself down and toddles off to the kitchen. She duly appears and presents the sandwich to the Heep who, with imperial aplomb, proclaims it to be well-filled with chorizo and licks his lips. I decide to strike while the iron is hot, get the attention of the provider of well-filled sandwiches, and order a tuna sandwich. But what happens?

What does she do? Instead of going into the kitchen to get the sandwich, the Ukrainian shouts the order to the old *àvia* in the big owl specs who then trudges through to the gleaming new stainless-steel kitchen. The effort of giving an order has clearly been too much for the Ukrainian because she is now slumped again over the bar top.

Bar Miranda used to be called Bar Felip but they knocked down old Bar Felip a couple of years back, converted it from a lovely old dump where you had to climb though the blue smoke and the old guys playing dominoes in the side room to get to the toilet. It was the kind of place where they sloshed the wine into your glass at the bar, forgot what you had ordered and charged you the first thing that came into their head when you left. Then the *Ayuntamiento* (town hall) spoiled everything when it decided the old bar was not good enough. It was an eyesore, an embarrassment to the village. Tourists might get the idea Spaniards were a bunch of backward peasants. The same bright sparks decided that the wall of stones to which the bar was attached was a medieval tower, a national treasure and that everyone, including the tourists, had a right to enjoy one of Spain's forgotten heirlooms and bask in its glory. They operated on the bar and separated it from the tower. And now that the building surgeons have done their work, the bar is a three-story, slick-modern, white complex straight out of an architectural magazine, the sort of design you see everywhere you go I Spain. The bar counter is roughly in the same spot as in dear old Bar Felip, only much longer, but it is not the same. Before you couldn't get more than two people behind the bar, now you could get a dozen. They have real chairs outside on the street now. They are made of bright aluminum with polished dark wooden slats. True, you see them all over the place but at least they are not those trashy red-plastic ones with Coca-Cola splashed all over them, same as those awful red Coca-Cola parasols that Bar Felip had. Now the terrace has those tasty green canvas parasols that you see everywhere.

But I have not come to admire the architecture. I'm looking for *La Vanguardia*. It's usually left on the bar. I enquire of the staff but they don't know what's happened to it. I simply wish to read John William Wilkinson's column. The Barcelona daily is in Spanish but Wilkinson, an Australian, writes a delightful column in English. Something to do with promoting the awareness of the English language to Spaniards.

The order goes out to Enric, the son, to track it down. But we will get to that thorny question later. First the sandwich. Yes, the sandwich. So, when the Ukrainian waitress brings the sandwich, obviously passed to her by the grandmother, it's disappointingly thin. I open it and show it to nosey parker, Heep.

"Oh no, I got more than that", the Heep sniffs with imperial disdain, rubs his nose with his index finger, sniffs, pulls open the neck of his T-shirt like an elastic band, takes a sniff of God knows what odor is trapped down there on his hairy chest, surfaces, releases the neck of his wilting, rusty-colored T-shirt, which he believes to be the height of elegance, throws up his head, sniffs again, twitches, grabs his forehead, strokes his grey whiskers and goes back to reading *El Periódico*.

But wait a cotton-picking minute. What's all this? Before I can inspect the *bocadillo* contents further, Enric's young blockhead son comes in and hands *La Vanguardia* to toothless old Jose Mentira at the next table. And not to me. Wait a minute! "Hey, what's this?" I protest. "I asked Enric for that paper."

Old Jose Mentira at the adjoining table has been glued to the sports pages of *El Mundo Sportivo* since we came in and sat at the table next to him. Mundo Sportivo has plenty of pics in it, maybe that's what is holding his attention so long. Not the text. Fortunately, emperor Heep intercedes at this point and offers to give Jose Mentira

the *El Periódico* in exchange for *El Mundo Sportivo*. That's a pretty enticing deal for Jose Mentira because *El Periódico* has lots of pics too. And that's how I finally get my hands on *La Vanguardia*.

So, I say to the Heep, turning the pages to find John William Wilkinson's column, the tuna sandwich in one hand: "It is clear that if one desires a good sandwich one should ask the grandmother directly. She will then pass on the order to someone else. But since she makes the worst sandwiches, it is a question of understanding the pecking order behind the bar. Or trying to. Is it not?"

The Heep loves this kind of convoluted dialogue, it appeals to his linguistic antenna. Heep is an ex Oxford man. Studied French, got turfed out without a degree. Heep being Heep, he ended up as a conductor on the buses in London, as he never tires of telling you, the Oxford bit that is, (not the buses, which he loved) so one is amused to indulge him with this form of alien English address.

Enric has disappeared again outside to light up. Or serve a customer. The two Ukrainian, Russian or Czech girls are again slumped on the gleaming marble top of the bar and may well have fallen asleep. The rest of the bar staff, do what they always do when there are no customers to serve, they stare glumly through the open door on to the street or through the big windows into the midday heat at the rough-hewn stones of the medieval tower, wondering where all the tourists have gone.

"Tits. Look at those, rrraaaghhh," the Heep enthuses, creating a huge round ball in the air with his hands when a pretty girl comes into the bar. I refuse to look up when he insists. "Must be the daughter," old nosey parker concludes. He misses nothing, knows everything about everyone, is a walking Spanish Who's Who, knows everyone in Catalunya if not all Spain. But back to *La Vanguardia*. I take out the pink section to give to the Heep while I read Wilkinson's column.

"Oh no you can't do that," Heep booms "You don't separate them. You mustn't do that."

A few minutes later, the old grandfather reprimands me for separating the paper. He must be about eighty, because that is how old his haggard face and wispy white hair says he is. Heep was right. This Vanguardia thing has gotten them all riled up. There follows some discussion between the Heep and myself about Spanish bar management methods.

"Put up the prices when you've no customers," I say.

"And then one of the cousins says, listen, I've got an even better idea. We'll take on more staff as well. Brilliant!"

French arrivals have dropped off by over twenty per cent, the paper says. The French mostly drive down and petrol is well over $130 a barrel in June. So why then has Bar Miranda taken on extra staff? And why have they taken on the Czech, Russian or Ukrainian girls and where did they dig them up? And why are they so grumpy and tetchy? And why has son Enric pressed his fourteen-year-old son into service when they have so few customers? And what is Enric saying to his fourteen-year-old son now looking up unblinkingly at his father from the aluminum chair on the deserted terrace as we leave the bar? The need to keep an eye on La Vanguardia and never leave it in the kitchen in case a crazy foreigner wants to read it? Make sure the *bocadillos* are well filled? Where to stash your black money? When the French will be back?

The Heep has answers to all of these questions. "He hates the fucking French," he says in regard to Enric and adds, adopting a Cockney accent in reference to the son "God bless 'im 'eez obviously not interested in serving the tables."

So, we leave the two of them in deep discussion on the deserted terrace in the deserted square and head up the narrow street past the church and the *Bar d'Esports* to Inez's herbal shop where we give Inez an update on matters Bar Miranda.

"Degenerados" she fumes. "The whole country! An outrage! That bunch of degenerates owns the whole three-story block and they've got other property as well so what are they worried about?" She's pretty fired up. I am going to have to take a trip up to the Pyrenees again soon to see the Moon Men and get some mountain weed to soothe her nerves. Pili's too, for that matter.

21

Rainy Day Cadillac

WHEN SALVADOR DALÍ WAS BORN IN 1904, CARS WERE A BIT of a novelty. His father, for example, never had a car in his life and it was not until 1941 that Salvador himself acquired his first car in America, which naturally was a Cadillac, a marque that he was faithful to all his life, even though he never drove. Claiming to hate the industrialization and mechanization of society that would see its greatest expression in the horrors of the First World War in Europe, his love of the Cadillac can only be understood now in its blatant vulgarity as a symbol of wealth and power. Salvador, despite the contradictions, was mesmerized by the panache of the Cadillac, in thrall to the associations of wealth, power and success that could be pegged to its owners.

Lowered by a giant crane and filmed by TV cameras the rainy-day Cadillac was placed in the middle of the courtyard of the Dalí Theatre Museum in Figueres on Wednesday 23 October 1974. Donated by Cadillac it was the first Cadillac to be donated by General Motors (GM) to Gala and Dalí. Under Dalí's directions, a plumber fitted a trough on the roof of the car that had been perforated to supply a continuous shower of rain. A dummy chauffeur was put at the wheel and two hundred Burgundy snails were released into the humid interior. It remained only for Dalí to carpet the interior with lichen and moss and to wait for these to take root on the plastic and the metal. Visitors could insert a coin in the slot of a meter to make the rain come on.

Dalí liked to boast it was one of a very small series. Only five were made, he would say — one for President Roosevelt, one for Clark Gable, and one for Al Capone. Who the recipient of the fifth special Caddy was, he never divulged. He was never a stickler for accuracy and could not count. Not the way you learn in school in any case.

The first Cadillac was exhibited, with great success, at the surrealist exhibition in Paris, the second at the World Exhibition in New York, and the third at the surrealist retrospective at the Museum of Modern Art in New York. The fourth, on permanent exhibition at the Dalí's Museum, is the one that Gala used to drive and in which the couple drove coast to coast during their stay in America.

Having launched a Cadillac de Luxe with great commercial success, GM decided to introduce a more sophisticated and more expensive model. Asked for his suggestions, Dalí immediately proposed calling it the Cadillac de Gala, and sent off a sketch he rushed off in five minutes with a ballpoint pen on the notepaper of the St. Regis Hotel in New York. Based on a then current Cadillac, he draped the car in a metallic violet-colored shell, hiding the body panels and the roof but leaving the windows visible.

Nothing more was heard from GM after Dalí sent them the sketch, but a year or two later a new model was launched on the market which Dalí claimed was his Gala Cadillac. Dalí called his lawyers who sent GM an ultimatum. Pay him ten thousand dollars for the name or he would sue. The next morning a registered letter arrived from GM, containing a cheque for ten thousand dollars, but without any explanation. Pressed further, GM said it could have used a variety of names for the car, a horse's name for example, so Dalí asked his lawyer to write back to the company and find out if a horse had written to them.

As an artist it was the appearance of a car that attracted or repelled him. Despite his passion for science and technology, he was not interested in the technicalities. Cars were never one of his major obsessions, but they did feature in some of his paintings: *Remains of an Automobile Giving Birth to a Blind Horse Chewing a Telephone* (1939) and *Automobile Giving Birth*, depicting a horse surging triumphantly from a car over the remains of industrialization.

His first Cadillac was a 1941 Cadillac Sedan. It was bought on 11 July 1941 and had California plates. The precise date is known because it appears on an FBI report. Tipped off in Cadaqués that Dalí, (reportedly "an ardent fascist" by someone who knew him), had been stopped in America on suspicion of being a Nazi spy, author Stan Lauryssens requested the file from the FBI in Washington under the Freedom of Information Act. One of the first entries was submitted by an unnamed FBI agent in the summer of 1942 in connection with *Operation Pastorius* — the codename given by the FBI to a supposed plot by Nazi agents to blow up an aircraft industry factory in Philadelphia (named after Franz Pastorius, the first German emigrant to America in 1683). The FBI report states that Salvador Dalí and his wife Gala were interrogated on suspicion of being German saboteurs, possibly involved with one or other of the two teams of saboteurs, one headed for Amagansett on the New England coast, the other to a location south of Jacksonville, Florida. The operation saw Dalí's Cadillac being searched outside the Humboldt Hotel in Winnemucca, Nevada, while the couple were asleep in their beds. Nothing incriminating was found. The presence of paint brushes, oil paints and completed canvas paintings, one of them addressed to Senor Salvador Dalí, Marquis de Cueves (a Spanish friend of his) were enough to convince the FBI agent that the couple were on legitimate business but in no way connected with the German saboteurs. Dalí is described as being thirty-eight years old,

five feet eight inches in height and weighing one hundred and thirty-five pounds, but "cannot speak English." The file released to Lauryssens contained only six pages. Fifty-three pages were blanked out, suggesting that Dalí's adventures in the U.S. were well documented over the years by the FBI.

There was enough to report on: his sex parties in the St Regis Hotel, his meetings with Andy Warhol, with the Duke of Windsor and his wife Wallace Simpson — the Duke is now known to have made a pact with the Nazis: If Germany won the war they were to depose his brother George, King George V, who had been forced to accept the crown when Edward abdicated the throne to marry Simpson, an American socialite.

At the time he painted *Automobile Giving Birth*, Dalí was revolted by industrialization and in his works preferred to replace inanimate objects with living organisms. His fascination with the motor car was reflected in his writing too. After acquiring his first Cadillac he wrote a novel in French under the title *Visages Cachés* (Hidden Faces) in 1944-45, which included the following interchange between a mother and daughter (two fashion freaks presumably).

> "Tell me, mother, did you go and look at the streamlined car you promised me?"
>
> "Yes, but I didn't like it at all," replied Barbara uncompromisingly.
> "Why not, mother?"
>
> "Because it's like you… It's too naked, and really embarrassing to look at. Too many curves, too many bumps, too many bottoms, too much everything! I told the salesman I would take it only if it could be delivered dressed. He seemed flabbergasted, so I explained to him I found it too naked! It must be covered with a tarpaulin cut along the lines of a tartan suit!"
>
> Barbara approached her daughter, seeming not to notice her nudity any more, and continued in exalted fashion: "Wouldn't it

be amusing — a dress shop for cars! Very elaborate evening dresses, with low-cut bosoms to show off the radiators emerging from a froth of organdy, and long satin trains for gala evenings. That would automatically reflect our fashion collections: winter, spring, summer and autumn. Convertibles in ermine with the door-handles covered in sealskin, and bison sleeves around the radiators. Can't you just see our Cadillac driving across a frozen landscape near Leningrad?"

J. Edgar Hoover hopefully never had to read the excruciating dialogue of Hidden Faces. To keep him focused when dealing with Salvador and keep his hand off deputy Clyde Tolson's knee, his secretary of fifty-four years, Helen Gandy, would pop in occasionally and drop the Dalí file on his desk. Whenever the Port Lligat provocateur was up to his old tricks, a new memo was added.

Hoover had good reason to keep an eye on the mustached Catalan. That greaseball Spic regularly disturbed his equanimity and invaded his territory. Not just when it came to orgies: Hoover had ducked down that dark alley before Dalí. But front-page stories that challenged the nation's moral assumptions, were serious questions for holier-than-thou Hoover. Like that Charles Lindbergh kidnapping affair or that libel business of child star Shirley Temple and that *wadyamacallim* famous English author's accusations of pedophilia. But Lindbergh first...

The aviator made history in May 1923 when he flew non-stop across the Atlantic from New York to Paris in his custom designed, single-engine monoplane called the *Spirit of St Louis.* Nine years later, his young son of ten months was whisked from his cot at home and found dead nearby six weeks later. A German immigrant, Bruno Richard Hauptmann was arrested, convicted of the crime — some claim wrongfully — and sent to the electric chair. Hoover, who loved to see his name and hopefully his face on the front page, took credit for solving the case; as he took credit in the Twenties with making

America safe from what were termed *public enemies*: small time crooks like Bonnie and Clyde, Machine Gun Kelly and John Dillinger who made lots of noise and were good for the headlines and great for the movies. Not like the mob. They operated under the radar. Hoover left them alone. Top mafia boss Meyer Lansky was reputedly blackmailing him with photos of him and his deputy engaged in homosexual activity.

Enter Salvador Dalí. Having stepped onto American soil for the first time in mid-November 1934, Dalí was immediately the talk of the town. He had stage-managed his entree while crossing from Le Havre, France on the steamship Champlain, the tickets paid by Pablo Picasso. New York could not get enough of him. Society hostess, heiress, raver and inventor of the brassiere, Caresse Crosby invited him and his wife Gala to an oneiric (dream) ball with the grand title of *Bal Onirique* at the midtown Cog d'Or restaurant before his return to Europe early in 1935. As a tribute to the artist, guests were invited to invent their own costumes based on a recent dream they'd had, Whether Caresse took her dog Clytoris with her is not recorded, but the terrible twins turned up dressed as the Lindbergh baby. Photos in *New York's Sunday Mirror* of 24 February 1935, show Dalí with his head swathed in a white gauze like a baby and on his chest a glass case with what looks like two funnels for pouring liquid, the stems of which could be interpreted as nipples in reference to a dummy tit or a wink in deference to Crosby's brassieres. Gala had the effigy of a baby doll on her head with two big white arms outstretched. The pictures caused an outrage and were associated with the kidnapped Lindbergh kid. Bruno Richard Hauptman was front-page news at the time, having been arrested in September 1934, just before Dalí's arrival. Against his nature, Dalí was forced to apologize. American sensitivities had not degenerated enough to encompass Salvador's 'artistic statements' with equanimity.

Then there was the Shirley Temple affair. Miss Gandy must have dropped the Dalí file on Hoover's desk a few times over that one too. Hoover was a great fan of the child star with the cute little face and the curly ringlets who could sing, tap dance like Bo Jangles, upstage her adult co-performers with her sheer brass-tack ingenuity and wholesomeness, purity and innocence. In the Depression era, she was a tonic, raised people's spirits, gave them something to live for. Mothers loved her, fathers loved her — Halleluja! — even clergymen loved her. The problem was pedophiles loved her too. As Graham Greene, one of the great English writers of the age, noted. Reviewing her starring role in *Wee Willie Winkie*, released in 1937, Greene pointed out that audiences were being hoodwinked. Temple, then nine years old, was being marketed as an innocent kid but had a "more secret and more adult appeal." The subliminal meaning was clear. Hollywood was guilty of the sexualization of children. "Her admirers," he wrote in his *Night and Day* magazine — "middle-aged men and clergymen — respond to her dubious coquetry, to the sight of her well-shaped and desirable little body only because the safety curtain of story and dialogue drops between their intelligence and their desire."

A few panting pedophiles might have gotten the message on a moment's reflection but the rest of the nation was not up to the challenge of looking at themselves in the mirror, or admitting that they were patsies with the consciousness of a snail who had been hoodwinked by Hollywood. And so, they continued to gush and coo at the young star's antics with the same drooling dedication that they projected on that other — doggy — hero of the age, Rin Tin Tin. The great unwashed were putty in the hands of the Hollywood moguls. They had their number, could read their unformed souls better than they could themselves.

John Edgar Hoover himself was into wholesomeness. And if he liked men, or in any case his deputy that he dined with every day for

forty years, he was no pedophile. And to show his support for Shirley (after 20th Century Fox successfully sued Greene for libel in the child star's name and closed down the magazine), he gave her a guided tour of FBI headquarters in Washington in June 1938, dangled her on his knees for the cameras and waited for Miss Gandy to appear again with the Dalí file.

As a deep-sea diver when it came to the subconscious, Dalí knew a man-eater when he saw one and constructed a collage, which he presented at an exhibition of his latest work at the Julien Levy Gallery in New York on 21 March 1939. Entitled *Shirley Temple, the Youngest Most Sacred Monster of the Cinema in Her Time*, it portrayed Shirley as a sphinx stretched out in the sand and looking at the viewer from a black-and-white photo cut out from a newspaper and stuck on the body of a deep-red colored lioness with childish breasts and sharp white claws. A blue vampire bat sits on her head with its wings outspread. Bleached bones, the remains of her victims, are strewn around the beast. A human skull lies between its forepaws and in the distance, another. Far back, in case you don't get the message, is the beached wreck of a boat showing only its spars, in allusion to a rib cage.

Hoover could have killed himself for not spotting it sooner. In the Dalí file. That picture of Shirley Temple. He'd looked at it time and again and didn't quite get it. Maybe that Dalí guy was on to something, maybe Shirley needed protection from a real man, a big daddy to look after her. Not like that Spanish pimp. And he duly presented her with a fountain pen that — like those James Bond gadgets — she only had to press to squirt a cloud of gas into the eyes of any Hollywood producer getting 'funny' ideas. It was a bit late in the day. Shirley was twenty-one by then and her star days over. But, what with chasing Commies, gays and lesbians all over town, he just hadn't had the time, dammit. Those orgies of Dalí's at the St Regis had sidetracked him too and they'd looked into getting him on a

corruption of minor's rap but when their inside man told them there was a horse involved: a big white stallion that drank champagne out of a silver bucket, they got stalled on that angle. First, they couldn't get the name of the horse so they couldn't indict it. Then Clyde said he'd have to tread easy, could get the nation's animal-lovers upset, if not the bookies, and by extension, the mob. He just couldn't put a stamp on him, couldn't finger the Spanish buffoon as a Nazi, couldn't finger him as a Commie either. Now the guy was claiming to be a Catholic and if Hoover tried to touch him, before you know it, he'd have the Irish in Boston and New York down on him, and knowing those dirty drunken Micks, they'd set the Pope onto him too.

Clyde was the one who told him over dinner that he'd taken a big chance going to that event in the Plaza hotel in forty-six. In drag. "What were you thinking of, Johnny?" he said. "It's bad enough them sniggering at us behind our backs in the bureau, those bastards calling us Johnny and Clyde and you go give them more ammunition putting on that fluffy black dress with flounces, those lace stockings and high heels, that black curly wig and those false eyelashes, make up plastered all over your face. Goddam it man, what were you thinking? You could have ruined yourself. Ruined us."

"Nobody saw me," Edgar muttered weakly, poking at his T-bone with the fork, as tears of self-pity welled in his eyes.

"And that pervert Roy Cohn, because look what happened to him: AIDS! Jesus Christ man, what were you thinking, getting mixed up with that scum? Him and McCarthy!"

"Jesus Christ! That old cocksucker," Richard Nixon said, when given the news in 1972 that the head of the G-men had been felled by a heart attack at the age of seventy-seven. Only nine years older than Salvador, Hoover had pulled in some big fish in his time like Pretty Boy Floyd, Baby Face Nelson; kept Charlie Chaplin out of the

US for twenty years on a supposed 'Commie' connection — "I would not go back even if Jesus Christ were the president," said London-born Chaplin — but he never did manage to put the cuffs on that slippery Spanish hustler. If only he'd been able to get the name of that horse!

When the great call comes from that mansion in the sky, it is said that God entitles you to a quick re-run of your earthly existence before you go. In that last second before he made his departure, Edgar was clutching a champagne bucket. He was in the elevator of the St Regis hotel with a big white horse. Towering over him, it studied Edgar J intensely with its big watery blue eyes as the elevator shot higher and higher. It was about to tell him something. Its name, maybe. But when it spoke, it was with the thunderous, husky tones of his dear Clyde. "And do you know, Johnny, what *Tricky Dickie* said when he heard you'd had the heart attack? He said, Jesus Christ, that old cocksucker," the horse said.

A big crystal-tear rolled from its pink eyelid and slid slowly down its nose. Far below on the sidewalk of Broadway, J. Edgar could see smarty-ass Nixon who needed a shave as usual. He was surrounded by a huge crowd and was pointing a finger in the air and shouting "There he goes at last, the bastard, that old cocksucker. If I'd had the guts, I would have fired him but he had too much on me."

Meyer Lansky, the mob's accountant, raised his hat. With two fingers he blew a kiss of thanks from his lips as he waved a porno pic of Johnnie doing "it" with Clyde, in *colto flagrante*. The crowd cheered and threw their hats in the air. Some of the faces in the crowd, pale and illuminated by a penetrating blue light, stood out from the rest. They were looking up at him. Expectantly. They were also grinning. Edgar focused his gaze on their burning blue eyes and his heart sank. They were the faces of those he had had murdered or had fingered for the state: Baby Face Nelson, Machine Gun Kelly, Ma Barker, all the poor white trash that made great headlines for trying to buck a rigged

system. "Pour encourager les autres," as Voltaire said when the British shot admiral Byng on a captured French warship in 1757. For losing Minorca to the French.

The big crystal tear was now hanging from the horse's nostril. It swole bigger and bigger, slid slowly from its nostril through all the space that had existed in the universe from the beginning of time, and plopped into the empty bucket, and BANG! burst into a billion blinding shards as the elevator crashed through the roof and WHOOSH! J. Edgar Hoover shot off into interstellar space heading for the black hole reserved for him by the Devil. High on a cloud above New York, God and the Devil watched him go. God handed the Devil back his map of *Hell Holes of Eternity,* and ticked the box next to J. Edgar's name in the *Great Ledger of Good and Evil.* The Devil countersigned and handed the ledger back. God had done all he could in J. Edgar's case. Even sent down some angels in disguise. But the old faggot was a hard nut to crack. He'd either importuned them or had them denounced and locked up as homosexuals or commies. Getting the Great Ledger to balance was one helluva job with these people.

22

Cursing in Catalan for Beginners

TWO GREEN-PAINTED SENTINEL BOXES STAND ON THE GRASS IN front of Rocco's farmhouse. I was about to say lawn, but it is more a rough field covered with grass, an unruly meadow where sheep used to graze in days gone by. You cannot miss the boxes. They're the first thing you see once you've come down the hill, see what looks like the roof of a low farmhouse and try to figure out how to get in. There's no point in trying to open the gate; it would take about half an hour for you to get the rope or string or wire or whatever junk is holding it up — it changes all the time — and there's always the danger that if you do, the gate will fall off and collapse on the grass. Or on your feet. The sentinel boxes are toilets. They are about the size and shape of those old telephone boxes they used to have all over the place in Britain, but have largely disappeared. Normally I use the one on the right, as the one on the left is so disgusting, though the one on the right, come to think of it, is not much better of late: it used to have a little pail where you put the paper after wiping your arse but that's gone. So now it's matter of dropping your load down the hole like a bomber pilot over Berlin during the war, wiping your arse, then looking for somewhere to hide the paper. And since they're a bunch of purists, these hillbillies, paper is frowned on. God help you if you leave any lying round in the wrong places.

The patio looks like a junk yard. There's about a dozen cats of all sizes lounging in the sun as if they've had the luck to get something

to eat. Or heading for the kitchen door of Rocco's place to squeeze themselves in, climb on the table, the oven, the sink, all over the ship where they might snatch something the hillbillies have dropped on the floor, left lying on the table, couldn't be bothered to clean up or just plain left on a plate for the flies, while they rolled another joint and poured some more wine into a chipped glass or a cup without a handle. Outside on the patio there's a hen with its beak clipped that thinks it's a cat. It competes with the cats and the kittens for the nuggets of dried food that Zippy strews on the paving stones. The hen sneaks up behind, gets close to the cats, or more often the kittens, and stares them straight in the eye. Since it towers over them like a skyscraper, they get the message immediately and drop any food the poor creatures have managed to scavenge. The threat of that beak poking out their eye is enough. Even cats know that. What a nasty bastard! I give it one up the tail and it's off like a shot. But it's prescient, has a sixth sense, recognizes another bastard instinctively when it sees one, because it's a fraction of a second too fast for my boot which clips, but only just, its feathered tail.

It's getting dark. I've been reading Jack Kerouac's *Big Sur* where he's got himself dumped on the highway in the middle of the night out there in California, so he can write about the sounds of the sea. I'm sitting in a camper parked up on the road above the farm with the curtains drawn, holding the wind-up fluorescent lamp I bought for two euros in the Chinese shop in town. Zippy found it for me. She seems to know about these things. If not much else. "You just keep pressing this," she said, making a clicking sound. "And the switch is on here." And hey presto, it lights up. Since I hate throwaway batteries, it's an improvement, although the light is cold and bluish.

I've just turned the camper round so I'm facing the hill and the sky above it. For the past nearly two weeks the windscreen has been pointed at the trees which let through some sky, but I got sick of looking at the trees and the track leading down to the farm, so I

thought I'd have a change tonight, reversed the camper in the parking space off the road and turned it round so I'll get the clear sky in the morning when I wake up. That was after I ate. Then I walk down the track to the farm and find Zippy poking at her face, peering into a small mirror perched on the window shelf at the door of Rocco's place, so I make a noise to let her know I'm at the door, thinking she might be embarrassed at getting caught making herself up. The music is pounding before I get to the gate and I think "Oh, Oh, she's managed to connect up Rocco's system of non-stop, boompa-boom rave, techno music. Close up it's deafening."

"The gas fridge is still fucked." That's what I say to Bennie, after crossing the yard to his lair. He's lying on the bed with his nose in a comic — the *Furry Freak Brothers* or *Fat Freddie's Cat*, something like that—and Evelin, his daughter who is about twelve, is sitting in the wicker chair playing with a ball on a piece of string, dangling it mindlessly up and down wondering why it isn't behaving like a *Yo-Yo*. I cross the yard and go back into the kitchen of Rocco's place and open the fridge door and true enough, what a pong. That's just after I tell Zippy to throw away the stuff in the fridge. Poor kid, she's twenty and all she seems able to do is listen to music she's got plugged into her ears semi-permanently.

Yesterday Bennie was gone all day. He had to help load bales of hay up at Pepe's farm. Pepe's place is reached by a sidetrack halfway up the hill. You could easily miss it. It's just before the spot where Remi parks his jalopy. That's where the track is that leads to Pepe's farm. When Bennie comes into the kitchen, it's after four. He's got straw in his hair and in his beard and his little goblin, eyes are twinkling. "Em cague en déu," he says first thing. He says that a thousand times a day regardless of the occasion: "Em cague en déu."

He must speak and understand Catalan reasonably by now. Or so you would expect since he gets a nice big plate of *estofado* every day from Pepe's wife which he sloshes down with liberal lashings of

wine after he comes back from leading the cows up to pasture in the hills. And they only speak Catalan at Pepe's. I can see him saying that when Pepe's wife puts the plate under his nose: "Em cague en déu" — literally, "I shit on God." Accompanied by a grin and those twinkling eyes, shitting on God says everything about Bennie, his philosophy of life in a nut shell. He loves the sound of it. Perhaps he is a crypto linguist, stuck at lesson one. I've always wondered why Spaniards wanted to shit on God and how they did it. There's an even longer variation which is "Em cague en déu i en la puta mare que el va parir." Or I shit on God and his whore of a mother who gave birth to him. Yes, when it comes to blaspheming, the Spaniard's your man.

I must have a word with Bennie about it; increase his range, top up his vocabulary. You have to have a life ambition higher than saying every five minutes "Em cague en déu," otherwise life is not worth living. But I'm not hopeful. He's happy with the way things are, with what he's got, what he's acquired. I see it every time he says it, see that little smirk of self-satisfaction on his little woolly-whiskered coupon. It's a sort of mantra, I reckon — he wandered through India for a couple of years when he was young, begging, so maybe he picked up something. It's not the kind of thing you'd get from your ordinary, average guru, unless they've got Catalan gurus out there in India. But it's a mantra just the same. He's also saying you've got to know your limits. Which is why he is never going to say anything other than "Em cague en déu," a thousand times a day for the rest of his life, never say anything else but that in his miserable fuck'n *puta vida*!

He told me a story once. About how his father died. He was sick and dying and the family wouldn't give him a drink of the hard stuff — and if Bennie is anything to go by, his old man must have been knocking the hard stuff back by the bucket-load all his puff — but then the doctor said it didn't matter anyhow because he was a goner anyway, so they could give him a drink okay if they wanted. So, Bennie poured him a nice big shot of *jenever* and his old man tossed

it back in one, said, "Nou, dat was lekker," — well, that was nice—closed his eyes and popped his clogs, as they say. Those are the two things I remember best about Bennie. The death of his father and swearing in Catalan. There's more to Bennie than that of course, but those are the main things. I had some issues with him but Bennie the Bean was all right.

23

One Big Mac-Daly with Ketchup, Pliz

BY THE EARLY SIXTIES DALÍ HAD LOST HIS MAGIC TOUCH IN HIS painting and became increasingly dependent on others to maintain his output. Six years younger than Dalí, Isidro Bea became his assistant from 1955 onwards and was responsible for most of his output, which Dalí passed off as his own. Originally a painter of theatre decors, Bea had a studio that worked almost exclusively for the Gran Teatre del Liceu, Barcelona's opera house, located on the lower reaches of the Ramblas.

Commissioned to decorate a ceiling for a wedding reception in a mansion in Palamós on the Costa Brava, Bea was asked to do a design based on a small Dalí sketch with butterflies. Being used to working on a grand scale, he blew the butterflies up to the size of horses and projected them on to the ceiling. Seeing his sketch enlarged a hundredfold, Dalí, who was a guest at the wedding, immediately asked Bea to come and work for him.

In his first try-out with the artist, they slid the covers of *Paris Match* magazine together with some Dalí illustrations into an overhead slide projector powered by an ultra-bright lamp used to display images to audiences. To get the right surrealist composition, they moved the images about and projected them onto a canvas like a magic lamp.

It was the start of big things. Isidro worked fast, pencil-copied the outline, quickly applied the sea and the sky with figurative brush

strokes while Dalí, snuggled in his old sofa watched, and later added a tiny lobster or some crawling ants as a finishing touch. A second assistant applied a signature.

Isidro's specialty was blowing up a small image into a huge painting, thinning the oil paint with white spirit to create a soft, glamorous pastel effect. Over the years, he would create such well-known canvases as *The Last Supper, the Discovery of America by Christopher Columbus, the Battle of Tetouan, the Railway Station of Perpignan* as well as the 'atomic' paintings of objects flying around in space.

From the early Sixties on Dalí depended entirely on Bea, having lost the mythical and magical surrealist touch that had been the crowning glory of his great creative years in the late Twenties and early Thirties. He was now reduced to recycling his ideas to keep the money press rolling.

"All of them were blowups, theatre backdrops, stage designs that took me only a few days," Isidro said. "It took me only a few days to copy every square inch of Senor Dalí's Battle of Tetouan from a color photograph in *Life* magazine. A giant canvas (4 x 3 meters) like *Saint James the Great* he had to finish in a few hours because Dalí was pressed for money."

"He gave me a postcard of the *Cathedral of Santiago de Compostela* and a handful of scallop shells from the beach and smack in the middle a color photograph he had cut out of *National Geographic* of a white horse rearing on its hind legs." In the right-and left-hand corner, Dalí painted a portrait of Gala draped under a white sheet that he copied from an old art book in his Dalí's library as well as rocks and cliffs of Cadaqués, Cap de Creus and Port Lligat, copied from a tourist brochure."

When an important visitor came, Isidro was required to hide under the stairs or was banned to the secret studio, the only part of

the house with walls spacious enough to work on the huge canvasses. But the day he finished the Saint James canvas and a client appeared, he was tending the plants outside, pretending to be the gardener. The client was Lady Beaverbrook the wife of Canadian UK publishing magnate, Sir Max Aitken, Lord Beaverbrook. She asked Dalí to explain the meaning of Saint James the Great.

"Senor Dalí coughed and said the subject of the painting was the anti-existential idea of the fatherland and the fruit of the four petals of a jasmine flower in an atomic cloud whereby the shells are a metamorphosis of Spanish castanets that symbolize the birth of Aphrodite of Crete. When I heard Senor Dalí saying that, rolling his rrr's as in Spanish, exaggerating his pronunciation and articulating every syllable, I nearly died laughing."

Isidro had used a fast-drying industrial paint as an undercoat and diluted it with white spirit because he was always pressed for time. "Without blinking an eyelid, he (Dalí) also told Lady Beaverbrook that he diluted his oil paintings with the poison of a thousand wasps. Which was rubbish … Like every other commercial painter in the world, he used white spirit as a diluent. Lady Beaverbrook bought the painting on the spot for a million dollars."

A few days later Isidro handed Gala the invoice for four days work which came to 75 dollars. "She gave me 50 dollars, take it or leave it…I've heard all those gory stories of Senor Dalí's sex orgies. While he was jerking off in his New York hotel, I was doing the slave labor in the secret studio."

When Isidro fell ill in 1972 and was hospitalized, panic broke out in the Dalí household in Port Lligat, as there was no-one to crank up production and keep the money coming in. Extra assistants were hired. By the time Isidro came out of hospital a few months later, three other artists had been added to the team: Georges Mathieu, a French abstract expressionist, young Canadian artist Timothy Adrian Phillips, and Manuel Pujol Baladas, who had

worked for Walt Disney and was known in the secret studio as the Young Dalí because he was able to imitate Dalí's early surrealist style.

It had become a grotesque comedy. And since they all had their own style, it raised a few eyebrows. Whenever clients or museum curators complained that no two of his recent paintings looked alike, they were told that Dalí was so creative he continually invented new styles.

Dalí is quoted as saying that even if a painting had the slightest touch of his hand; say only a signature, that it was considered the work of Dalí. He actively encouraged the fakes that were on the market in his name. Money was the ruling factor, and the reason why there are so many fake Dalí's on the market today.

"I like to start off the day by making twenty thousand dollars," he once said. At the height of his fame, he bought in over a hundred thousand dollars a week. By the Seventies, Dalí's net worth was estimated at around ten million dollars. The couple's lavish lifestyle required a feverish work tempo on Dalí's part.

When rumors began to circulate in the Seventies that he had developed Parkinson's disease, he made a point of defusing them. To prove to his critics that he was still able to create art, he called a press conference at which he demonstrated that he was able to steady his own hand, thereby making it acceptable for some to believe that he was still able to produce art just as he had before.

Stranger still was the rate at which Dalí was producing not just any kind of art, but canvases painted in oils. At the height of his career, he was averaging one canvas a month. However, during his twilight years, between 1981 and 1983, Dalí — wonder upon wonders — was somehow able to create nearly a hundred canvases, (about one canvas a week), without anyone blinking an eyelid.

Whether for money or the promise of eternal fame, Dalí allowed his name to be used by others so that his art could live on, even when

he was unable to paint. He was once offered a million dollars for his mustache according to Bea, but wanted two million. For a million the buyer could have half the mustache, he said.

The problem, as Carlos Lozano says in *Sex Surrealism Dalí and Me*, was that "Dalí had the eye but not the hand. His small paintings had been executed with a draughtsmanship he was unable to repeat on a large scale. El Divino wanted to be considered one of the great masters but already as a young man he realized that he lacked that "special something." And to compensate for the lack, he played the fool, or cretinized, as he liked to call his buffoonery. For that reason, he decided to abandon all attempts at painting the grand canvases he so much admired and employed a prosaic subterfuge: he projected drawings and photos onto the canvas. Then by means of a mechanism he hated and that betrayed his public face, he adjusted the size and with a pencil drew the object to the desired size. This was how he did *Tuna Fishing* which he sold for 280,000 dollars to Paul Ricard when the French spirits merchant came to Cadaqués to buy a few watercolors."

To scotch rumors that his paintings were fakes, Dalí, ever the consummate performer, simply arranged for a photographer to capture him in front of the canvas, holding a paintbrush as if he were actually working on the painting. Says Stan Lauryssens — who should know, having moved so many fakes himself — "He became the most forged artist in history because he himself was responsible for most of the forgery and spent his life defrauding the art world while blatantly admitting it, only to see the price of his work soar. Art investors love the limelight. What people believe is great art is what makes the art world tick. Dalí became a luxury product like Louis Vuitton handbags."

Lauryssens was ideally placed to comment on fakery, especially regarding magazines and front covers. He had started life, as he liked to say, making holes in cheese and graduated from there at the age of

twenty-two to being a reporter for Belgian weekly *Panorama* after the editor heard him sing and recite poetry with a band in an Antwerp Club. To increase circulation the editor decided to do a weekly front cover splash on the film stars of the day, people like Al Pacino, Faye Dunaway, Barbra Streisand and Paul Newman. And although he never visited Hollywood, Stan was *Our Man in Hollywood.* That at least was the by-line on the stories that he hacked out on a mechanical typewriter in a tiny room in an Antwerp back street. With a pile of Variety and Hollywood Reporter back issues at his elbow, he flicked through the stars of the day and, with a pair of scissors and a pot of glue, cut and pasted his way to international fame. He concocted *live* interviews and wrote glamorous cover stories featuring movie stars like Karen Black, Anita Ekberg, Anne Bancroft, Nick Nolte, Robert de Niro and Telly Savalas (Kojak). Then he did a story on Salvador Dalí and when the famous face appeared on the front cover of Panorama, it was picked up by the (unnamed) president of a U.S. investment company then in Europe pushing bonds to GIs in Germany. The company, Money Management Counselors (MMC) was looking for something new and reckoned the art market fitted the bill. Based on the Salvador Dalí story, he offered Stan a job. Confessing that he was "fed up with all these con-artists trying to fool the art world," he said Stan was just the man to run the new fine arts branch they were opening to supply their wealthiest clients with the finest artworks available.

Stan naturally told him the truth, that he knew nothing about art — it takes one to know one. The president, recognizing a man of modesty just like himself, was not to be fooled. "You know Salvador Dalí, don't you? You interviewed him in Hollywood, didn't you? Boy, oh boy that was one hell of an interview!" he reportedly said.

And since good hacks rarely get the praise they deserve for their creative efforts, Stan let the warm glow of praise and admiration flush through his starved veins and held his peace. Thus, he became an art

consultant and investment broker. Money Management Counselors' (MMC) ultimate aim, as he found out later when the whole business had gone belly-up, was to set up a chain of McDaly art gallery franchises that would supply, not hamburgers or French fries like McDonalds, but Dalí artworks to wealthy middle-class people with aspirations to taste. With the police on his tail, he bought a house on the hill near Port Lligat and was soon hobnobbing with the remnants of the great Salvador's court, largely unemployed by the demise, or approaching demise, of the master. Lauryssens met Dalí once before he died, when he was in dilapidated condition, to put it kindly. He used to meet up with all the old servants in the Bar Boia, a beach bar in Cadaqués — Captain Peter Moore, Alfredo Caminada, Isidoro Bea, among others — where they shot the breeze over drinks and the tapas, and let it bleed.

One last parting shot about Dalí is supplied by Isidoro Bea. "One day, towards the end of Senor Dalí's long life, a little plane was flying along the coast trailing the familiar banner saying "Welcome to Dalí Land."The artist himself was sitting in his garden. He gasped for air and lifted his head. His watery eyes looked up at the thundering machine high in the clear blue sky and he called up, "Where is Dalí-land? Who is Dalí?"

24

Going up the Country

IT'S EARLY AUGUST AND REMI IS GETTING READY TO LEAVE FOR the Boom festival in Portugal. Mosquitos are buzzing in the warm afternoon air inside the hut. They don't bother Remi, who is wandering around stripped to the waist with a sort of colored rag round his head, all bones and white hair on his chest and strings of white hair hanging down behind, just about touching his shoulders. He is either possessed or enlightened. His large bright eyes sparkle and when he explains something, in perfectly enunciated Dutch or English it's as if he's lecturing to a class — his father was a history professor.

On the table is a basket of small green apples plucked from the garden. Remi lives on them. He cuts them carefully with whatever knife is to hand. There's also a map of Spain and Portugal on the table. I gave him the map last night and he spread it out on the table to work out the route. He did it with a piece of string. He took an apple, tied the string to it and placed it on the map in a rough line across the country from the Pyrenees — where we are — to Portugal, where he is going. Through the places he needs to pass through, roughly speaking. It's over a thousand kilometers as the crow flies, a bit more taking the *Ruta Nacional*. The motorway is out because he can't afford the tolls and the car's fifth gear is bust so he has to drive in fourth, which means he can't do more than eighty kilometers an hour, and at that speed what's the point of the motorway? The cars and trucks are only going to be honking behind him to pass all the

way. So, it's the *Nacional*. Two days, he reckons. To get there. I give him a hundred euros, two fifties. We worked out it's about eleven hundred kilometers to Portugal to the Boom Festival and eleven hundred back. So, at ten liters a kilometer, at the current price of petrol of 1.40 euros a liter, give or take say, that comes to over three hundred euros, a fortune for Remi who has no money.

He was up quite late last night trying out his instrument. Then Milco's daughter Zippy, popped her head through the door of the hut and they went off to finish the last of the lentils I cooked earlier in a big pot up at Rocco's place where there's a half decent kitchen, not like here in the hut, the *cabanya*.

Remi is supposed to get up at five, get his shit together, lug it half way up the hill to where his car is parked. His big motorbike is there too but he can't go on that because it's out of action, something to do with the brakes. He has a car, a big Ford Taunus, twenty years old if it's a day. The Argentinian guy he was laboring with on Leo's place gave it to him when he left. Leo's place is about ten kilometers further up the road. About ten minutes round the bends. It's a lovely old Catalan farmhouse. It stands by the side of the road and could have been an inn a century back. Leo is a miserable specimen who wouldn't give you the time of day unless he thought it was worth something. He used to be an architect and is trying to be an artist. Remi and the Argentinian were converting his barn into a meditation center for well-healed clients to come and relax after a mentally-scarring life of keeping an eye on their investment portfolio, light a candle or two, sniff the incense, and look into Leo's deep blue eyes as he ponces around in his robes, nodding obsequiously to their every word, pretending to be a guru. You really don't want to know much more than that about the abject creature.

The alarm goes off in the dark but later, when it gets light, Remi's still in bed, in the bunk opposite. His brown tanned and bony skull are gleaming in the light coming in through the window. Outside it's

drizzling. It's after nine in the morning and he still has to carry his stuff up the hill: the tea chest that acts as a double bass and the accordion that he has reconstructed, together with his personal effects, which can't be much.

It would take a Leonardo da Vinci to explain how he squeezes music out of the monstrosity he's constructed. He's going to play it at the festival, God help them. I gave him that little accordion a year ago and he reconstructed it. Some of the keys were not working so he attached one of those little plastic keyboards to the side. The kind of thing you give to a kid for its birthday to blow into. To keep it out of mischief. You're supposed to press the keys with your fingers while blowing into the mouthpiece to get a sound. You'd save yourself a lot of trouble by just buying a kazoo, sticking it between your teeth and blowing.

The kazoo sounds like you're humming through your nose. This contraption is no better. First, Remi doesn't blow into it. That would be too easy and Remi doesn't do easy. Instead of blowing into the mouthpiece he pumps up air through a tube. And this tube runs from just under Remi's nose into the keyboard and from there to his foot. Under his foot is a pump. One of those plastic things that sighs and sucks like a dying toad when you press it with your foot, the kind of contraption campers use to pump up airbeds. Somewhere on his head, or attached to an arm, is a tambourine. He might just possibly have a pair of cymbals to clash between his knees, attached by strings to his arms — I get so confused just trying to describe it. The demonstration he gave the other evening has wiped out all my memory reserves and left only a general impression of a one-man band. And he has to lug this monstrosity up the hill with all the rest — his tent, his food supply for on the way, the cans of sardines, and the water bottle. God knows who is looking after his big scruffy, hairy dog. Charly, he's called. He's one of those big, keen enthusiastic

dogs with hair over his eyes. He's like a big adolescent, full of beans, always raring to go. He'll come bouncing into the hut with Remi as if he's heard they're holding a party for dogs and it's about to start any minute. Maybe *he's* going to Portugal too. Get a sardine on the way. Look out of the window. Bark once to tell Remi to take a left turn, twice for a right. "Ata boy, Charly, have another sardine."

He went off. I don't know when. I didn't see him go. Sometime in the afternoon, I suppose. And by the time I saw him again, the Guardia Civil had raided the place and that sucked up everybody's energy. But he came back alive and those ravers down in Portugal didn't stone him to death as we feared they might when he started blowing into that thing and pumping on the bellows.

But don't get me wrong. Remi is good musician He studied piano at music college and has a classical education. He sometimes plays the piano down in the village at Conchita's place with some young Spanish guys who come up from Barcelona on odd summer weekends. One of them has a sax and they'll bang into *Going Up the Country*, that Canned Heat number that remains the beloved hymn of all mountain men. Just give them some of that old…

> *I'm gonna leave this city, got to get away*
> *I'm gonna leave this city, got to get away*
> *all this fussing and fighting, man*
> *you know I sure can't stay*

…and those mountain men just can't help themselves. They're in seventh heaven where dear old Remi is, 'gien it laldy' on the ivories. Hours later they'll be snoring on their backs like hogs with socks on; their guts gassed up with booze, their tobacco-stained breath rotting the wings off the upside-down mosquitos in the nooks and crannies of the pits they sleep in, while choirs of scruffy angels belt out snatches of the sacred hymn of the Hippies in their sozzled heads…

I'm goin' up the country, baby don't you want to go?
I'm goin' to some place, I've never been before,
I'm goin' I'm goin' where the water tastes like wine
We can jump in the water, stay drunk all the time

...looping all night long in the caverns of their skulls, fading to a sizzle as their hog snores blissfully gobble up the remains of the night.

25

How the Rat Pack Milked the Cash Cow

THEY ALL ROBBED HIM BLIND — COLONEL MOORE, SABATER, Descharnes — the secretaries appointed to look after the master's money after it became too much for Gala. Ducking and diving for years with the money she received from Dalí's paintings, Gala used every means possible to smuggle large sums in or out of Spain, Switzerland, and France. Banknotes were stuffed into suitcases under the bed in Port Lligat and in safe-deposit boxes at their Paris hotel where they were forgotten or lay so long, they were no longer legal tender. The artist then turned the management of his affairs over to a succession of secretaries but, since the pair were too stingy to pay them money, they had to operate on a commission basis. This was music to the ears of the mendacious characters it attracted since it allowed them carte blanche to make their own deals with his art, or what passed in the end for his art.

You could almost say that Salvador had created himself to be robbed, cheated and plucked like a chicken just to enjoy the experience. His servants obliged with relish. Still, there was something strangely Biblical about the arrangement, something to do with retribution and payback, if you could just get your head round it. But it was not the Parable of the Good Samaritan, about the good, decent man going down the road who falls among thieves, but another version, the Parable of the Bad Samaritan about the good, decent thieves going down the road just trying to scrape a dishonest

buck, who fall into the hands of an even bigger thief, lose their self-respect and become even bigger thieves than they were before.

They were the cream of their profession, the three of them: Colonel Moore the first, a smoothed-tongued Irishman with friends in the Vatican who later opened his own gallery in Port Lligat with the flotsam and jetsam of Dalí's production; Enric Sabater Bonany, ex-footballer, photo-journalist, PR man, travel agent, pilot and hard man who carried a loaded pistol in a shoulder holster; and last of the Magnificent Three: Robert Descharnes, a wimpy French photographer and Dalí biographer, immortalized by a neighbor who saw him sneaking up the hill regularly with a portfolio of the master's stuff under his arm after the genius died. All together, they multiplied Dalí's works by the thousands over the years and made themselves multi-millionaires.

Moore's arrival in Dalí's fantasy space is a fantasy tale in its own right. Peter Moore or Captain Moore, as he liked to call himself, was born in London in 1919 of Irish parents. His father was from Cork and his mother was born in Liverpool of Irish parents. Being an engineer, his father worked for Vickers-Armstrong on the continent, which meant Moore was brought up in Nice where he went to school. Orphaned at the age of fourteen when both his parents died in a car crash, he joined the Royal Corps of Signals when he was nineteen and had a distinguished career with the Psychological Warfare unit of the army. He occasionally reported to Winston Churchill. When he was discharged in 1946, Churchill put in a good word for him with Sir Alexander Korda, then head of London Films, a front for espionage during the war. Korda offered him a job in Rome at an astronomical salary with a house and car thrown in. In 1955, when he was filming Richard III, Korda wanted Dalí to paint a portrait of the actor Laurence Olivier, in the role of the hunchbacked king, to publicize the film. Dalí demanded ten thousand pounds and to be paid in lire, a difficult undertaking

because of the exchange controls then operating. Korda sent Moore to fix a price with the artist. Moore, a talented negotiator, was supervising the installation of closed-circuit television in the Vatican at the time and had made the acquaintance of the Pope who was interested in TV. Dalí wanted to meet the Pope. Moore got him a ten-minute meeting with Pius XII in November 1949 and the deal was cemented. Moore kept the oil painting of Olivier for forty-five years until the Dalí foundation bought it for half a million dollars in 2000. Dalí hired Moore as his full-time personal representative in 1964, and offered him 10 per cent commission on all business generated by the artist's graphic works. It was the beginning of a slippery slope, down which Dalí's reputation as an artist plunged with alarming rapidity with the artist's active engagement and consent, while Moore encouraged Dalí to authorize the mass production of lithographs. Some were sold as originals, others carried forged signatures and yet others were blank sheets signed by Dalí on which lithographs were later printed. A thriving parallel trade in fake Dalí lithographs developed. Moore auctioned four hundred works from his own collection in Paris in 2003 for four and a half million euros. He was arrested and convicted in 2004 after the FBI and Interpol tracked him down as the holder of a painting called *Double Image of Gala* which had been stolen from the Knoedler Gallery in New York and which was now in the Port Lligat gallery he ran with his wife. The police also uncovered ten thousand fake Dalí lithographs. Captain Moore was convicted but released by a Barcelona court because of his advanced age (eighty-five) and fragile mental state. He died in 2005. A delightful, flamboyant man, great raconteur and bon viveur, he liked to be photographed stroking Dalí's ocelot. Fellow Irishman, Ian Gibson, described him as "great fun," a person who was led astray by Dalí's avarice. "Dalí was cruel and heartless, immersed in his sleazy world, and everyone who ever worked with him got corrupted eventually," Gibson said.

Moore himself said that for nearly twenty years he was "locked up" in Dalí's madhouse. "One day in New York would cost us fifty thousand dollars, and his hotel bills could run up to half a million a month. When he had a sex party in New York, he wanted live lobsters for decoration with butlers walking through his St Regis suite pouring out bushels of lobsters that crawled off in every direction. The guys at the Fulton Market loved me. I used to buy four or five hundred live lobsters at a time." With his connections, Moore also arranged a visit to the Vatican where Dalí gave a two-hour speech in Latin even though he didn't speak a word of the language, and asked the Vatican to film him nailed to the floor in the Sistine Chapel in the same way as Christ had been nailed to the cross.

Enric Sabater Bonany was a different kettle of fish. There was something of the archetypal Spanish *chulo* about him. Where a gentleman like Moore might keep a perfumed handkerchief in the top pocket of his blazer, folded with precision into three little pyramids hailing the Holy Trinity upstairs, the chulo in the old days might show a hint of ivory and metal, the razor imperceptibly pulling down the pocket rim of his black, white-pinstriped suit jacket. That might be unfair since the chulo is more a Spanish than a Catalan archetype, but this was the guy who whipped out his pistol and shot Salvador's dildos one by one in the secret studio in the garden where he kept them lined up on the shelf with his snuff movies and other porn paraphernalia, according to Isidro Bea. One after another, the dildos that Salvador had painted by hand for his own use. Of John F Kennedy, the Pope, Charles de Gaulle, Mao Tse-tung, Fidel Castro, Adolf Hitler and even Mother Teresa (who was a man, he claimed). And *Pop! Pop! Pop!* He blasted them all, one after the other, after he drove Gala back one night from the casino where she lost another fortune. And that got Sabater so pissed off, so fucking pissed off and *Pop! Pop! Pop!* Salvador became terrified of him, it is said. But to be fair to Enric, the master's head was porridge by then. It was not so much the bullet Salvador feared as food

poisoning. He would get Arturo Caminada to taste his soup and his *paella* before his shaking hand raised the spoon to his trembling lips.

Born in the little village of Corça near Girona of a humble family, when he was working as a photojournalist (he was a good friend of Josep Pla) with Radical Press in the US, he came to photograph Dalí in Port Lligat. When a fly landed at the side of the Divine One's mouth, he took an iconic shot. They became good friends and Sabater spent nearly thirteen years between 1968 and 1981 photographing Dalí, accumulating a photo library of over twenty-four thousand photos that in later years he made good use of in photo exhibitions all over the world. "My court photographer" Dalí liked to call him as his fellow Catalan photographed his antics in relaxed mode at home in Port Lligat and shuttled with him and Gala between New York and Paris. Dalí never paid him a penny and Sabater never asked for money.

When he first appeared on the scene, Moore was understandably worried. "Captain Moore shadowed the man's every move like a bird of prey, not knowing Senor Sabater was the predator and Moore would soon be en route to the abattoir," says Carlos Lozano. He penetrated the divine circle in 1970, and being a strapping, good-looking lad, he naturally fell into the footsteps of the silent legions that had gone before him and did his duty as regards Gala, when the great call came, and him only in his early thirties.

"We have found someone younger, more intelligent and better looking," Gala bluntly informed Moore whereupon the man with a carnation in his very English blazer made way for the man who carried a gun tucked into his waistband.

Sabater had his talents, though. He was a good negotiator, had the virtue of being Catalan and Dalí was fond of him. Then word started leaking out about Sabater's peculiarities and his growing wealth. He had a thing about tax havens, got Dalí to sign over to him in tax haven Curaçao, the reproduction rights to six hundred of his

works and set up a web of companies to channel the gains. When he retired, he went to live in Andorra, another tax haven. He was a personable lad, Enric. A man you'd be wary of, but likeable. Being of the press persuasion himself, he was naturally wary of journalists, gave few interviews, gave little away. Until the New York Times correspondent in Madrid revealed that he was a millionaire several times over, had two luxury residences on the Costa Brava, one with a lobster pool, plus a yacht and a reputation for hosting lavish parties. He then came under scrutiny internationally. In retrospect, the charges sound pretty mean given that Moore had acquired a fortune or over forty-three million dollars by that time. But then Moore went about Cadaqués in a rusty old moped and slippers and Sabater piloted his own plane. Perhaps we are missing something as regards Sabater. Dalí dedicated over a hundred paintings, drawings, lithographs and etchings to the man, during the time that he worked for him, that Sabater published in a book in 2012 before he died of lung cancer in Pamplona in 2013. Dalí seems genuinely to have liked him, even more probably because he was a fellow Catalan. In keeping with Sabater's wishes before he died — a faithful servant to the end — the news of his death was not made public as a token of his respect, discretion and fidelity to "Senyor Dalí" as he referred to him.

Once Sabater's name was written on the wall in capital letters, he was persuaded to bow out honorably. Reynold Morse, a Cleveland industrialist, major collector and close friend of Dalí's, then persuaded a reluctant Robert Descharnes to take on the job. Descharnes had come into the picture in 1950 when he met Dalí travelling on the S.S. America — whether to New York or back is not clear. Descharnes was only twenty-four at the time and Dalí forty-six. Like Dalí, he was also a filmmaker. They collaborated on a film called *The Prodigious Adventure of the Lace Maker and the Rhinoceros*, the narrative of which was apparently as bad as the title. It was never released. Moore thought him a poor businessman, timorous, endlessly procrastinating and niggling over details. Robert Descharnes turned out to be every

bit as untrustworthy as his predecessors. When Dalí could not bear to return to the Port Lligat house after Gala's death, Descharnes temporarily moved his family into the house and was regularly seen by neighbors shipping out his archives, drawings and various objects to Paris. Trying to milk the imperial brand because of his so-called expertise. Descharnes published a book of Dalí's paintings done in 1982 and 1983 when he was on his last legs. How a man whose right hand shook uncontrollably, who had taken to signing his works with his thumb print, could create a hundred paintings looking unlike anything he had done before raised a few eyebrows in the art world and when doubt was finally allowed to set in, Descharnes's reputation — if such a thing can be said to have existed — was in tatters and the man discredited. Neighbors in Port Lligat, keeping a closer eye on the man than the experts in the art world, were happy to regale the press with tales of Descharnes regularly sneaking up the rocky hill with Dalí's treasures under his arm.

Say what you like about the Rat Pack, they at least sat — or tried to sit — tall in the saddle. After the 'cowboys' rode off into the sunset, black night collapsed over the Ampurdan desert. The only sound heard in the dark was the scurrying of little creatures. Later they would emerge from their holes, don suits and ties and proclaim themselves the Guardians *ad eternum* of Dalí's heritage. The Rat Pack's inherent weakness was its temporality. The *cowboys* were short-term bit actors. The *suits* were your men for the long-term vision, keen to see their names listed on the masthead of a museum, and named as fortunate beneficiaries of a pension fund generously watered, year in, year out, by millions of visitors come to genuflect before the creations of the master's mind and subliminally breathe in the pestiferous fumes rising from the slowly rotting corpse in the tomb beneath their feet.

There was always something dubious about that claim of Figueres mayor Marià (Mariano) Lorca's that Dalí had gasped confidentially

in his ear that he wanted to be buried in his Theatre Museum. The claim had a hollow ring to it. But who was to gainsay a mayor and president of the Girona chamber of commerce? Or question the motives of a man with an eye to the main chance? Dalí's corpse entombed and centered in the Theatre Museum was a better prospect in terms of visitors and income for Figueres — and the museum — than having it out there in the sticks, in Púbol. And since Marià's ear was the only ear to be favored with such a confidence by an octogenarian trembling with Parkinson's, his claim was naturally disputed. People who had known Dalí from the earliest years, the retainers, family and — dare we use the word: friends? — said he had always wanted to be buried in Púbol Castle beside Gala. They protested the mayor's claim, and set up an association to contest it.

Main Chance Marià knew well the story about the goose that laid the golden egg. Or was it eggs? What with all those big white eggs on the roof of the Theatre Museum, anyone could be forgiven for drawing the obvious conclusion that the master himself had laid them. Marià knew his history. Had seen what had happened in Egypt, the endless hordes of tourists flocking to Tutankhamen's tomb. Once Dalí's cadaver was safely entombed in the basement, Marià dispatched his ambassadors, sent runners throughout all the lands wherein men dwell and across the great ocean seas, with the good news that the sacred remains of the *Pharaoh of Figueres* had come home to roost and could be venerated by worshippers for a small fee (discount for groups).

Following a decade of litigation, *Lali Bas Dalí*, daughter of the artist's favorite niece Montserrat, was disinherited and her further right to royalties denied by the foundation that administers the artist's patrimony for the state. She was also asked to pay back what royalties had been paid to date. "Put the handcuffs on and drag me off, I'm not paying a cent," she said and dug her heels in.

26

On Taking the Piss

DALÍ WAS FOND OF 'CRETINIZING' PEOPLE. A CRETIN IS PERSON who is a complete fool, an idiot, a moron. A century ago, the word also had a medical connotation and was understood to be a mentally-handicapped person, physically deformed by a thyroid deficiency.

"Taking the piss" was one of the Heep's favorite expressions. It is less popular in the West of Scotland and probably unknown to most Americans. Taking the piss or taking the Mickey (Mouse), as London Cockneys say, is more or less the same thing. Dalí loved "to take the piss."

In July 2017, taking the piss went global as an expression when low-cost, barrel-scraping, Irish-owned airline *Ryanair* complained about passengers taking advantage by exploiting hand-baggage regulations to avoid paying extra fees.

"Are passengers taking the piss," a reporter asked Ryanair's chief financial officer, Neil Sorahan. Indeed, they were, and little kids, toddlers even, were in on the fraud, trundling their trolley cases across the tarmac heading for the planes in a "loveless tangle of mutual exploitation," as a columnist in *The Guardian* newspaper put it.

A new space was thus created for the unloved Salvador Dalí to be imagined as such a little toddler, well below the age of reason, dragging the baggage of his art through airport hallways, heading for

the jet of art-world fame, flashing a ticket he had forged that blinded all who saw it when the self-proclaimed genius waved it under their nose. All of course except the more perspicacious observers with the nose for the 'piss-taker.' And Dalí was one if ever there was one.

By the time he was fifty he had pulled so much wool over the eyes of so many sheep that they thought they were goats and brayed accordingly. In an art world where it had been elevated to an art form, piss-taking became shorthand for revolutionary insight in the hands of one of the last of the great chancers.

Peter Moore, the first manager of his fortunes, said when he quit Dalí in 1974 that the artist had amassed a fortune worth over thirty-two 32 million dollars. At the age then of seventy, he had turned every trick in the book, spent much of the war years from 1940 to 1948 in America dallying with Walt Disney, doing set designs for director Alfred Hitchcock, turning his hand to designing tarot cards, condoms, ladies knickers, when he was not trying to flog something in an advert. And if the greatest period of his work as an artist had been between 1926 and 1938, by the time his itchy fingers discovered the magic of signing blank sheets and the money was rolling in faster than his reputation was flying out the window, he stepped up production, signing even more blank sheets for lithographs, the number of which will never be truly known but which is estimated to run to hundreds of thousands.

Emilio Puignau, builder and manager of his house in Port Lligit (and former mayor of Cadaqués), recalled an incident in 1974 when French customs stopped a truck coming into France over the Pyrenees from the Principality of Andorra. On searching it, they discovered 40,000 blank sheets destined for a dealer in Paris that bore the signature of Salvador Dalí.

"In his shack, in the little alley outside the house," Puignau said, "there were several boxes of these sheets, a table and Dalí was sitting

at it. I remember well those entire days that Dalí would spend signing in a totally automatic fashion: a man placed a sheet on the table, Dalí signed and while it was removed, someone else would put another sheet in its place and so on, again and again, as if it were a printing shop…I told him once I couldn't understand what it was all about and I dared to say to him, If you sign so many blank sheets, they'll be able to print any imitation they want on them, anything that looks like Dalí. His reply was: I've already been paid what they offered for the work. So, what they do with them is no concern of mine."

Andre Breton nicknamed him, "Dollar Mad" — Avida Dollars. It was an anagram of his name. The blank sheets created an ancillary industry of their own, passing between shady hands in the murky back lanes of the art world, eventually prompting an international scandal when the scale of the deceit became known.

In the early Sixties already, Dalí had become excited at the chance of making easy money by making duplicates and would append his signature to reproductions of his work done by others. It was around 1965 that he started to sign blank sheets of lithographic paper.

"It all started," Peter Moore said, "when one of Dalí's French publishers persuaded him to sign some blank sheets so that he could put the prints on sale even if Dalí did not turn up in Paris to sign them personally. Dalí was paid an extra ten dollars per signature. It was like running off dollar bills in his own mint. The first time he signed 10,000 sheets and made $100,000. After that, signing blank sheets became second nature and he developed a mania for signing for its own sake. Anything placed within reach he signed: blank paper, books, prints.

Beyond all the frenzy was the showman. Taking the piss — *tomar el pelo* — is a well-known Spanish habit and Dalí was its master. The man who invented the happening before it went public, the greatest

showman on earth who acted out his self-created myth wherever he went, who mesmerized an army of courtiers, hangers-on and celebrities with his appeal in the same way as the Pied Piper of Hamelin enchanted the rats with the music of his pipes.

"All le great people who realize sensational achievement is impotent," he told BBC presenter Russel Harty in Frenglish in 1973, "Napoleon, everybody. Le people who is not impotent make childs, embrions and no more. But immediately que le sex work with extreme difficulty, you create fantastic music, architecture and invasions, imperial invasions."

Dalí the ringmaster, who conducted a non-stop variety show on two continents, whose uttering of inanities were proclaimed the utterings of genius, who wrote a play in which he was God, who bathed in the glorious accolades of his many admirers and supporters, became an irritant as the years dragged on. No one likes to be made a fool of. Not even fools. But, indifferent to the suffering of others, unable to love anyone but himself, the great masochist, the self-confessed cuckold, tried to turn a trick to the end like an old whore.

27

Gala's Last Ride Home

GALA'S SOUL WAS NOT DESTINED FOR THAT GENTLE EASING into the good night. Into the great by and byes. Nor would Dalí's be when the time came seven years later. After a relationship of nearly sixty years, the terrible baggage they each carried on their shoulders spilled its broken contents onto the sands of Port Lligat to reveal the putrid content of the lives they had led. Gala was the first to go. With a taste for supping on the sentiments and souls of others, Dalí could now enter a new realm of suffering: his own, and have his liver devoured every day by the same mythical eagle that Zeus sent to Prometheus as punishment for being a trickster.

Outraged at the vast sums of money she was spending on her last lover, the worm finally turned and in 1981 Salvador beat up his then eight-seven-years old wife so badly that she had to be taken to the hospital with two broken ribs. In February the following year, she reportedly slipped—was pushed, some say — twice in the bathroom, broke her thighbone and was taken to Figueres hospital only to discover that the ruptures to her skin could not be closed. Her condition deteriorated and she was sent for more intensive care to the Platon Clinic in Barcelona where she underwent another operation on 2 March that year. Facelifts over the years, particularly in her old age, had left her skin so ravaged, so brittle that the skin ruptures would not close properly. She had also suffered severe hair loss and been given more than a hundred hair extensions over the years,

according to her hairdresser. *The Madonna of Port Lligat* had turned into an ugly old hag that even Dalí could not bear the sight of.

Back home in Púbol Castle at the end of April her condition showed no improvement. She was confined to her bed and lay there with her eyes closed. Her circulation was bad and at the slightest bump or knock blood clots would swell up under her skin. Antoni Pitxot drove up every day from Figueres to see the couple and one day when he came up, Dalí asked him to go and fetch a priest to come and say the last rites. Pitxot was horrified at the idea, protesting that if she saw a priest, she would think her end was nigh and the very sight of a cleric would kill her. "Look, a few prayers won't do any harm and anyway she's very religious and has a mystical side to her," the wise Dalí said.

The curate Pitxot came back with was a young man. That was bad enough, but more to Dalí's dismay he wasn't dressed as a priest but wore street clothes, at which Dalí protested. "Don't worry, I've brought a sash," the priest said, taking the sash from his pocket and placing it over his wrist. They then went up to the bedroom where Pitxot and Dalí stood staring at the prostrate figure on the bed. And as Dalí nudged Pitxot— now a little to the left, now a little to the right to keep the gap between them closed in a natural way — the priest muttered the last rites.

Later she was taken to the house in Port Lligat and placed in the one of the twin beds, with its red covers and backrests in the shape of red lips, the head of a carved eagles looking down on her. Dalí lay in the other twin bed, listening to her moaning and groaning. She lingered on in agony for a few months more and eventually went into a comma. Dalí rushed around the house at his wits end, continually asking the servants for news of Gala as he rambled through the multi-layered house. Was she still alive? Was she gone yet? When the last breath escaped her lips on the afternoon of 10 June 1982 at the age of 88, the silence was broken by Dalí's heart-rending sobs.

She had one final journey still to make. It had been her wish to be buried in her home at Púbol Castle where a crypt had been prepared for her by their builder, Emili Puignau. It had two tombs, one next to the other, to host both Gala and Dalí. The tombs were said to be connected internally so that the couple could clasp each other's hand through eternity. To comply with Gala's wishes they had to break the law and move the body quickly to Púbol before the authorities, or the press, got wind of it. Moving a corpse from the place of decease, was against the law. There was no time to lose.

Gala's naked body was wrapped in a blanket and bundled into the back seat of the Cadillac. Chauffeur and personal assistant Arturo Caminada took the wheel. A nurse sat in back propping the corpse upright with cushions to make it look as though they were out for a drive. Then they set off up the narrow rocky road past the hotel at the top of the hill, took the road between the dry-stone walls heading down towards Cadaqués before turning back up at the little roundabout heading away from the coast and over the mountain.

The first few kilometers were the trickiest because the nurse had to try and keep the corpse sitting upright against the window in the back seat should the big Cadillac attract the attention of a local on the bumpy empty road or when it passed between some houses in the June heat. Arturo was feeling particularly self-conscious because *La Senyora* always sat beside him in the front seat and never in the back. And knowing that the Catholic Church has never been very clear about how the long the soul remains in the body after death, he refrained from looking in the overhead mirror. Local superstition had it that it could take days, weeks, months, and sometimes not at all. There were some souls, the superstitious fisher folk said, that never went to rest but came out to cry when the wind howled in the hollows of the hills, passed across the tracks over the mountain in the headlights of the car in the twilight in the shape of a fox, a boar, a goat or a rabbit.

But once they were over the mountain, the Bay of Roses lying spread out below to the left, and easing down on to the Figueres highway and from there out to the little village of Púbol, Caminada started to relax and when they arrived at the castle, the nurse took Gala by the ankles, Arturo by the arms, and they carried her up the stairs to the lounge where they laid her on the sofa. A day or two after that the embalmers came up from Barcelona, dressed Gala in her favorite red Dior evening gown and laid her to rest in the crypt under the stony gaze of the mythical beasts that Emili Puignau had carved from stone to guard the dead.

Like Caminada, Emili had been with the couple from the beginning when they bought the fisherman's shack in Port Lligat. That was just over fifty years before. Puignau shaped the place into decent living quarters, a kitchen in one half, a bedroom in the other. Like Caminada he too had served Gala and Dalí for nearly half a century and was not getting any younger. Like Caminada, Emili had been with the couple all his working life. Like Caminada he would receive nothing from either Gala or Dalí for his years of faithful service.

Gala remained a mystery all her life. Her Spanish was poor. Her Catalan wasn't much better, sufficient only for giving the servants instructions. With Dalí she spoke French. When she spoke about herself, her accounts changed from one moment to the next as though, like Salvador, she was continually reinventing herself. She kept a diary in Russian, it seems, but no one has ever found it. Since she never commented on her partner, never spoke about him to others, we will never know what her crazy life with Salvador looked like through her eyes. But she did reveal something fundamental about herself which perhaps says everything, if we can believe Dalí's account. And that was when they first met. When they were "courting." When she asked him to "croak" her. Is that how she saw herself? Deep down? As something putrid and rotten that needed

putting down? Some miscreant that did not deserve to live but needed someone who understood and who could put it out of its misery, squash it like a bug? But asking someone to kill you is a tall order. Murder is so much easier. It mostly happens unasked to other people, strangers if you're lucky.

28

Murder is so Easy

SOMEBODY GOT MURDERED AT THE WEEK END ON THE esplanade. I get to hear it from the post girl (it's a girl now) when she passes with her little yellow cart this morning. Within minutes, I'm descending the steps to the newsagents to get a local paper but the local Catalan papers, *El Punt* and the *Diari de Girona*, are sold out so I have to walk all the way into the village to try the newsagents in the square. It has plenty of newspapers and magazines on the rack outside for tourists: in French, Belgian, Dutch, English and German, but no Spanish newspapers. Rummaging in the gloomy interior I manage to get my hands on a copy of El Punt which is published in Girona.

Under the headline *Tourist Killed in Llançà*, it says, "Marc Ponsatí Pi (65) is reported to have killed a 55-year-old Belgian tourist yesterday in Llançà. The Belgian, together with his wife and two sons of 12 and 14, was listening to a Peruvian group giving a concert on the promenade next to the Casa del Mar restaurant. Ponsatí, who was sitting on a bench with his wife and baby daughter, was apparently asked by the Belgian if he could move along and make room for him and his wife. Ponsatí refused. There were words, and a blow was struck."

An hour or so later and less than a kilometer from the spot, the Belgian was crossing the main road along the coast to Port de La Selva when a Mercedes 200 appeared out of the dark and hit him. The Belgian only had time only to push his wife and kids to safety.

The Mercedes braked and reversed twice over the prostrate body of the Belgian. In an attempt to stop the lunatic, a bystander hurled a steel *petanque* ball, weighing close to a kilo, through the window. The Mercedes reversed over the body again, and with no lights on, disappeared into the night. Soon after, the *Mosos d'Esquadra* picked up the 65-year-old Pontasí near Port de La Selva.

Further reading reveals that Ponsatí is your classical lout. He had already threatened some tourists with a shotgun a few years before, forced his way into the homes of two building workers and trashed them because he was not happy about the job they had done on his new villa. He was also at loggerheads with the town hall. Someone had built flats across from his historically-listed second home, overlooking the sea on the road between Llançà and Port de La Selva, spoiling the view.

When Ponsatí appears in court later, the photo shows him coming out in handcuffs after the first hearing. He sticks out his tongue at the press and enquires after the camera of one of the photographers. He is dressed in white. White shorts, white, short-sleeved shirt, white socks and white shoes. Probably not much over five feet, he looks small next to the police officer by his side. He has a solid shock of dark hair on his scowling face and he looks in pretty good shape for his age. As well he might. He has a wife who is forty years his junior.

In the car later, Alina, Pili's sister, doubts whether or not we'll see justice. It´s who you know that counts, she says. And isn´t Ponsatí a cousin of the counsellor for Girona and well attached politically?

"Marc is an idealist, the environment is all he thinks about, and nobody who knows him can believe he would deliberately run someone down," says Gabriela Chamizo, lawyer of the accused. It's all been a tragic accident in which the innocent *petanque* ball is totally to blame. After the Belgian punched Ponsatí on the nose and made

it bleed, Ponsatí called the police and the Belgian took to his heels. Ponsatí, *el vei de Roses* (the Roses man) as the papers label him, went after the Belgian to ask his name, lost him in the crowd and went back to get his car. Not long afterwards, they crossed paths. The Roses man saw the Belgian on the highway, stopped the car, was surrounded by a group of Belgians, one of whom hurled the steel ball through the window and hit him on the ear. Stunned and in panic, poor Ponsatí lost his cool. And "disoriented by the impact," the paper says, "took off in desperation. And in that state, he ran over the Belgian."

According to the autopsy, the Belgian did not die from the first impact but from the second or third impact when the car reversed over him and damaged his internal organs.

"It all happened in a matter of seconds. Pontasí and his wife didn't know the Belgian had died till they were stopped by the police," said the lawyer of the accused. Poor Pontasí has been criminalized. Judge number four of Figueres was asked for a reconstruction of the facts with the aid of experts from the Autonomous University of Barcelona.

"In the car was the eighteen-month-old daughter of Ponsatí and his twenty-four years old wife. Why don´t they imprison the person who threw the steel ball?" protested the lawyer for the defense, insisting the "ball-thrower" should be identified and traced.

In the police version, the ball-thrower tried to stop the car from reversing over the prostrate body of the Belgian. A request for bail was denied.

Over two years later in September 2003, El Punt ran a headline saying "Roses man gets 11 years for homicide for running down tourist in Llançà."

The report goes on to say: "Roses man Marc Ponsatí Pi, 67, has been sentenced by the criminal section of the Audiencia de Girona to

11 years in prison for manslaughter for killing a Belgian tourist in Llançà on July 25, 2001, attacking him with his car and running over him twice. The court acquitted the accused of one count of murder and three counts of attempted murder for which the prosecution demanded a penalty of 65 years in prison. According to the court, only a single criminal act had been committed because the accused did not intend to run over the companions of the victim, who were unharmed."

The tribunal considers that Ponsatí acted "with irritation" because Belgian tourist Luc Eugene Jean Marie V. Schiepers, just before being knocked down by the defendant, had struck him a powerful blow on the nose in the course of an argument. This state of irritation, coupled with the personality of the accused, who shows marked signs of paranoia, has meant that the court has taken attenuating circumstances into account in the conduct of Ponsatí. In arriving at its judgement, the tribunal had doubts when it came to determining the true intention of the accused when he left the highway, mounted the pavement and drove the car at the victim, his wife and two accompanying nephews. The court gives the benefit of the doubt to the accused, who has always denied that he had intended to run over the tourist.

On the other hand, it has been determined, based on the sudden braking of the car, that the Ponsatí car was travelling at a speed of 24 kilometers per hour, a speed not considered excessive. The fact that the defendant was travelling at that speed gave the victim time to realize the danger and push his family aside, which also worked in the favor of the defendant as the tribunal considered that there was no question of malice aforethought because there was the possibility of the victim reacting and so it dismissed the charge of murder. The sentence, in addition to the privation of liberty, orders Marc Ponsatí to pay the victim's widow the sum of 96,789.30 euros in damages.

In the photo accompanying the article, Ponsatí, in glasses, open-shirted and wearing braces, is not looking too pleased. He's got fatter since the first photo and his once-dark hair has turned white.

I read the report several times in an attempt to understand the court's reasoning. How can deliberately reversing and running over a person twice not be construed as murder? There is obviously something in what Alina says. "Attenuating circumstances...the benefit of the doubt?" Later by chance, reading up on Dalí, I come across another member of the Ponsatí clan. A Dr Carles Ponsatí was Dalí's chief physician when Dalí died on 23 January 1983 gasping his last in an oxygen tent in Figueres.

29

Salvador's Ignoble Demise

POOR SALVADOR, THINGS HAD COME TO A PRETTY PASS. There he was. On his knees weeping his heart out, poor sod. The barrel of his life had been emptied and in the sludge at the bottom was the buffoon's multi-colored tunic, soiled, tattered and pestiferous. Maybe the life of the average *schmuck* was not such a shambles after all. Just about anyone would be happy with not being Salvador at the end. If he'd known what was coming next, he would have stayed permanently on his knees wailing and gnashing his teeth. But he didn't have the guts to cash his chips sooner; he was terrified of death. It took him seven years to die after his muse departed to pastures unspecified and the old witch (as some called her), was no longer able (as some claimed), to poison him.

Dalí's health began to get complicated already in the early eighties after the couple returned from Paris to Spain for the last time and the ever-faithful Alfredo Caminada picked them up in the Cadillac at Perpignan airport in mid-April 1980. Dalí had decided to make a comeback at his *Theatre-Museum in Figueres*. Looking exhausted and a shadow of his former self, he rapped on the table three times on opening day 24 October 1980 and announced, "Here I am now," in shameless imitation of the historical words of Josep Tarradellas "Ciutadans de Catalunya, ja soc aqui." that the exiled president of the Catalan government pronounced to a rapturous crowd on 23 October 1977 from the balcony of the

Generalitat in Barcelona's Plaza Jaume, on his return to the fatherland from thirty eight years of exile in France, after Franco died.

Dalí's reception was, naturally, not of the same order. Gala sat beside him, looking like the madame of an old-world Parisian brothel, her face daubed with make-up, her lips a shocking red, her wig held in place by her habitual Minnie-Mouse bow.

After that inglorious entry into Spain, it was all downhill as his body ran riot trying to run his mind into an early grave before he could commit even greater ignominies as he juggled with lawyers, planning and scheming his legacy, betraying friends and family left right and center as to where he should be buried and who was to receive the bounties that his hands and his mind had created, trying to two-talk his way into a ticket to eternity.

Then came the lingering flu, indications of Parkinson's, the prostate operations, depression and a succession of hospitals, clinics and doctors. Or psychiatrists, for that matter. But what could you do with a case like Dalí's? Barcelona neurologist Manuel Subirana thought his problems were more psychological than physical. Examining him in May 1980 Subirana said that he "could not get anything of medical value out of a man who had spent his whole life lying professionally."

Out of action and the public eye for an unbearably long six months the seventy-six-year-old might have been on the ropes but he was not out yet. Feeling a bit chirpy not lot afterwards, he called a press conference for his adoring admirers — the world at large — to let them know the Divine One still had a trick or two up his sleeve. He gave one of the shortest speeches on record. "I shall be so brief, I have already finished," he said and left. Which about summed up his life. The game was up. The demise of his muse Gala in June 1982 left him with neither strength for painting nor provocation. Retreating

deeper into Púbol Castle, he locked the doors, closed the windows and refused to talk to visitors. Alternating between bursts of lucidity, disorientation and insane rages, he threw his food at the nurses and lay in bed ringing the electric bell night and day for attention. Reduced to an ignominious silence, he lay awake listening to the screaming inside his own head, terrified of falling asleep in case he did not wake up again.

"He hardly spoke," said Elda Ferrer, one of his nurses at Púbol castle in 1983, "He sobbed constantly and spent hours making animal noises. He had hallucinations and thought he was a snail." In the space of two years she only understood one coherent phrase: "My friend Lorca."

Then came the fire. A push-button bell had been set up for him to summon attention, day and night. And so that it would never be out of reach it was attached to the sleeve of his dressing gown. Pursued by his demons, reduced to a skeleton, he had come to resemble the emaciated night-cavalier *Don Quixote* in his paintings, but without the nobility. With the morals of a mouse and the dignity of a fly addicted to horse shit, he kept pressing the buzzer off and on, driving the staff to desperation, provoking a short circuit that led to a fire in his bedroom.

Just before dawn on Thursday 30 1984, his bed began to smolder. The room was poorly ventilated. It was perhaps half an hour before the flames appeared. As the room filled with smoke and the bed grew hotter, Dalí became aware of what was happening. He must have pumped the bell-push in a frenzy but it was no longer working. He must have tried to shout. Nobody came to his assistance. He threw himself out of bed choking and began to crawl towards the door to the passage. Then, at the foot of the bed, he collapsed. The bedroom was a ruin. The heat was so intense it nearly melted the silver frame of one of his pictures.

The eighty-three years-old child received first and second degree burns on his leg. His local physician did not considered them serious enough to send him to hospital but twenty four hours after the fire, a specialist in burns was summoned from Barcelona and on his advice Dalí was dispatched to the Pilar Clinic in the Catalan capital which issued an official medical report the following day saying his burns were on his right leg, buttocks and perineum and affected 18% of his body. A long and difficult skin grafting operation was needed if he was not to die of infection, the chances of which were certain without the operation.

On 9 September, eleven days after the fire he underwent an operation lasting over six hours. It was touch and go to see if the skin grafts held. In the next few days, battling fever and respiratory problems, he pulled through. He never returned to Púbol. He stayed in the Pilar Clinic until 17 October 1984 when Arturo Caminada arrived with the Cadillac and they ushered the skeletal figure through the press reporters baying and clicking round the clinic entrance into the car and drove him to Figueres. Never again would he set foot in Port Lligat or Púbol. The Torre Galatea in the Theatre-Museum was to be his final watering hole.

His last five years were shrouded in secrecy. The only news of his condition or his doings came in the form of the occasional press release prepared by his aids and revealing the occasional mundane — and improbable — fact that he was writing a poem or contemplating a new work.

Only two people were capable of deciphering the rasping sounds coming from his throat — Arturo Caminada and Antoni Pitxot. But these gasping utterances were so very rare that no one could interpret his wishes. The great days of communicating his insanities on television were over. And if by some miracle his powers of speech had been suddenly restored, the grotesque white plastic tube inserted by his doctors into his nose and leading directly to his stomach, would

have prevented its interpretation. His once proud black mustaches had turned as dirty grey as the tufted hairs on the underbelly of a billy goat and the raging challenge of his eyes — so instantly recognizable as the provocative trade mark he had developed to hide his pathological shyness — had dimmed to the cowering, timorous pinpoints of a tiny mouse whose neck has been clamped to the mousetrap board, condemning it to contemplate the world an inch from its nose with unmitigated terror.

Author Ian Gibson had been trying for years to interview Dalí. Knowing Dalí's close friendship with the poet Federico García Lorca, he had sent him a copy of the first volume of his biography of Lorca, which had just been published. He phoned Antoni Pitxot to see if the artist had received it. Pitxot, having talked to Dalí, phoned Gibson. "If you don't come today, he may change his mind," he said. No sooner said than done, at six that same evening Gibson caught a plane from Madrid to Barcelona, "dashed up the motorway in a hired car," and was shown into the hall where Dalí sat on his thrown like a Persian satrap.

Dalí's physical appearance was truly appalling. The handsome face had caved in, the slavering mouth hung open and from his mouth issued a clutter of plastic tubes. After a shaking hand had grasped mine, Pitxot sat to one side of the throne while I took my place on the other, placing the tape recorder on the table beside us. Fixing me with watery, sea-blue eyes, terrible in their intensity, Dalí began to speak fast in an almost unintelligible mumble of Spanish and Catalan made even more difficult to follow by the feverish drumming of his right hand on the chair.

Once Gibson became acclimatized to Dalí's voice, he realized, with Pitxot's help, that he was telling him how much Federico García Lorca had loved him. The poet's love for him had been intensely physical, he said. No question of mere affection. Dalí had tried to return the passion but was unable to. Instead, Lorca had made love

in Dalí's presence to the attractive, seductive Margarita Manso, a painter and friend from their student days in Madrid, and dedicated a poem to her.

"Gala was hardly mentioned — it was Lorca who was on Dalí's mind. I came away with the impression that Dalí's friendship with the poet was perceived by him as one of the fundamental experiences in his life. I also left with the impression that very few people indeed, perhaps only Antoni Pitxot and Arturo Caminada, could possibly make out Dalí's speech," says Gibson.

He had not long to go. He died on the morning of 23 January 1989 of heart failure. Softly in the background Wagner's *Tristan und Isolde* was turning on the gramophone. When his will was made known and it was learned that he had bequeathed his estate to the Spanish state and not to his native Catalunya, all hell broke loose. The finest minds of the Spanish legal and financial professions were tasked with dissecting the mess that he and his spouse had left behind in the tangle of wills they had carelessly conceived; in the questionable rights they had conceded to all manner of parasites and flim-flam artists who had sucked the blood out of the all-too willing victim; in the fakes and trash that they had flooded the art market with like junk bonds bearing his signature, of which it is said there are over 666 different versions, the same number as the *Beast of the Apocalypse*.

Had it not been for the fact that as a young man, knowing no better, he had produced enough masterpieces to offset some of the damage he did later to his legacy by his insistence on playing the fool, they would have cast his corpse on the dung heap on the outskirts of town. When the details of his will were made known and the news spread that he had betrayed his native Catalunya, school children marched through the streets of Figueres demanding the return of The Great Masturbator which had been bequeathed to Madrid. In a humble and insignificant little town not far from Figueres, the citizens removed the street sign with his name on it that they had

erected years before in a rush of pride when the fame of their beloved Dalí was at its height and was untarnished. He was one of us, they said at the time.

When his will was read and his faithful servant — Arturo Caminada, who had been with him since he was seventeen — learned that after forty years of service his master had left him nothing, not a single miserable peseta, he observed, matter-of-factly: "Senyor Dalí loved no one." He was loved by no one in return.

Few artists have expended so much energy in vain. Dalí's problem was that just like the rich man in the Bible whose overloaded camel could not pass through the Eye of the Needle Gate in Jerusalem because he would not dump his baggage, Dalí, having created an ego to outshine the sun, could not let go of it at the finish. Whimpering and moaning, he thought he was a slug, leaving a silvery track of slather, shedding the water of his life, as he dragged his puffed flesh blindly across the floor. His pretentions to genius, his studies of the great philosophers and scientists of the ages whom he considered his peers, his so-called inventions, the fine works of art he produced in his early years before cretinizing himself into a cheap con-man, had all been for nothing. He had learned nothing. He lacked humility and never understood what most simple, decent men accept, which is that life is pure and simple in essence and that the humble donkey flicking flies from its ears in the heat of midday before lowering its weary head to the clear water of the stream, knows that better than man.

30

Prayer for the Donkeys

AT THREE IN THE AFTERNOON IN EARLY MARCH, THE PORT OF Llançà is deserted. Two middle-aged men and a woman, blown in by this morning's breeze, are eating at the corner window of the covered veranda of Els Pescadors. A grey cat sallies across the narrow street heading for the beach or out along the pier to its home in the rocks. A car does a U-turn when it discovers the narrow street comes to a dead-end, whirls round the stones that demark the spot where the fishermen's confraternity used to be before they knocked it down, and heads back out of the port area. Another grey cat, clearly in a hurry, makes its crooked way across the car park and rubs its behind on a car bumper. An irregular metallic tick comes from the rigging of a yacht. The breeze ruffles the fronds of the palm trees and they shiver, not quite at home this far north.

A couple cross the car park. They've just come out from lunch at El Pescadors. They're in their forties, and French probably, judging by the way they are dressed. She walks a meter behind, wearing a synthetic emerald green anorak and he has a navy-blue sailor's cap on his head. On the corner, across from Els Pescadors, is a fish shop. In the evening around six when it opens and they unload the fish in crates sprinkled with ice, fresh from the fishing boats, it throws its harsh light through the big windows onto the narrow main street and onto the even narrower lane to the side which goes up the hill. Fifty meters further up is a green neon sign saying simply *Hotel*. It's on the

roof and above the door of La Goleta. On the glass door of la Goleta a sign in Spanish, Catalan, English and French says "Enquiries for a room please at Els Pescadors." Really, it is a rooming house built for numbers, the French mostly who come to eat the fresh oysters, the prawns and *gambas* that have crawled this very minute out of the sea. Or so the petulant money grubbers at the flashy, newly renovated restaurant on the corner like to tell them.

Further up the hill from La Goleta, the road curves sharply to the right. At the top of the hill it takes another sharp turn on a blind bend. To prevent accidents and see around the corner, a big round, fish-eye mirror has been attached to a post so you can see if there's another car coming. It's a big mirror, over two feet in diameter. and it's new. The raging Tramuntana ripped the old one from its moorings during the winter and deposited it in front of our flat. The mirror is plastic and has deep scars across its surface. When it was ripped from its moorings by the wind it was blown down the road and got scarred. I know, because I picked it up and hung it on the wall of my studio.

Next morning as usual, I saunter up the hill to visit my dear friend Steve. He spends most of the day at the computer, which is where he is now.

"They don't know you're a dog," he says quoting a cartoon on the Internet in which one dog says to another as they log in: "They don't know you're a dog."

I'm trying to register so I can read some newspaper or other. Or at least the bits and pieces that are offered.

"Do I have a digital radio?" cries Steve. "Yes."

I can't get a word in when he's wound up, so I let him get on with it. I hardly know what a digital radio is.

"Salary?"

"Bugger all," I say.

"Sixty to a thousand pounds," he selects.

"Age group?" I'm close enough to be among the pensioners, but I keep that to myself.

"Under twenty-five," he selects "You did well last year." And I become a creative media person, under twenty-five earning up to seventy thousand a year by the time we're finished.

"That'll sort them out," he says gleefully.

I go back downstairs and stand looking out the big glass doors that run the length of the living room wall from where you can see the curving beach, the port and the hills. Mist hangs over the two peaks of the Donkey's Ears where we cast Francesc's ashes to the wind in keeping with his last wishes. Francesc was Pili's father. In the living room behind me, the late morning television is full of the images of thousands of sheep being dumped from the upheld claws of tractors, into a pit. Smoke rises into the air over the rolling hills of Durham. All over the world people are going mad, children and adults, from the obscenity of industrial food production.

Below, in the port of Llançà, the Tramuntana has started up again. It is blowing hard and the white crests of the waves are riding in from what appears to be the north. Yesterday three pairs of magpies played tag on the roof next to the flat, cawing and chasing each other in a pairing game. Spring is in the air. The red flowers of the cactus are in bloom. White waves surge over the black volcanic rocks below the coastal path. The still water in the lea of the rocks is clear so you can see the dark, round shapes of the sea urchins. Salvador loved sea urchins. He ate piles of them. I went fishing for them from the rocks, one year in November. With a long pole, with a hook attached that you angled underneath the sea urchins and scooped them delicately out of the water. Pili showed me how to eat the orange part inside.

Only a few weeks ago, we bumped up the rutted track under the pine trees to the Donkey's Ears. In Alina's little dark blue Volkswagen.

Prayer for the Donkeys

The three of us. Alina, Pili and me. With Francesc's ashes in an urn. To the twin peaks of the Donkeys Ears which are at end of the *Albera* range where the Pyrenees peter out and descend into the Mediterranean. That's where Francesc wanted his ashes to be spread. First, we looked for a suitable spot and then we scattered the ashes and the breeze caught them and took them over the gorse, the sweet-smelling flowers and the thyme towards the sea. The sea was far below, shining and still and deep as a mirror. And though I knew Francesc only from the photo that Pili kept on the little mahogany table by the window in her flat, I thought he must have been a good kind man. Who loved animals. Just like Pili. And at that moment — standing in Steve's living room looking out the sliding glass doors down onto the curving beach, the sea and the Donkeys Ears in the distance — I thought of Francis Jammes, a 19th century poet of the French Pyrenees. He wrote a poem called *Prière pour Aller aux Paradis avec les Anes*. (Prayer to Go to Paradise with the Donkeys). The wind had suddenly died. And in that breathless space, for a long moment we were all gathered up together, Francesc, Pili, Alina, me, the cats roaming the breakwater; the little birds in the olive tree, and we were swept up across the sky with a swarm of wheeling starlings, over the vacant houses, the railway line, up the hills towards the Donkey's Ears, and as we soared higher, we saw far below in the mirror of the sea strange shapes that looked much like us.

Prayer to Go to Paradise With the Donkeys

When the time comes for me to go, Oh Lord, let it be
On a feast day when the countryside is celebrating
And the wind whirling up the dust. And just as I did here below,
Let me take a road of my own choosing, when I go to Paradise,
Where the stars are out in the middle of the day.
I'll take my walking stick and I'll take the high road
And I'll say to my friends the donkeys,
My name is Francis Jammes and I'm going to Paradise

Under Dalí Skies

Because there's no Hell in God's good country.
And I'll say to them, come along with me,
Dear, tender friends of the blue sky, poor dear beasts
That ward off flies, blows and bees with a flick of the ear.
And when I come, let me be in the company of these beasts of burden
I love so much, because they bow their heads so gently
And put their little feet together when they draw to a halt.
So sweetly and gently it goes straight to the heart.
And I'll come followed by thousands of the ears of those that
Lugged wicker baskets on their flanks,
Dragged the carts of circus acrobats
Or carts with feather-dusters and tin-cans
Or those with battered water bidons
And she-donkeys, broken-stepped, stuffed full as goatskins
Or those they draped in pantaloons because
Of the blue suppurations made by the
Stubborn flies caked round their wounds.
Dear Lord, make sure I come to you with these donkeys
Make is so that angels accompany us in holy peace
To bushy streams where cherries tremble like
The laughing flesh of maidens
And make sure, prostrate in this resort of souls
Now on your divine waters, I'll be just like the donkeys
Contemplating their gentle humble poverty
In the limpidity of your eternal love.

Francis Jammes (1868-1938).

31

The Resurrection of the Mustache

DALÍ'S MUSTACHE LIVED A LIFE OF ITS OWN. EVEN AFTER HE died, it continued to flourish in the tomb by special arrangement with the Divine, feeding on the essence of the universe. Following a long legal process lasting a decade, the court granted permission in 2017 to exhume his body. When the tomb was opened, it was discovered, lo and behold, that his little mustache had been living the life of Larry down there in the dank darkness and was in frisky, pristine condition, sitting firmly on the master's stony upper lip, its little tentacles raised victoriously in their familiar 'up-yours' position.

Narcís Bardalet, the embalmer who tended Dalí's body after his death in 1989 helped with the exhumation in July 2017. When they opened the crypt, Bardalet laid eyes on Dalí again for the first time in decades, "His face was covered with a magnificent silk handkerchief. When it was removed," he told Catalan radio station RAC1, "I was delighted to see his mustache was intact … I was quite moved. You could also see his hair."

Dalí's body resembled a mummy; it was like wood, so hard that experts had to use an electric saw rather than a scalpel to collect bone samples. His body would last a good while longer, the embalmer predicted. The mustache is still there and will be there for centuries to come.

In an operation lasting about four hours, forensic experts extracted samples of his skin, nails, teeth and two large bones that were sent to a forensic laboratory in Barcelona and the Instituto de Toxicología de Madrid. To prevent drones recording the exhumation through the overhead glass cupola and sneaking the images to the front pages of the eager press, security guards placed tents around the crypt.

The tomb was opened at the request of María Pilar Abel Martínez, a tarot card reader, born in 1956, who claimed her mother had had an affair with Dalí during the year before her birth. Pilar Abel, as she was referred to in the press, said it was an open secret in her family that the artist was her biological father. She first learned of her "true" paternity from the woman she considered her paternal grandmother who would say, "I know you aren't my son's daughter and that you are the daughter of a great painter, but I love you just the same."

Her granny also told her she was odd, just like her father, who had apparently had a secret liaison with the artist in the summer of 1955 when her mother was twenty-five and working as a nanny in a house in Cadaqués that Dalí frequented. Dalí was fifty-one at the time and living in Port Lligat with Gala. And on this shaky basis, delivered with the necessary gush and sentiment, she quickly had the nation in thrall. Open-mouthed in front of the telly, millions of Spaniards wiped tears of commiseration from their eyes, greedy for more.

Looking for an explanation to the phenomenon, the mind of the nation was inevitably all over the ship in a nano second. With Easter coming up, Dalí's imminent resurrection understandably triggered associations with the resurrection of Christ from the tomb. Public interest shifted from death to rebirth. On one TV chat show about Pilar's credentials, the question of DNA inevitably arose whereupon one well-weathered lady panelist brought up the case of a certain Maria del Carmen Bousada who had given birth to twins in 2006 at the age of sixty-seven.

On that measure Pilar still qualified (with the help of medical science and God willing) for passing on the Dalí genes to a little genius of her very own. For ten years she had been trying to prove her parentage. Earlier samples of Dalí's DNA had been tested with inconclusive results. In 2007, the courts granted her permission to extract DNA from the skin, hair and hair traces found clinging to his death mask. However, the results proved inconclusive. Another attempt to find DNA was made later the same year, using material supplied by the artist's last manager, Robert Descharnes. Although Pilar claimed she never received the results of the second test, Descharnes' son Nicholas told Spanish news agency EFE in 2008 that he had learned from the doctor who conducted the tests that they were negative. Spain held its breath again until it was announced nine years later that permission had at last been granted to open Dalí's tomb to extract the necessary DNA.

Pilar's appearances on TV began to resemble weekly draw for the *Lotería Nacional*. Was she going to get the big one, the annual *El Gordo*? Under Spanish law, Pilar Abel would have been heir to a quarter of Dalí's fortune if the DNA tests supported her claim. The Gala-Salvador Dalí Foundation, which controls the artist's lucrative estate, had unsuccessfully sought to fight the exhumation by appealing against an earlier court decision to let it go ahead. As Dalí had bequeathed his properties and fortune to the Foundation and the Spanish state, Abel had brought her claims against both.

When the results of the tests were made public in September 2017, analyses of two forensic institutes, one in Barcelona the other in Madrid, showed that there was no connection. Many people were not surprised but many were disappointed. Abel's goal had been "to carry his surname with pride." She came over well in the media and was seen afterwards on TV, wiping away the tears of disappointment from her eyes as the media squeezed the last drops of lemon juice from her ravaged countenance before consigning her to the obscurity basket.

The more sanguine sector of the public was not taken in, however. By then they'd all had had enough of the antics of the 'pythoness' as one of less kind journals dubbed her. "Salvador Dalí is not the father of Pilar Abel, the pythoness who has been promoting herself as his daughter on television and in court," it trumpeted.

If truth be told, the results were a profound disappointment to both camps. Whatever way you looked at it, the entire nation — everyone connected somehow to another person — was devastated. They'd all been secretly hoping against all hope that the old fart had redeemed himself in death, done something decent for once in his miserable life and had fathered a child. It was even rumored that clandestine clubs had been set up to reinstate him as a noble *pater familia* of the nation to scotch once and for all those slanderous assertions of pederasty and perversion spread by Communists and left-wing agitators to discredit the government.

Salvador did not always have a mustache. He only started to grow one around 1930. Early photos of him in Port Lligat and Cadaqués (when he was doing his best work), show him olive-skinned and clean-shaven. In sense, the appearance of the mustache heralded the shift away from his work as a pure artist to that of a performer, a showman, and finally a buffoon.

Ultimately, his mustache was his ruin. As his sister Anna Maria had astutely perceived in her memoir *Salvador Dalí Vist per a Sua Germana*. And as Josep Pla said when he fired off his final remark on the feud between brother and sister: "The first thing he has to do is shave off the mustache."

The adoption of the mustache also signaled his surrender to the recognition that he was second rate. "More than anyone he wanted to emulate Velazquez from whom he had taken the mustache and the long frizzy hair," his assistant, Carlos Lozano wrote in his memoir *Sex, Surrealism, Dalí and Me*.

The Resurrection of the Mustache

The dear fellow rarely washed, never used the wash basin or the shower. His greatest vanity was his famous mustache. To keep it in lift-off position he would rub it every morning with a mixture of bee's wax, honey, rhubarb jam and Hungarian pomade. In reality, Dalí never did have much of a mustache. All he had on that trembling upper lip were a few pathetic little wispy hairs that his hairdresser had to beef up by adding extensions. There was something almost sexual about the process, as well as the result.

"He never paid me, of course. Not a single peseta," said Luis Llongueras, his hairdresser for over forty years. Llongueras took a grey hair from master's mustache in the Torre Galatea before the master departed for the fifth dimension. Before paying a million dollars for the grey hair, the savvy buyer is well advised to do a DNA check. Beforehand. There are so many grey hairs in the world, they could be anybody's. Caveat emptor.

Birds will rise on the wing till the end of time, but Salvador Dalí will not. There he lies, returned to the theatre of his own absurdity, in his stone tomb in Figueres, with his dirty finger nails and his waxed mustaches, a prisoner for all eternity whose soul was unable to leave the body because his great ego could not die to death nor let death embrace him and take him home.

32

Keep A-Knocking, Cécile

GALA HAD A DAUGHTER CÉCILE, WHOM SHE IGNORED ALL HER life. She has been branded a heartless bitch as a result. That is the standard narrative. As usual it is mindlessly repeated. As usual the truth is more nuanced.

Brought up surrounded by some of the greatest artists of time, as a child Cécile enjoyed the attention of film director Luis Buñuel and artists and poets like Marcel Duchamp, André Breton and René Magritte. Max Ernst and Picasso — who were great friends — painted her. Picasso used to take her to boxing matches and they would go and have a swim in Vallauris, on the French Riviera when she visited his Cannes studio. She would visit him whenever she pleased in his studio in Paris. "He was so alive, so earthy, so absolutely not abstract! He never got old. I never felt the 40-odd years between us," she said.

Her father married Gala in 1917. A year later Cécile was born and, taking her father's real name, was christened Cécile Simonne Antonile Grindel. Cécile had barely reached speaking age when her parents met the then struggling artist Max Ernst in 1921. Ernst moved into the family home, a beautiful, eight-room classical building in the center of Eaubonne, a community in the northern suburbs of Paris. Later he moved into her mother's bed to form a *ménage à trois*, sharing Gala with her father — one on each side, one presumes, with Gala the sandwich-filling in the middle.

Keep A-Knocking, Cécile

In his spare time, Ernst painted the entire house. He finished one room and then did another. He painted a duck on wheels above Cécile's bed. In a corner of the dining room he painted a woman's naked torso with her body sliced off, (appetizingly showing her entrails) and for good measure some naked ballerinas on a boat on the ceiling. And to dispel any misconceptions that he might be warming up for more religious themes, he painted another room red with another huge nude on the walls, clasping enormous breasts. In the 'marital' bedroom, he made another statement of intent, painting ant-eaters with long, fleshy pink snouts slurping up tiny ants. There were big human hands around the windows. "We lived there, all together, quite naturally, for a few years. I don't remember finding it odd," Cécile said.

She was only 11 when Gala met Dalí and abandoned both her husband and her daughter. "After she met Dalí in 1929, she was not interested in me any more…she was never very warm, even before. She was very mysterious, very secretive. I never got to meet my Russian family. I didn't even know when exactly she was born," she said.

After Gala left Paul Eluard, Cécile went to live with her paternal grandmother in Paris, seeing her father regularly, and her mother once or twice a year. For Gala, Cécile didn't really exist anymore.

Getting to see her mother was never easy. One day in June 1940, as the *Wehrmac*ht was marching towards Paris, Cécile was told by the Wheat Office, for whom she worked, that everyone had to flee the city and make their own way south. Recalling the summer villa her mother rented for the summer in *Arcachon*, a little resort in the south-west near Bordeaux, she headed there as millions took to the roads fleeing the advancing German army.

On arrival she knocked but they would not let her in. *Keep A-Knocking* (but you can't come in), Little Richard's hit song —

heralding the arrival of Rock and Roll in 1955 — would have served as her theme tune. It's not difficult to imagine her putting it on the record player regularly and turning the volume up full blast.

"I arrived at the villa and asked to see my mother. The maid said that Gala didn't have any daughter and that I was a liar. Gala wasn't in and I had nowhere else to go. I kept talking with the maid who finally and defiantly said: "Marcel Duchamp and Man Ray arrived this morning. We'll see if they know you." She opened the door; Duchamp and Man Ray were playing chess. "They knew me well, of course, so I was safe," she said.

She tried to see Gala several times after that in Port Lligat, but was turned away. On the last occasion (in June 1982), hearing that Gala was at death's door she went to see her again, only to have the door slammed in her face. Not by Gala obviously, who was in comma, but by the servants or whoever was dictating household policy.

In June 1951, Eluard's married his third wife, Dominique (Odette Lemort) a thirty-six-year-old French journalist he met in Mexico. He had been seriously depressed since the death from a stroke in 1946 of his second wife Nusch, a former music-hall artist. Dominique saved him, gave the poet for whom love was the link between man and universe, the will to live again. Her youth — she was nearly twenty years younger — brought his own youth back to him. Not for long, alas. He was felled by a heart attack in November in 1952 at his home in Charenton-le-Pont, in the south-east suburbs of Paris. After his death Cécile agreed to waive her rights to her father's estate and Dominique proceeded to sell it off bit by bit. The two women seem to have had an amicable relationship — Dominique witnessed Cécile's wedding in *Charenton-le-Pont* in May 1953 to her third husband, Robert Dreyfus.

Paul Eluard was an avid art and antique book collector. Well-known pictures taken by the photographer Brassaï, show him at

home surrounded by oil canvases by Picasso, Braque, Max Ernst, Chirico, Chagall and Dalí. Eluard liked to discover new talents, and had a flair for the art market. "Poets were not rich. His passion for art, and his avant-garde taste, meant he could support himself by buying and selling art," Cécile said.

Short of money later, she remembered the frescoes painted in the former family home by Max Ernst in the Twenties and drove with her fourth husband, writer and savvy businessman Angelo Boaretto, to the house in Eaubonne which was still inhabited by the same artisan jewelers who bought it from Eluard in the late Twenties. They rented it for three months and set about uncovering Ernst's painting which were hidden under the wallpaper. One evening, the day before the restorer was due to pack and leave, some plaster fell off the ceiling and another painting by Max Ernst appeared. "I had totally forgotten about that one. These were the naked ballerinas on a boat. We called Ernst. We wanted him to sign his work. I wasn't sure how he'd react. In fact, he was very happy to see all those long-forgotten décors." Ernst duly signed the frescos. For a fee. And Cécile auctioned them off. The Shah of Persia's wife, Farah Diba, bought the biggest panels which are on view today at Tehran's modern art museum. As for the artisan-jewelers, they couldn't care less about Max Ernst. "All they wanted was to get their wallpaper back on time for Christmas," she said.

With the proceeds from the Ernst windfall, Cécile spent decades with daughter and two sons by her third husband, Robert Dreyfus, trying to buy back some of her father's collections. Only a few months before she died, Barcelona documentary maker Joan Boffil looked her name up in the Paris telephone directory and to his great surprise got her on the line. She had given only three or four interviews in her life. Bofill was the last. He called to see her several times and spent five hours recording her on film with her family. Gala, it appears, had sent her affectionate messages all her life — she showed Boffil the

photos, postcards and letters. Cécile's daughter Claire, said it was probably her mother's entourage that wouldn't let her in to see her as she lay dying. And it certainly wasn't Salvador, "because he had a good relationship with Cécile all her life and was kind, and always tried to please her."

Even at the age of ninety-seven, she remained scathing about her mother, Gala. "She was hard. Hard and inflexible. It was like knocking your head against a brick wall. Simple as that. It was part of her. It was her nature," Cécile reportedly said in a trembling voice into the camera. She never understood all the fuss people made about the great artists she had known, they were just people like everyone else. "My life was very ordinary…I may not have had much of a mother, but at least I had a nice papa."

33

The Circle of Gala's Life

UNTIL THE DISCOVERY OF A LITTLE NOTEBOOK IN A TRUNK IN Púbol castle in 2005, Gala had always been a bit of a mystery. She never spoke to the press about herself or about Dalí and the few titbits that did emerge — how she'd dressed the cat in Salvador's underpants, lost a fortune again at the casino or punched another guest on the nose — may have revealed something about her temperament, but hardly said much about her background or where she came from.

Published in Catalan in 2011 as her *diari inèdit* (unedited diary) under the title of *Gala Dalí, La Vida Secreta* (Gala Dalí, *The Secret Life*), there's a photo of a young and pretty Elena Diakonova on the dust-cover before she re-invented herself as Gala. She has a look of deep distrust on her face, wary of the world, wondering what her next step should be. The photo could have been taken in Moscow before she left for Paris in 1916 or soon after. She's also cradling a cat, innocently asleep in her arms — or feigning sleep so it can't be interrogated about the secrets the book proclaims to reveal. Far from being a diary, it is more of a memoir of her childhood. No one, unless they have doubled as fairies or elves when they were toddlers, has ever led a secret life between the ages of six and eleven. Secret lives are for the likes of Lady Chatterley's Lover and meant for recording and spilling the beans on someone you have known intimately. Usually for devious reasons as well as for the money.

Be that as it may and leaving aside whatever salacious revelations the title promises, Gala's notebook is a portrait of a self-confessed Romantic, looking back on her childhood at a distance of forty or more years and experiencing again the conflicted feelings inherited from a fatal attraction to 19th century Romantic literature. With guilt, shame, embarrassment, trust and mistrust, fear of abandonment, loneliness, disappointment, terror; the lack of affection in her "disunited family," all passing review, little wonder that the Devil occasionally pops up out of the gloom to frighten her out of her wits and restore her sense of reality.

Gala is a case book study of what Mario Praz called the *Romantic Agony* in his classical work on the Romantic mindset. First published in Italian, the title could have been written with the little Muscovite in mind — *La Carne, la Morte, e il Diavolo nella Letteratura Romantica* (Flesh, Death and the Devil in Romantic literature) it codified the imagination of the bourgeois renegade trying to break out of its cage and find freedom in thrills, sex, horror and the supernatural.

Born in 1894, Elena Diakonova was brought up in a small flat near the zoo on the outskirts of Moscow with her two brothers, Vadim (Vadka) six years older and Nikolai (Kolka) a year younger. Her first memory was the birth of her sister (whose name she never mentions, but appears to have been called Lidia) — the horrible cries of her mother in childbirth, the whispered anguish in the household about her bleeding, the fear for her mother's life. How she'd been sent to sleep on a mattress at the neighbor's upstairs, to be brought down next day to witness her mother convalescing in bed, and hear her father say to her, pointing to a big box sitting on top of the wardrobe, "We've got a lovely little baby, we bought it for you.'

When they brought the baby, a "lump of congested red flesh, puffed up and wailing," she was repulsed. She lay down beside her mother and "embraced her with her all her tenderness and compassion," to show how terribly thankful she was for the gift.

Never before had she consciously hid her feelings, when confronted with their evident deception, she said. It left her feeling embarrassed and ashamed. Later that day her parents invited her to help bathe her new sister in the tub. She asked if she could hold it in her arms and although they agreed at first, they refused a moment later. "And that's how that day, one of the most important in my childhood, ended in tears," she wrote in her notebook. In French, the language of the Russian aristocracy and the aspiring bourgeoisie.

And so she continues, recalling incidents from her early years, what she felt and how she reacted. Her father told her that she'd never lied in her life. The challenge of the high moral standard she'd have to meet from then became a torment, imbuing her "with that virtually savage pride that I still suffer from today: certain things, words, intentions, lack of consideration, hurt me so deeply as to produce actual physical pain," she wrote.

When she was nine or ten, she caught scarlet fever. Her parents put her up in a hotel to avoid infecting the other children and left her alone. "Later, I'd be afraid my father would abandon me together with my brothers and sister to put an end to that disunited family existence, that life of bickering, scenes and rancor," she said.

Fortunately, her parents loved to travel. And so, like the poet Arthur Rimbaud, who longed to escape his stifling bourgeois existence by descending impassable rivers pursed by Red Indians in his *Bateau Ivre* (Drunken Boat) she too could dream of the thrill of descending rivers, the great river Ob on a steamer in her case, to see her rich Uncle Artemi in Siberia.

In that sense, the construction of the Trans-Siberian Railway was a godsend. Started in 1891 it was slowly opening up the country. By 1894, it had reached Omsk where her grandfather — her mother's father — had had a gold mine. By 1898 the railway had reached the Ob River, where her uncle Artemi lived.

A giant of a man, he'd come once to Moscow when she was tiny, and they'd all gone for a stroll. First, he picked up Vadka and put him on one shoulder. Next, he picked up Kolka on and put him on the other. Then he bent down and picked up Elena like a tiny sparrow and sat her on top of his head. And with all three of them perched on his massive frame, he strolled along chatting with her parents.

Around the middle of May 1902, they set off on the eight-day trip to see him in NovoNicolajevsky (Novosibiriski) where they were building a bridge over the river Ob to allow the railway to continue over 3,700 km (2,300 mi) across Siberia before reaching Vladivostok on the Pacific coast. The Ob rose in Mongolia and flowed thousands of miles through Siberia into the Arctic Ocean. It was over forty miles wide at the mouth where it entered the ocean, but just over a kilometer wide where uncle Artemi lived; where she and Vadya nearly drowned crossing in a leaky boat that summer.

> Dear Uncle Artemi, everything he touched turned to gold. He was a one-man industry that sold everything. from agricultural equipment to haberdashery, pastries, patent medicines, hunting rifles, shoes for all the family; luxuries and bare necessities. He had boats, big islands that he converted into hunting estates; numerous herds of animals of all kinds; eggs from his hen-runs, butter from a processing plant that he sent all the way to Moscow by train. He had beehives for honey, made conserves from mushrooms picked from the woods and forests, fish and salmon, salted cucumbers, eggs.

When exactly she started to write the memoir of her childhood is not clear, but it was certainly after Salvador published his *Secret Life* in 1942. After fleeing war torn Europe, they'd gone to America in 1940 to stay at heiress Caresse Crosby's Hampton Manor in Virginia. Driven by an urgent need to set the record straight, in reaction perhaps to Dalí's fanciful portrayal of his own youth in his

Secret Life — which she had substantially re-written — feeling homesick or alienated in yet another country where she did not speak the language, seeing only the prospect of old age stretching before her, for whatever the reasons, the Russia of her childhood came flooding back and she saw her uncle's big wooden house once again, with its outhouses and sauna, stables for the horses, cows, sheep and pigs and beyond that the vast forest. Where they'd swung on the ropes hanging from a wheel in the garden, where cousin Saixa had thrown himself in the river, his clothes in tatters, after the gunpowder they stole exploded in his face; where Kolka had stabbed her, narrowly missing her eye, when they were playing cards; and Vadya got carried away by the current and nearly drowned. "We were Romantics," she concluded.

Her grandfather — her mother's father — had owned a gold mine near Omsk. At the end of the mining season, he'd return on horseback with his workers. Having been isolated so long out in the wilds, they ran amok when they hit town. Knowing they were coming, the towns folk barred their doors and waited for the drunkenness, revelry and debauchery to subside, her mother said, as the desperados descended on the bars, saloons and dance halls, staked their all on the turn of a card, downed one bottle of French champagne after another, pausing only to step outside with a bucket of champagne for the horse.

But Siberia was only a long summer interlude. Back in Moscow in 1905, the country was going to the dogs. When revolution broke out in December, they were living on Arabat Street, about a kilometer from the Kremlin. The army started shelling their building which was next door to the police headquarters, on the pretext that a red flag had been seen flying from a stairway window. Later they learned, it was somebody from the Secret Police who'd waved the flag. To justify the shelling and blackmail the owner of their building into paying them to stop the bombardment.

Just after that she saw the Devil for the first time. She'd be about ten then. She woke up and saw a fiery-colored head and a hooked nose glow in the dark. The maid, who was terrified of the Last Judgement would take her to church and scare the daylight out of her with terrifying stories of people being condemned to Hell and Eternal Damnation. Elena put the apparition down to that.

About a year later it all started again. One night her father read them Mikhail Lermontov's long poem of *The Demon*, one of the great classics of Romantic literature, published after Lermontov met a suitably Romantic end by getting himself killed in a duel at the age of thirty by a fellow army officer.

> It was about a fallen angel that took on the guise of a handsome young man, very pale-faced, with long black hair and fiery eyes who appears to a very pretty young novice nun, who has shut herself up in a convent hoping to escape from the disturbing, seductive visions that are tormenting her. The Demon — the fallen angel — is passionately in love with the nun and knowing that she feels the same, asks her to accept him and purify him with her love so he can return to God's side; their relationship would be the first step in his redemption and salvation. The novice is about to succumb to the demon's seductive charms and the idea of saving the one she loves, but when she is dying, when she is about to condemn herself for all eternity, a host of angels and archangels come and carry her away and save her from the evil one.

After father finished reading Lermontov's poem, to which she had listened with "passionate, exalted interest," her mother cracked an egg into a bowl, cooked it on top of the petrol lamp and served each of them a Devil's Egg before sending them all to bed.

Just before daybreak, she awoke with a start. There was something in the room: the same fiery head from the year before. She could hear its labored breathing. When she feigned sleep, it detached itself from

the top of the bed and scurried to the window, a dark mass against the greyish-black of the window and the night. Then it approached the bed again, came quite close and ran its cold trembling hands all over her young, lifeless body as she lay there motionless not daring to breath. All sorts of notions raced through her head. Vampires she'd heard the servants talking about. A strangled cry escaped from her throat and the apparition, the Demon, the vampire, whatever it was, fled to a corner of the room where it remained immobile in the gloom before approaching her bed again. Whenever it did, she'd let it know she was awake, and it would scurry off back into the dark, hiding at the bottom of the bed. As dawn started to break and the sky became lighter, she caught a glimpse of white feet and white hands. The closer it got to daybreak, the more agitated the apparition became, signaling a terrible anguish. It was trapped, caught in a snare, tearing and beating at the wall. Finally, it fled from the room. It was Vadka, her elder brother!

She mentioned the incident several times to Antoni Pitxot. She trusted no one. Not even Pitxot at the start. He'd lived all his life in Cadaqués, was a companion of Salvador's and visited the couple regularly. He knew her better than anyone. "She was an oriental woman, a prototype of the Russian soul, who could get carried away with the most irrational fantasies, headless of the consequences," he said. "She was adamant in her convictions, had no taboos about anything, especially when it came to erotic matters; had no regard for decorum or constraint about what is acceptable and what is not. She never dissimulated, always said what she thought. She was fanatical about Dalí, protected him, was terrified some character or other would come and rip him off. She distrusted everyone except the very people who were robbing him blind."

In the early Eighties, when they returned to Spain from New York, Dalí was seriously depressed about the state of his finances and Gala was distraught at the thought of losing him. She started writing

messages on scraps of paper — phrases, prayers, wishes — and hiding them. "She'd roll them into little pellets with her fingers and stick them between cracks in the garden furniture or press them into the bark of the pine trees," according to Pitxot.

He kept one of her little messages. "May Dalí be strong and well, in good health. May he be happy and content, strong and full of joy and live in New York and me healthy, beautiful, and young," she'd written on it.

Towards the end when her circulation was very poor and the least knock created blood clots under her skin, Pitxot would encourage her to go for a walk in the grounds of Púbol Castle. Walking was good for the system, he'd say, and show her a little technique to balance the body's energy flows that he'd learned from traditional Chinese medicine. And as she walked along, obediently pressing two bony fingers of her right hand into the palm of the left, she'd smile and break into Russian, her mother tongue. That took possession of her once more after nearly sixty years of exile, telling her who she was, who she had been. Allowing her to complete the circle of her life. At peace with herself at last, she became one with the vast forests and the great Siberian rivers of her childhood and heard them call her name. Her real name. Not the name that she had taken in pride. That she had taken to make something of herself in the world. When she called herself Gala. But the name she had been given by her parents when she came into the world. That she had been given in love when she was born. Her Russian name: Elena Ivanova Diakonova.

34

Aleshores

THE SUNLIGHT IS SHINING WARM AND SOFTLY WHITE IN THE early evening and the gulls are crying and wheeling over the port. In the recently pruned trees in a garden further down the hill, half a dozen beige and brown-breasted doves are cooing. A flock of starlings circles the trees. The beach is deserted. There is hardly a ripple on the water in the captive bay. In the wet sand perilously close to the waterside, three names are carved: *Sandra, Els, and Marion*. The sea will remove them eventually but hopefully not too soon. The tide hardly affects the waters of the bay here along the esplanade. It is fed by the sea that comes in round the breakwater, beyond the big rock of the *Castellar* — or the grander sounding *Isla Castella*, in Catalan. The rock is only three of four hundred meters long which hardly qualifies it as an island. There is a little story to it. Before they built the breakwater in 1991 to link the Castellar with the land, the sea used to come in through La Gola (the gullet). That was fine most of the time, but when it stormed and the sea was raging, it came sweeping through the gullet and carried the little fishing boats on the beach with it and wrecked the fishermen's houses. Then they closed off the Gola with a breakwater and stuck a parking lot on it. But that stifled the natural course of the sea, so that when the current now brings the water to the beach along the boulevard, it has to sweep round the Castellar and the long breakwater attached to it, and what it delivers is a much tamer, more placid variety of sea.

The young Dutch girls, because that is what I suppose them to be given their names, have left a little mound of pebbles and a few twigs, as an offering to the water gods. Presumably. Further along the beach, Sandra, Els and Marion have also erected a crucifix with canes, to which they've attached a piece of fine string to secure the outstretched arms with rocks. The sea is the place where souls return to.

At the end of the boulevard there's an angular, pinnacle shaped statue to the Catalan poet, writer and cartoonist, *Pere Calders i Rossinyol*. Rossinyol is Catalan for nightingale. Mr Nightingale's verse, for some reason, is carved on the inner side of the pinnacle, facing the building on the corner at the end of the promenade, so it gets the shadow and not the bright light or the best of the winds that blow over the sea. This is where they put Rossinyol's ashes. His epitaph reads:

Aleshores jo, sense el pes de la carn
em sentiré deslligat de mans.
I si finalment resulta que n'hi ha
hi aniré al cel, on passaré una llarga temporada.

Then, freed of the weight of the flesh
I will feel my hands unbound.
And if turns out there is one in the end
I will go to heaven and spend a timely season there.

But the first part of the story is missing. Aleshores simply means 'then' in English. In the sense of 'and then' or 'next.' Pere Calders said something before that *aleshores*. But what was it? Out of curiosity, I tracked the epitaph down to a story he wrote after he returned from twenty-three years of exile in Mexico where he had gone after the Civil War. It was published under the title of La Fi (The End) in a Catalan magazine. He put it this way:

> To finish my memoir, I was lucky enough to be able to anticipate things thanks to a prophesy made to me by a gypsy I met in

Barcelona. One feast day in the Port de La Pau, a brown-skinned lady wearing colored-silk shawls, told me for ten centimes that I would be knocked down and killed by a bicycle. But that was still not enough to tell me what would actually happen. So, as is my wont, I started to picture it in my mind. No doubt when the time comes, I will be a man of indeterminate age. I could well be into my third or fourth exile by then, making a living giving people lessons on one of those subjects I am not fully versed in. I have never worn a beret but the way I picture it, I am wearing one of those soft, flexible hats, high in the crown and narrow-brimmed, of a cool, sad green color. I am walking along the street looking down, my hands clutched behind my back, racking my brains for something that will bring in some money and make me famous. Suddenly, passing a crossing, a cyclist — you know what they're like — knocks me down with his machine and crushes me against a plate glass window. From a street further up a girl lets out a scream and everyone comes running to help. The collision jolts me and I get a whiff of a strange odor, some kind of gas you can't quite put a name to, and when I come back to life it is to say: "We're all ready now, gentlemen. Even the beautician is going to be late." My friends only start to come when I am in hospital where I am no longer able to recognize them. One of them, quite upset, says: "What a shame! He used to have such nice fair hair." Later I make a last attempt to shout out my convictions and then I am ready. A close friend comes to give a funeral oration but, annoyingly enough, he only says a few words: "It looks like a print they've made of him." Then freed of the weight of the flesh, I will feel my hands unbound, and if turns out there is one, I will go to heaven and spend a timely season there.

Exiled to France, then Mexico after fighting for the Republicans in the Spanish Civil War, he liked to say he'd seen more Indians (in Mexico) than fishermen (in Llançà) in his lifetime. After his return to Catalunya, when he was fifty in 1962, he worked as an editor with Montaner i Simon in Barcelona until he retired. When he died at the

age of eighty-one in 1994 his death was covered by all the Catalan newspapers. He was buried in Barcelona and his ashes placed in the monument looking on to the sea in Llançà, where he came on holiday just about every year from 1964 onwards. He was a "little big man," one writer said: small in stature but great in other respects. Admirers were driven to compare him with the great South American writers like Jorge Luis Borges and Gabriel García Márquez. Best-known for his *Hundred Years of Solitude*, Márquez also wrote a story about the Tramuntana when he lived in Barcelona between 1967 and 1975.

Sources

English

Bonhams Fine Art, lot 6115 Correspondence from Gala and Salvador Dalí to William Rothlein (1964).

Dalí, Salvador, My Life as a Genius (Solar Books, 2006).

Dalí, Salvador, *The Secret Life* of Salvador Dalí (Dasa Editions, 2000).

Dalí and Gala dressed for Oneiric Ball, photo and text of Dalí and Gala in scandalous guise referencing kidnapped Lindbergh baby (Sunday Mirror, New York, 24 Feb 1935).

Gibson, Ian, The Shameful Life of Salvador Dalí (Faber and Faber, 1989).

Gibson, Ian, Fire in the Blood (YouTube).

Gibson, Ian, Documentary with Gibson voice-over (YouTube).

Harty, Russell, Omnibus Hello Dalí, A Soft Self-Portrait, 1-5 Omnibus BBC (YouTube).

Hughes, Robert, Barcelona (Vintage 1993).

Lauryssens, Stan, Dalí and I, the Surreal Story (St Martins Press, 2008).

Lauryssens, Stan, The Fake Paintings of Salvador Dalí (YouTube).

Orwell, George, Benefit of Clergy, some notes on Salvador Dalí, Critical Essays (Secker and Warburg, 1946).

Pitxot & Auger, Port Lligat, Salvador Dalí House Museum (Fundació Gala-Dalí, Escudo de Oro, undated).

Pla, Josep, The Grey Notebook - El Quadern Gris (New York Review of Books, 2013).

Richardson, Sir John, Dalí's Demon Bride (Vanity Fair, Aug. 1989).

Schlieber, Ralf, Dalí, Genius, Obsession and Lust (Prestel, 1999).

Summers, Anthony, The Secret Life of Edgar Hoover (The Guardian, 1 Jan. 2012).

Thurber, James, The Secret Life of James Thurber (New Yorker, 27 Feb 1943).

Thurlow, Clifford, Sex, Surrealism, Dalí and Me, Memoirs of Carlos Lozano (Yellow Bay 2013).

Vidal-Folch, Ignacio, Barcelona the Secret Museum (Actena, 2009).

Spanish

Bofill, Joan, La hijastra de Dalí reivindica su lugar (Cecile Eluard interviewed before her death in 2016. El País, 20 Aug. 2017).

Gibson, Ian, Luis Bunuel entre García Lorca y Dalí (YouTube).

Gibson, Ian, Encuentros Literarios con Ian Gibson (YouTube).

Gibson, Ian, Conferencia - Ciclo de Grandes Hispanistas Británicas (YouTube).

Gibson, Ian, Entrevista CajaCanarias, YouTube).

Ibarz and Villegas, El Caso de Lidia Cadaqués, Revista de la Historia de la Psicologia, Universidad Ramon Llull/Universidad de Barcelona.

Munt, Silvia, Elena Dimitrievna Daikonovna Gala, documentary/film, 2003 (YouTube).

Parinaud, Andre, Confesiones Inconfesables (Bruguera, 1975).

Rahola, Pilar, La Bien Arraigada, Lidia de Cadaqués (La Vanguardia, 17 Aug. 2017).

TVE documentary Revelando a Dalí, 2014 (YouTube).

Catalan

Dalí, Anna Maria, Salvador Dalí Vist per la Seva Germana (Viena Editions, 2012).

Bas Dalí, Lali, Los Dalí, Historia de una Familia (Editorial Juventud 2004).

Gala-Dalí, La vida Secreta de Gala Dalí (Galaxia Gutenberg 2011).

Chacón, Manolo Moreno, Viatgers a Figueres, segles XV-XIX (Ajuntament de Figueres 1995).

Da Costa, Josep M, La Tramuntana (Quaderns de La Revista de Girona, 1995).

About the Author

Patrick Farnon was born in Hamilton, Scotland, studied French & Spanish at Glasgow University and is a Member of ALCS (Authors Licensing and Collecting Society). His short stories have appeared in Barcelona Ink, The New Edinburgh Review, Words, Trends, Stand magazine, Scottish Short Stories (Collins), the Scotsman Magazine.

As a journalist he has written for Havana Times (online), Jakarta Post, The Times, The Herald, The Scotsman, Holland Life, Industrial Relations Europe, Vision magazine and the Economist Intelligence Unit. He is also a translator of Spanish and Dutch. He lives in Amsterdam with his wife and daughter.

www.ingramcontent.com/pod-product-compliance
Lightning Source LLC
Chambersburg PA
CBHW072134170526
45158CB00004BA/1364